W9-BOV-489

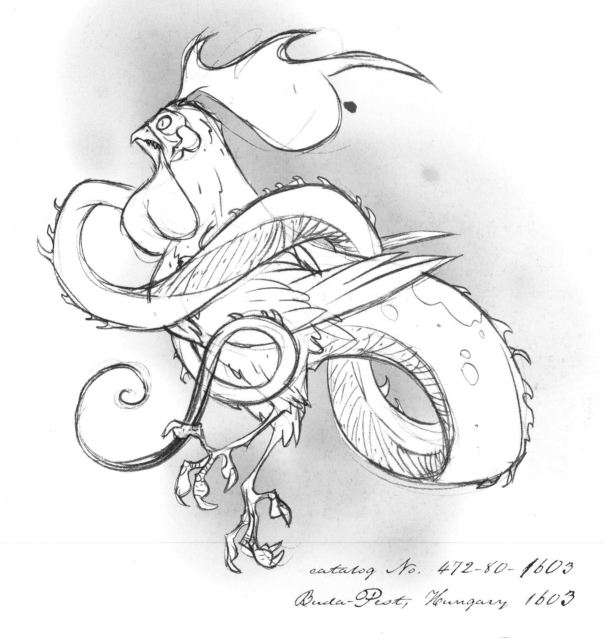

catalog No. 472-80-1603

Buda-Pest, Hungary 1603

one of Pair

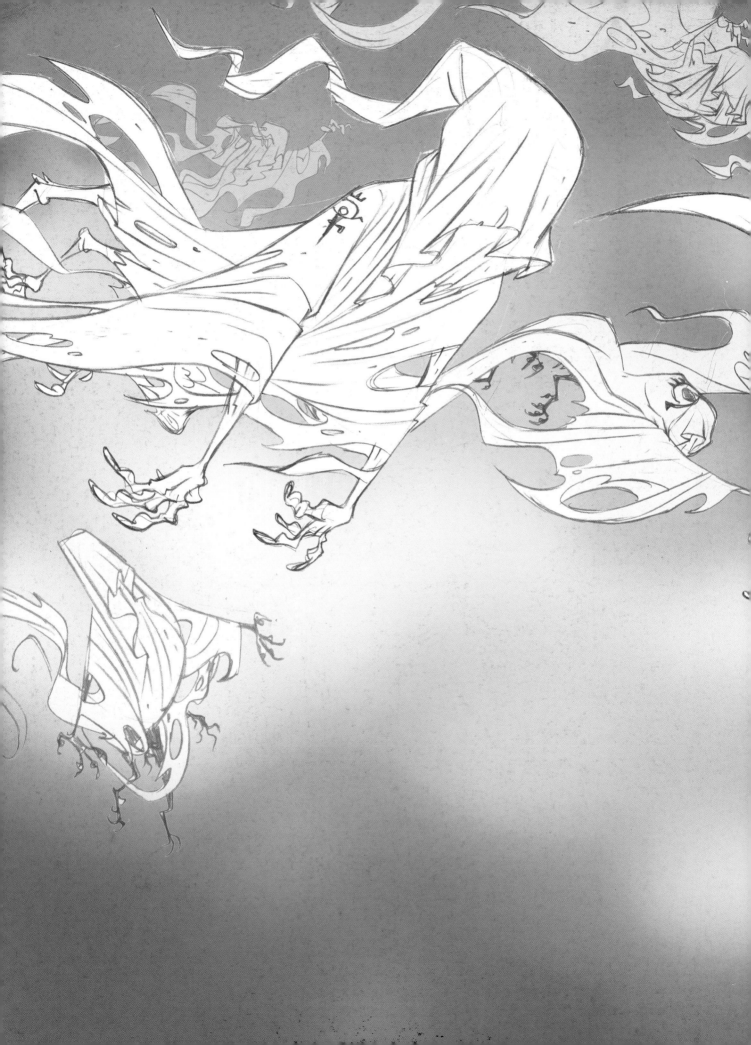

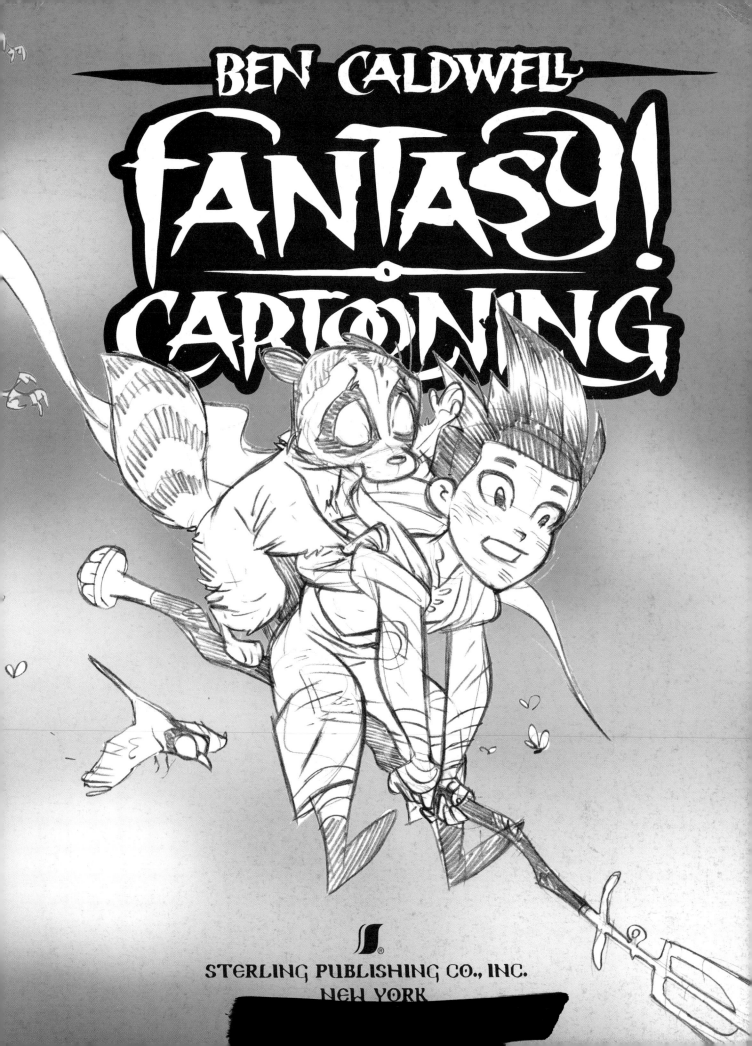

BEN CALDWELL

FANTASY!
CARTOONING

STERLING PUBLISHING CO., INC.
NEW YORK

VISIT ME ON THE WEB!
WWW.STERLINGPUB.COM
WWW.ACTIONCARTOONING.COM

LIBRARY OF CONGRESS CATALOGING-IN-PUBLICATION DATA

CALDWELL, BEN 1973-
 FANTASY! CARTOONING/BEN CALDWELL.
 P.CM.
 INCLUDES INDEX.
 ISBN 1-4027-1612-5
 1.FANTASY IN ART. 2. CARTOONING-TECHNIQUE. I. TITLE

NC1764.8F37C35 2005
741.5-DC22

10 9 8 7 6 5 4 3 2 1

PUBLISHED BY STERLING PUBLISHING CO., INC.
387 PARK AVENUE SOUTH, NEW YORK, NY 10016
© 2005 BY BEN CALDWELL
DISTRIBUTED IN CANADA BY STERLING PUBLISHING
C/O CANADIAN MANDA GROUP, 165 DUFFERIN STREET
TORONTO, ONTARIO, CANADA M6K 3H6
DISTRIBUTED IN GREAT BRITAIN BY CHRYSALIS BOOKS GROUP PLC
THE CHRYSALIS BUILDING, BRAMLEY ROAD, LONDON W10 6SP, ENGLAND
DISTRIBUTED IN AUSTRALIA BY CAPRICORN LINK (AUSTRALIA) PTY. LTD.
P.O. BOX 704, WINDSOR, NSW 2756, AUSTRALIA

PRINTED IN CHINA
ALL RIGHTS RESERVED

STERLING ISBN 1-4027-1612-5

FOR INFORMATION ABOUT CUSTOM EDITIONS, SPECIAL SALES, PREMIUM
AND CORPORATE PURCHASES, PLEASE CONTACT STERLING SPECIAL SALES
DEPARTMENT AT 800-805-5489 OR SPECIALSALES@STERLINGPUB.COM.

for my grandmother

CONTENTS

CONTENTS

CARTOON MAGIC

SO YOU WANT TO DRAW FANTASY CARTOONS? ME TOO! BUT LOTS OF PEOPLE TALK ABOUT "FANTASY" WITHOUT REALLY KNOWING WHAT IT MEANS. SO LET'S TAKE A FEW PAGES TO TALK ABOUT HOW TO GET THE MOST FUN AND CREATIVITY OUT OF YOUR FANTASY CARTOONS. THEN WE'LL BE SET TO DRAW A HOST OF FANTASY CHARACTERS AND SCENES!

DO NOT TOUCH

ONCE UPON A TIME...

"FANTASY" CONJURES UP IMAGES OF KNIGHTS, SWORDS, AND DRAGONS, AS IN THE CLASSIC MYTH "ST. GEORGE AND THE DRAGON."

MONSTER'S LAIR —
ISOLATED MOUNTAIN CAVE

③

MONSTER —
FIRE-BREATHING DRAGON

②

HERO —
WANDERING
ADVENTURER
ST. GEORGE

①

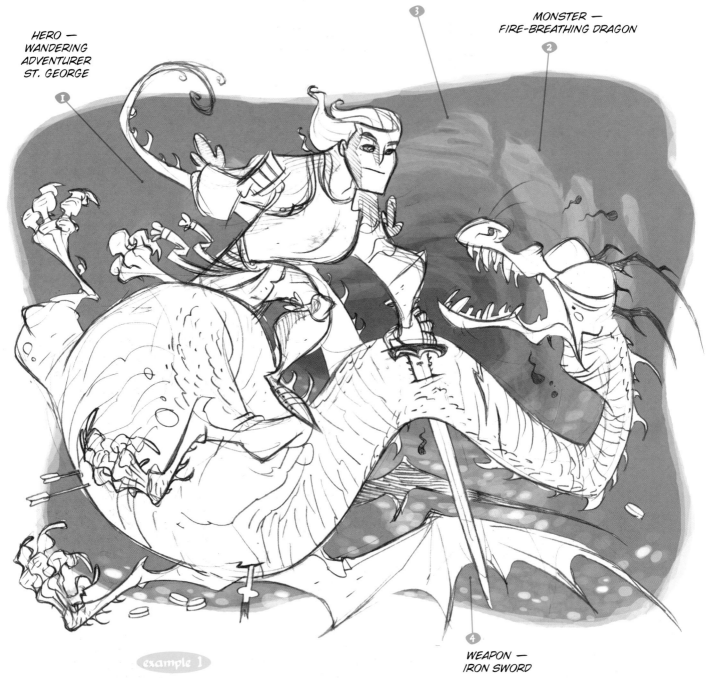

example 1

④

WEAPON —
IRON SWORD

THE SPECIFIC DETAILS OF THESE MYTHS — THE CHARACTERS, PROPS, AND SETTINGS — WERE USED BY ANCIENT STORYTELLERS WHO WERE FAMILIAR WITH THEM.

* "DRACULA" WAS WRITTEN IN 1894

BUT THEY ARE ONLY DETAILS, AND CAN CHANGE TO FIT THE TASTES OF ANY AUDIENCE. OUTSIDE OF ITS DETAILS, THE MODERN* "DRACULA" IS SIMILAR TO CLASSIC MYTHS.

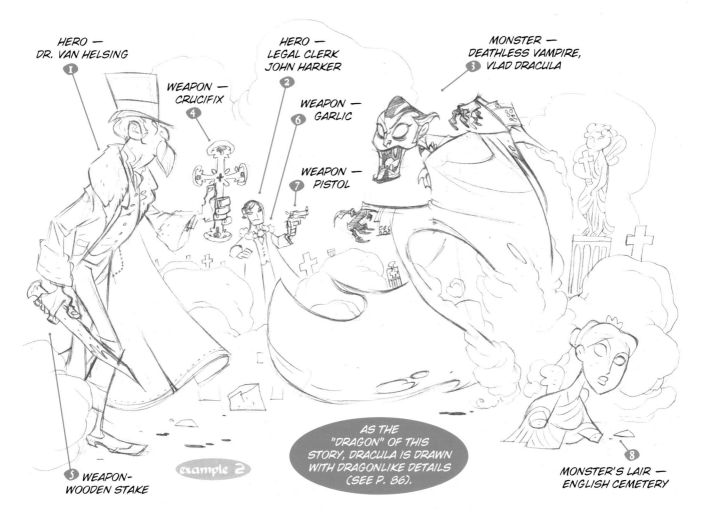

HERO —
DR. VAN HELSING
①

WEAPON —
CRUCIFIX
④

HERO —
LEGAL CLERK
JOHN HARKER
②

WEAPON —
GARLIC
⑥

WEAPON —
PISTOL
⑦

MONSTER —
DEATHLESS VAMPIRE,
VLAD DRACULA
③

⑤ WEAPON-
WOODEN STAKE

example 2

AS THE
"DRAGON" OF THIS
STORY, DRACULA IS DRAWN
WITH DRAGONLIKE DETAILS
(SEE P. 86).

MONSTER'S LAIR —
ENGLISH CEMETERY
⑧

LOOKING AT THESE EXAMPLES, YOU MAY HAVE NOTICED THAT WHILE SWORDS AND GUNS ARE OBVIOUS WEAPONS, GARLIC AND SHARPENED BITS OF WOOD ARE NOT!

THE STRANGE AND DREAMLIKE NATURE OF FANTASY IS EMPHASIZED BY GIVING "NORMAL" OBJECTS AND PLACES SPECIAL MEANING OR POWER THAT THEY LACK IN OUR OWN WORLD.

BELT OR GIRDLE —
SPECIAL BELTS WERE WORN BY
MANY HEROES, INCLUDING THE
BRAVE LITTLE TAILOR, AND
HYPPOLITA, THE AMAZON QUEEN

MAGIC SLIPPERS —
CINDERELLA AND DOROTHY
USED FANCY FOOTWARE

APPLES —
A PERENNIAL FAVORITE. GREEK,
NORSE, AND HEBREW MYTHS HAD
APPLES OF IMMORTALITY; SNOW
WHITE WAS POISONED BY AN APPLE

BROOMSTICK —
WITCH'S VEHICLE OF
CHOICE IN OLD EUROPE

TRIPOD —
APOLLO'S MAGIC CHAIR, USED BY
THE DELPHIC ORACLE TO
PROPHESY THE FUTURE

SPINDLE —
CURSES SLEEPING
BEAUTY, SPINS GOLD
FOR RUMPLESTILTSKIN

WHETHER YOU FILL YOUR FANTASIES WITH STRANGE NEW CREATURES OR FAMILIAR ELVES AND GOBLINS, YOUR MOST IMPORTANT TASK IS TO AVOID DRAWING THE **EXPECTED** DETAILS — THIS WILL PUT YOUR AUDIENCE TO SLEEP.

INTRIGUE YOUR AUDIENCE BY TAKING THE BASIC **IDEAS** BEHIND FANTASY CHARACTERS (KINGS, WITCHES, AND SO ON) AND BY CARTOONING, EMPHASIZE THE WONDER, TERROR, AND WEIRDNESS OF TRUE FANTASY ADVENTURE!

a LIVING WORLD

ANOTHER DIFFERENCE BETWEEN "NORMAL" AND FANTASY WORLDS IS THE INSULAR NATURE OF FANTASY — EVERYTHING IS RELATED TO EVERYTHING ELSE. FAIRY TALES ABOUND WITH LUCKY MEETINGS, LOST FAMILY MEMBERS, AND FATE-FILLED DESTINIES.

IN A FANTASY WORLD, EVERYTHING IS CONNECTED TO EVERYTHING ELSE TO CREATE A LIVING WORLD. ANIMALS TALK AND ACT LIKE PEOPLE. EVEN TREES AND RIVERS HAVE VISIBLE PERSONALITIES, IN THE SHAPES OF TREE SPIRITS AND RIVER GODS.

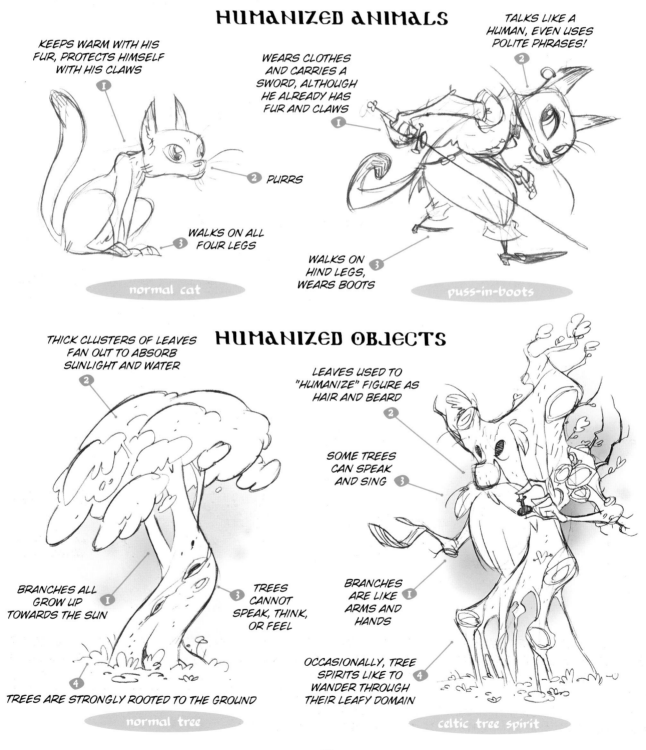

HUMANIZED ANIMALS

KEEPS WARM WITH HIS FUR, PROTECTS HIMSELF WITH HIS CLAWS

2 PURRS

3 WALKS ON ALL FOUR LEGS

normal cat

WEARS CLOTHES AND CARRIES A SWORD, ALTHOUGH HE ALREADY HAS FUR AND CLAWS

TALKS LIKE A HUMAN, EVEN USES POLITE PHRASES!

WALKS ON HIND LEGS, WEARS BOOTS

puss-in-boots

HUMANIZED OBJECTS

THICK CLUSTERS OF LEAVES FAN OUT TO ABSORB SUNLIGHT AND WATER

BRANCHES ALL GROW UP TOWARDS THE SUN

TREES CANNOT SPEAK, THINK, OR FEEL

TREES ARE STRONGLY ROOTED TO THE GROUND

normal tree

LEAVES USED TO "HUMANIZE" FIGURE AS HAIR AND BEARD

SOME TREES CAN SPEAK AND SING

BRANCHES ARE LIKE ARMS AND HANDS

OCCASIONALLY, TREE SPIRITS LIKE TO WANDER THROUGH THEIR LEAFY DOMAIN

celtic tree spirit

WHILE SOME ELEMENTS OF A FANTASY WORLD HAVE OBVIOUS PERSONALITIES (WITH FACES, VOICES, AND SO ON) *EVERYTHING* IN FANTASY — OBJECTS, PLACES, EVEN BACKGROUNDS — SHOULD BE DRAWN WITH A VISIBLE SENSE OF CHARACTER!

HOW DO YOU DO THAT? GOOD QUESTION! THAT'S WHY THIS BOOK IS CALLED "FANTASY CARTOONING." *CARTOONING IS USING LINES, SHAPES, AND SYMBOLS TO SHOW INVISIBLE IDEAS — LIKE THE PERSONALITY OF A CHARACTER, OR THE MOOD OF A PLACE OR EVENT.*

OBJECTS WITH PERSONALITY

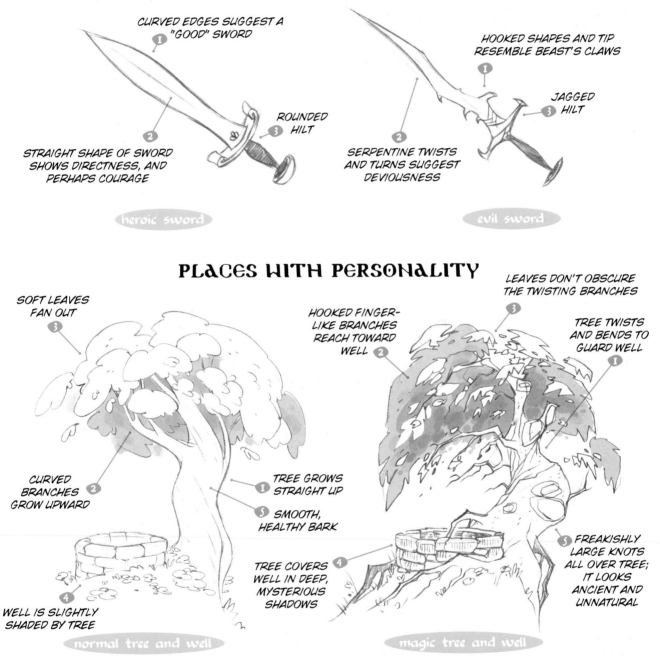

CURVED EDGES SUGGEST A "GOOD" SWORD ①

ROUNDED ③ HILT

STRAIGHT SHAPE OF SWORD ② SHOWS DIRECTNESS, AND PERHAPS COURAGE

heroic sword

HOOKED SHAPES AND TIP RESEMBLE BEAST'S CLAWS ①

JAGGED ③ HILT

SERPENTINE TWISTS ② AND TURNS SUGGEST DEVIOUSNESS

evil sword

PLACES WITH PERSONALITY

SOFT LEAVES ③ FAN OUT

CURVED BRANCHES ② GROW UPWARD

WELL IS SLIGHTLY ④ SHADED BY TREE

TREE GROWS ① STRAIGHT UP

SMOOTH, ⑤ HEALTHY BARK

TREE COVERS ④ WELL IN DEEP, MYSTERIOUS SHADOWS

normal tree and well

LEAVES DON'T OBSCURE THE TWISTING BRANCHES ③

HOOKED FINGER- ② LIKE BRANCHES REACH TOWARD WELL

TREE TWISTS AND BENDS TO GUARD WELL ①

FREAKISHLY ⑤ LARGE KNOTS ALL OVER TREE; IT LOOKS ANCIENT AND UNNATURAL

magic tree and well

IN THE END, THE IMPORTANT THING TO REMEMBER ABOUT FANTASY IS THAT THE DETAILS AREN'T TIED TO ANY PRESET IDEAS OR HISTORICAL PERIODS.
THIS BOOK IS FILLED, NATURALLY, WITH FAERIES AND DRAGONS AND THE LIKE, BUT THESE ARE JUST A STARTING POINT. THE DETAILS IN YOUR DRAWINGS HAVE ONE PURPOSE: TO SHOW A WORLD THAT IS MORE BEAUTIFUL, MORE TERRIFYING, AND MORE MYSTERIOUS THAN OUR OWN.
LET'S DRAW!

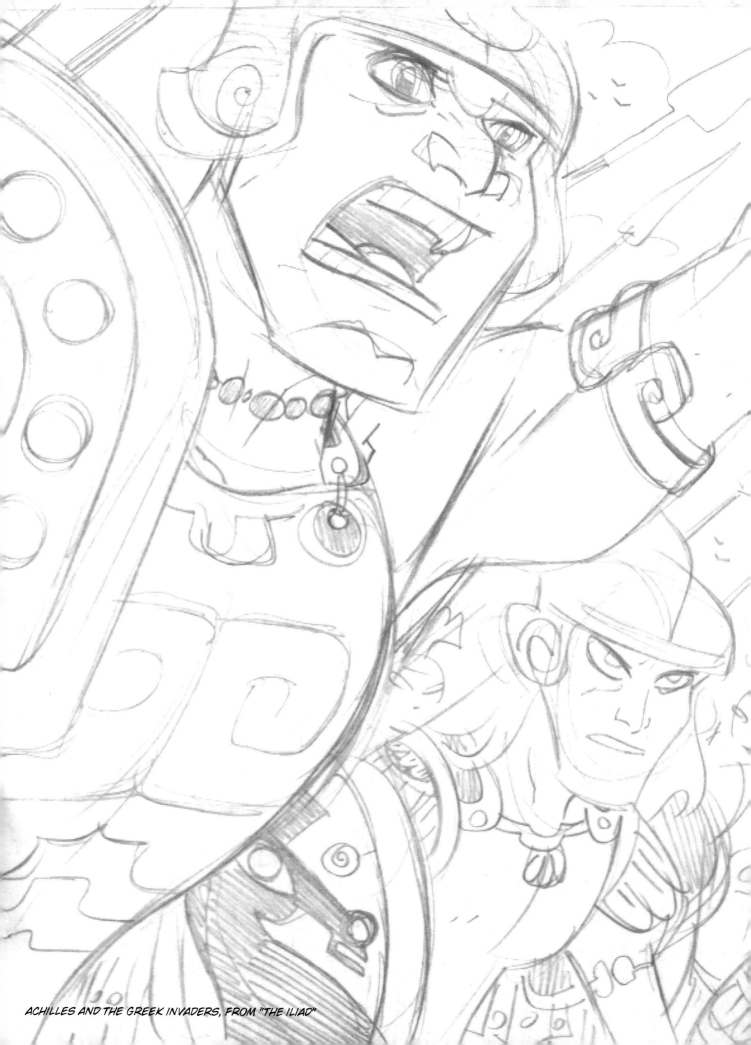

ACHILLES AND THE GREEK INVADERS, FROM "THE ILIAD"

HEROES AND VILLAINS

EVEN THE STRANGEST FANTASY STORY IS USUALLY ROOTED IN THE STRUGGLE BETWEEN HUMANS AND THE WIDER WORLD AROUND THEM. SO FIRST WE WILL LOOK AT DESIGNS FOR HUMAN HEROES, MAGI, AND BANDITS. THEN WE'LL TURN THEM LOOSE ON THE WORLD OF FANTASY!

THE HEROIC IDEAL

HEROES COME IN ALL SHAPES AND SIZES, BUT THE TYPICAL HERO LOOKS SOMETHING LIKE THE ANCIENT GREEK ADVENTURER, HERAKLES.

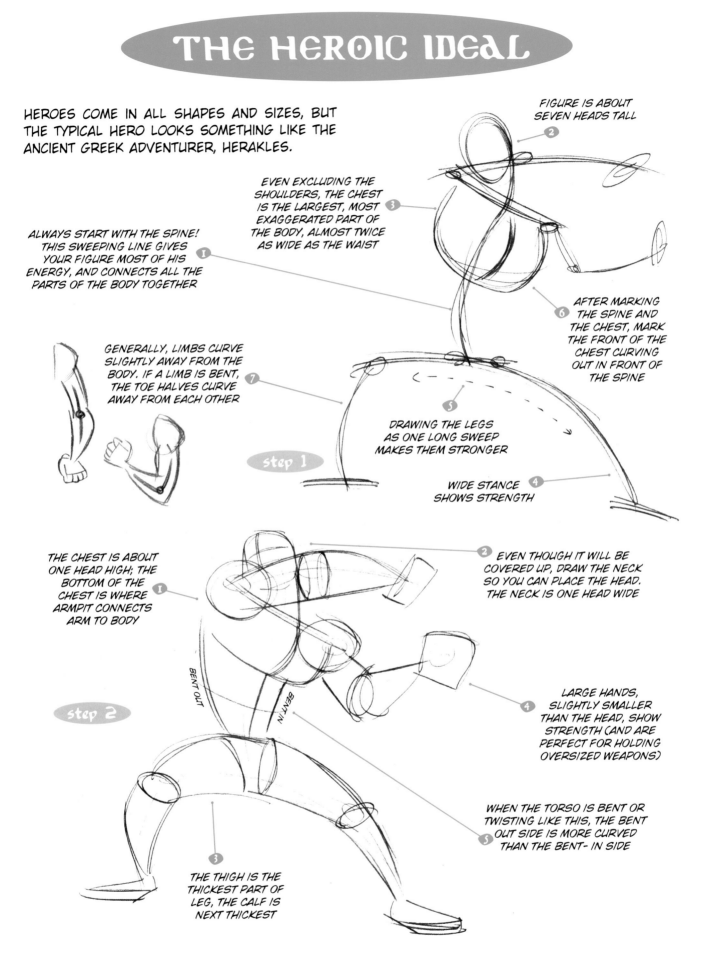

FIGURE IS ABOUT SEVEN HEADS TALL — **2**

EVEN EXCLUDING THE SHOULDERS, THE CHEST IS THE LARGEST, MOST EXAGGERATED PART OF THE BODY, ALMOST TWICE AS WIDE AS THE WAIST — **3**

ALWAYS START WITH THE SPINE! THIS SWEEPING LINE GIVES YOUR FIGURE MOST OF HIS ENERGY, AND CONNECTS ALL THE PARTS OF THE BODY TOGETHER — **1**

AFTER MARKING THE SPINE AND THE CHEST, MARK THE FRONT OF THE CHEST CURVING OUT IN FRONT OF THE SPINE — **6**

GENERALLY, LIMBS CURVE SLIGHTLY AWAY FROM THE BODY. IF A LIMB IS BENT, THE TOE HALVES CURVE AWAY FROM EACH OTHER — **7**

DRAWING THE LEGS AS ONE LONG SWEEP MAKES THEM STRONGER — **5**

WIDE STANCE SHOWS STRENGTH — **4**

step 1

THE CHEST IS ABOUT ONE HEAD HIGH; THE BOTTOM OF THE CHEST IS WHERE ARMPIT CONNECTS ARM TO BODY — **1**

EVEN THOUGH IT WILL BE COVERED UP, DRAW THE NECK SO YOU CAN PLACE THE HEAD. THE NECK IS ONE HEAD WIDE — **2**

LARGE HANDS, SLIGHTLY SMALLER THAN THE HEAD, SHOW STRENGTH (AND ARE PERFECT FOR HOLDING OVERSIZED WEAPONS) — **4**

WHEN THE TORSO IS BENT OR TWISTING LIKE THIS, THE BENT OUT SIDE IS MORE CURVED THAN THE BENT-IN SIDE — **5**

THE THIGH IS THE THICKEST PART OF LEG, THE CALF IS NEXT THICKEST — **3**

BENT OUT

BENT IN

step 2

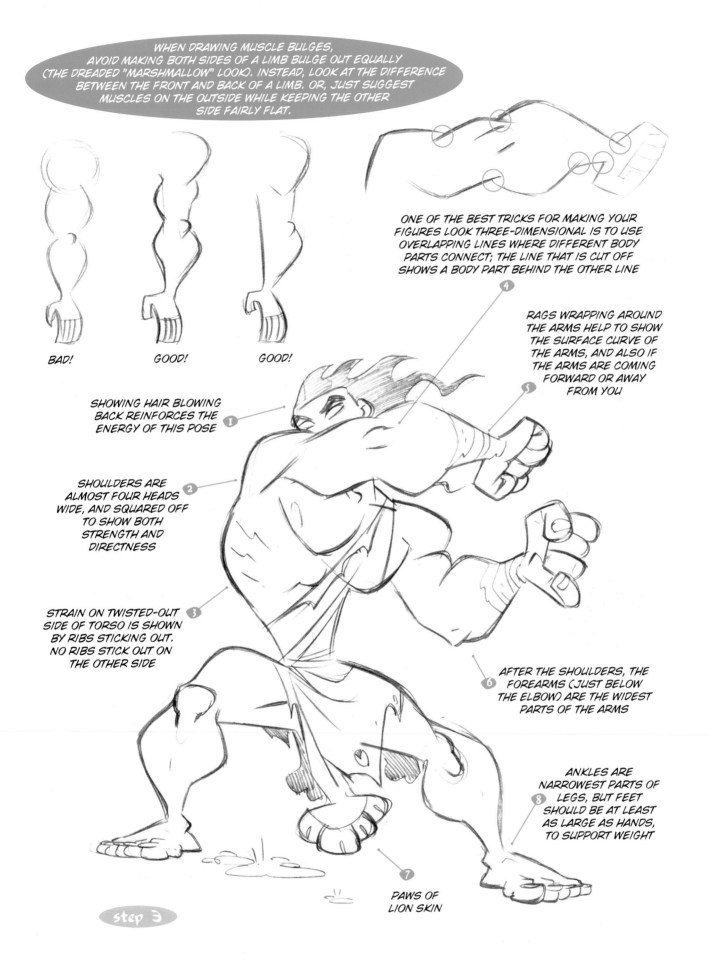

WHEN DRAWING MUSCLE BULGES, AVOID MAKING BOTH SIDES OF A LIMB BULGE OUT EQUALLY (THE DREADED "MARSHMALLOW" LOOK). INSTEAD, LOOK AT THE DIFFERENCE BETWEEN THE FRONT AND BACK OF A LIMB. OR, JUST SUGGEST MUSCLES ON THE OUTSIDE WHILE KEEPING THE OTHER SIDE FAIRLY FLAT.

BAD!

GOOD!

GOOD!

ONE OF THE BEST TRICKS FOR MAKING YOUR FIGURES LOOK THREE-DIMENSIONAL IS TO USE OVERLAPPING LINES WHERE DIFFERENT BODY PARTS CONNECT; THE LINE THAT IS CUT OFF SHOWS A BODY PART BEHIND THE OTHER LINE

RAGS WRAPPING AROUND THE ARMS HELP TO SHOW THE SURFACE CURVE OF THE ARMS, AND ALSO IF THE ARMS ARE COMING FORWARD OR AWAY FROM YOU

SHOWING HAIR BLOWING BACK REINFORCES THE ENERGY OF THIS POSE

SHOULDERS ARE ALMOST FOUR HEADS WIDE, AND SQUARED OFF TO SHOW BOTH STRENGTH AND DIRECTNESS

STRAIN ON TWISTED-OUT SIDE OF TORSO IS SHOWN BY RIBS STICKING OUT. NO RIBS STICK OUT ON THE OTHER SIDE

AFTER THE SHOULDERS, THE FOREARMS (JUST BELOW THE ELBOW) ARE THE WIDEST PARTS OF THE ARMS

ANKLES ARE NARROWEST PARTS OF LEGS, BUT FEET SHOULD BE AT LEAST AS LARGE AS HANDS, TO SUPPORT WEIGHT

PAWS OF LION SKIN

step 3

THE HEROIC FACE

THE MOST IMPORTANT PART OF MANY CHARACTERS IS THE FACE. THE FACE SHOWS A CHARACTER'S PERSONALITY AND EMOTIONS, AND IT'S UP TO YOU TO USE EVERY DRAWING TRICK YOU CAN TO CONVEY THIS INFORMATION!

IN THE INTRODUCTION, I MENTIONED HOW LINES AND SHAPES CAN BE USED TO REVEAL A PERSONALITY. LET'S LOOK AT THE BASIC SHAPES OF A HEROIC HEAD.

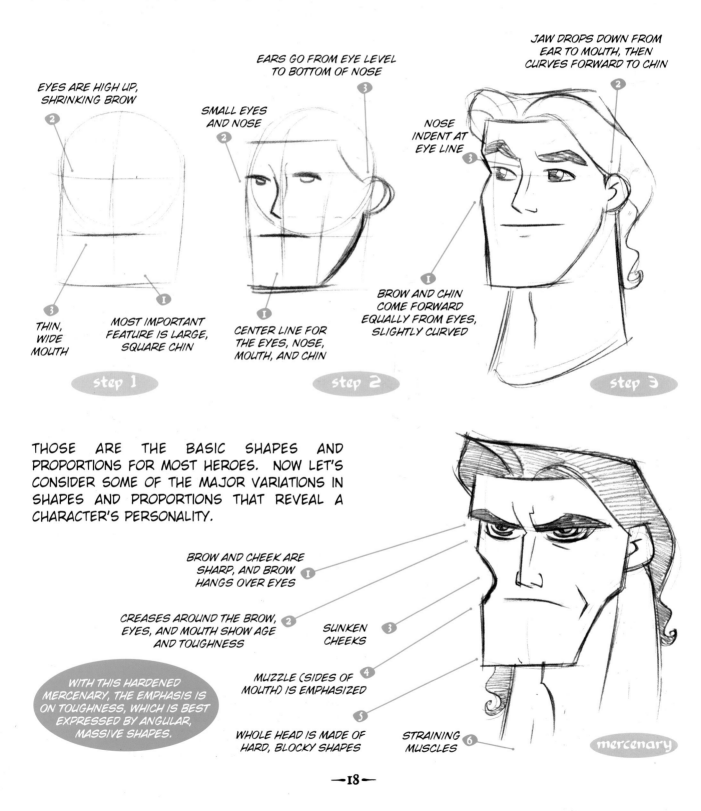

EYES ARE HIGH UP, SHRINKING BROW

THIN, WIDE MOUTH

MOST IMPORTANT FEATURE IS LARGE, SQUARE CHIN

step 1

EARS GO FROM EYE LEVEL TO BOTTOM OF NOSE

SMALL EYES AND NOSE

CENTER LINE FOR THE EYES, NOSE, MOUTH, AND CHIN

step 2

JAW DROPS DOWN FROM EAR TO MOUTH, THEN CURVES FORWARD TO CHIN

NOSE INDENT AT EYE LINE

BROW AND CHIN COME FORWARD EQUALLY FROM EYES, SLIGHTLY CURVED

step 3

THOSE ARE THE BASIC SHAPES AND PROPORTIONS FOR MOST HEROES. NOW LET'S CONSIDER SOME OF THE MAJOR VARIATIONS IN SHAPES AND PROPORTIONS THAT REVEAL A CHARACTER'S PERSONALITY.

BROW AND CHEEK ARE SHARP, AND BROW HANGS OVER EYES

CREASES AROUND THE BROW, EYES, AND MOUTH SHOW AGE AND TOUGHNESS

SUNKEN CHEEKS

WITH THIS HARDENED MERCENARY, THE EMPHASIS IS ON TOUGHNESS, WHICH IS BEST EXPRESSED BY ANGULAR, MASSIVE SHAPES.

MUZZLE (SIDES OF MOUTH) IS EMPHASIZED

WHOLE HEAD IS MADE OF HARD, BLOCKY SHAPES

STRAINING MUSCLES

mercenary

VARIATIONS

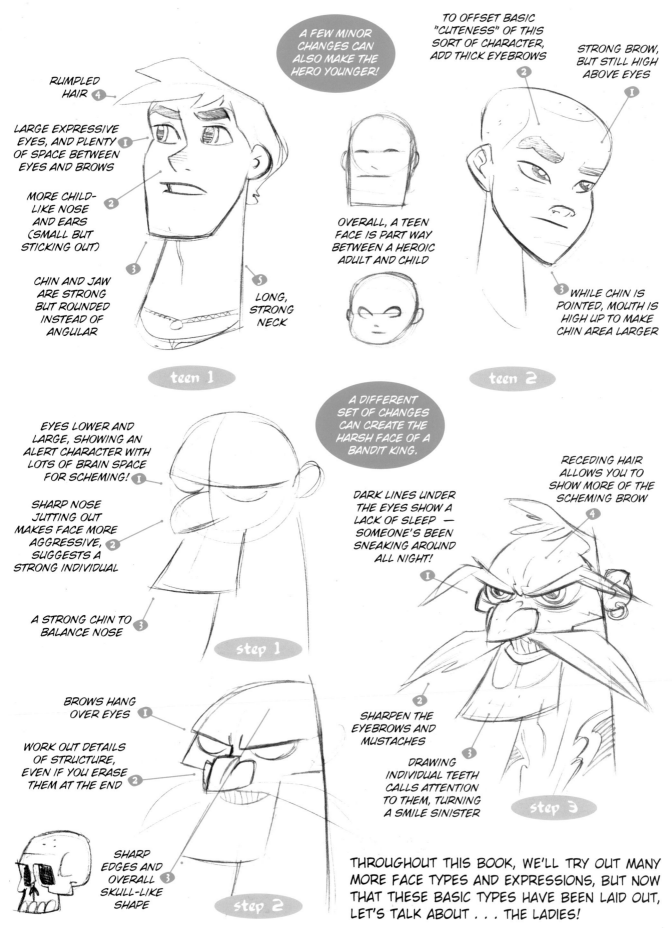

A FEW MINOR CHANGES CAN ALSO MAKE THE HERO YOUNGER!

TO OFFSET BASIC "CUTENESS" OF THIS SORT OF CHARACTER, ADD THICK EYEBROWS

STRONG BROW, BUT STILL HIGH ABOVE EYES

RUMPLED HAIR ④

LARGE EXPRESSIVE EYES, AND PLENTY ① OF SPACE BETWEEN EYES AND BROWS

MORE CHILD-LIKE NOSE AND EARS (SMALL BUT STICKING OUT)

CHIN AND JAW ARE STRONG BUT ROUNDED INSTEAD OF ANGULAR

OVERALL, A TEEN FACE IS PART WAY BETWEEN A HEROIC ADULT AND CHILD

LONG, STRONG NECK

WHILE CHIN IS POINTED, MOUTH IS HIGH UP TO MAKE CHIN AREA LARGER

teen 1

teen 2

A DIFFERENT SET OF CHANGES CAN CREATE THE HARSH FACE OF A BANDIT KING.

EYES LOWER AND LARGE, SHOWING AN ALERT CHARACTER WITH LOTS OF BRAIN SPACE FOR SCHEMING! ①

SHARP NOSE JUTTING OUT MAKES FACE MORE AGGRESSIVE, SUGGESTS A STRONG INDIVIDUAL

A STRONG CHIN TO BALANCE NOSE

DARK LINES UNDER THE EYES SHOW A LACK OF SLEEP — SOMEONE'S BEEN SNEAKING AROUND ALL NIGHT!

RECEDING HAIR ALLOWS YOU TO SHOW MORE OF THE SCHEMING BROW

step 1

BROWS HANG OVER EYES ①

WORK OUT DETAILS OF STRUCTURE, EVEN IF YOU ERASE THEM AT THE END ②

SHARP EDGES AND OVERALL SKULL-LIKE SHAPE

SHARPEN THE EYEBROWS AND MUSTACHES

DRAWING INDIVIDUAL TEETH CALLS ATTENTION TO THEM, TURNING A SMILE SINISTER

step 3

step 2

THROUGHOUT THIS BOOK, WE'LL TRY OUT MANY MORE FACE TYPES AND EXPRESSIONS, BUT NOW THAT THESE BASIC TYPES HAVE BEEN LAID OUT, LET'S TALK ABOUT . . . THE LADIES!

THE HEROINE

WHILE WE'RE ALL FAMILIAR WITH MALE HEROES, MYTH AND FANTASY ARE ALSO FULL OF HEROINES, FROM DAYDREAMING CINDERELLA TO ADVENTUROUS DOROTHY TO ENCHANTING CELTIC SORCERESS MORGAN LEFEY.

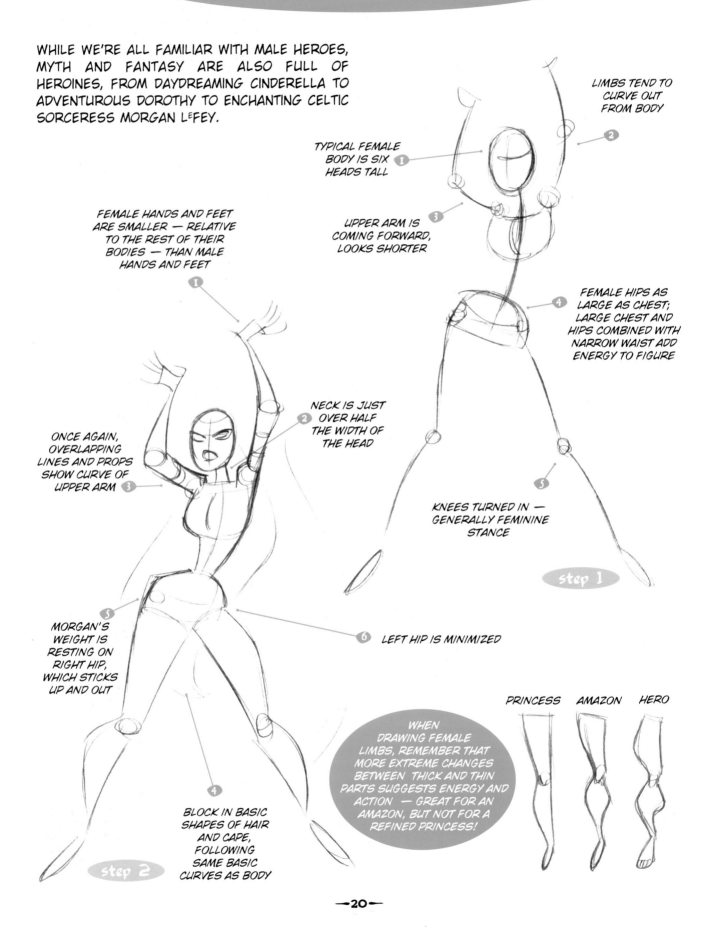

LIMBS TEND TO CURVE OUT FROM BODY ②

TYPICAL FEMALE BODY IS SIX HEADS TALL ①

UPPER ARM IS COMING FORWARD, LOOKS SHORTER ③

FEMALE HIPS AS LARGE AS CHEST; LARGE CHEST AND HIPS COMBINED WITH NARROW WAIST ADD ENERGY TO FIGURE ④

FEMALE HANDS AND FEET ARE SMALLER — RELATIVE TO THE REST OF THEIR BODIES — THAN MALE HANDS AND FEET ①

NECK IS JUST OVER HALF THE WIDTH OF THE HEAD ②

ONCE AGAIN, OVERLAPPING LINES AND PROPS SHOW CURVE OF UPPER ARM ③

KNEES TURNED IN — GENERALLY FEMININE STANCE ⑤

step 1

MORGAN'S WEIGHT IS RESTING ON RIGHT HIP, WHICH STICKS UP AND OUT ⑤

LEFT HIP IS MINIMIZED ⑥

PRINCESS AMAZON HERO

WHEN DRAWING FEMALE LIMBS, REMEMBER THAT MORE EXTREME CHANGES BETWEEN THICK AND THIN PARTS SUGGESTS ENERGY AND ACTION — GREAT FOR AN AMAZON, BUT NOT FOR A REFINED PRINCESS!

BLOCK IN BASIC SHAPES OF HAIR AND CAPE, FOLLOWING SAME BASIC CURVES AS BODY ④

step 2

—20—

BLANK EYES LOOK LESS
HUMAN AND MORE CREEPY

7

ONLY INCLUDE
STRUCTURAL DETAILS
THAT ARE IMPORTANT TO
FIGURE OR POSE;
MINIMIZE UNIMPORTANT
INFORMATION LIKE REAR
SHOULDER MUSCLE, AND
KEEP OVERALL SHAPES
SIMPLE AND FLOWING

1

UNNECESSARY
DETAIL NOT NEEDED
FOR THIS POSE —
SKIP IT!

EVERY LINE COUNTS —
RAGGED SHAPES LIKE
HAIR AND CAPE
SUGGEST DANGER!

2

WHEN ARMS RAISED UP OR
TO SIDES, COLLARBONES
IS MORE VISIBLE

5

EVERY CURVE OF CLOTHING
OR JEWELRY IS A CHANCE
TO SHOW BENDS AND
CURVES OF BODY

6

DESPITE LOTS OF
SURFACE ORNAMENT,
ACTUAL SHAPES OF
BODY AND COSTUME
ARE CLEAN AND SIMPLE

3

EVEN WHEN CHARACTERS
ARE WEARING FLOWING
SKIRTS OR ROBES, TRY TO
HAVE ENOUGH OF BODY
SHOWING THAT POSE AND
ACTIONS ARE CLEAR

4

step 3

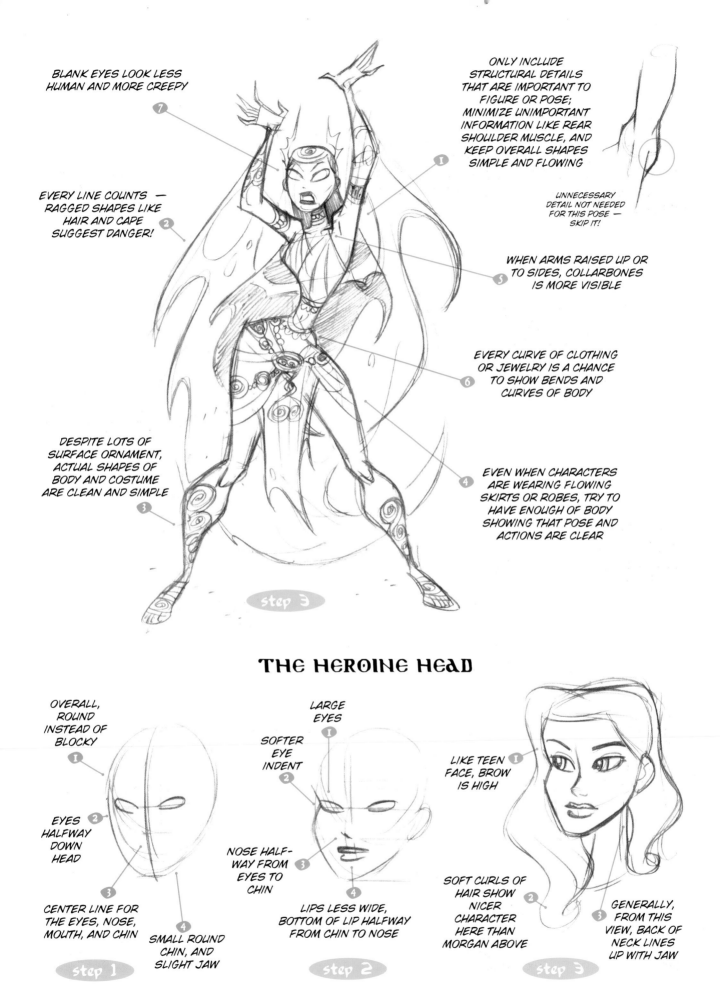

THE HEROINE HEAD

OVERALL,
ROUND
INSTEAD OF
BLOCKY

1

EYES
HALFWAY
DOWN
HEAD

2

CENTER LINE FOR
THE EYES, NOSE,
MOUTH, AND CHIN

3

SMALL ROUND
CHIN, AND
SLIGHT JAW

4

step 1

LARGE
EYES

1

SOFTER
EYE
INDENT

2

NOSE HALF-
WAY FROM
EYES TO
CHIN

3

LIPS LESS WIDE,
BOTTOM OF LIP HALFWAY
FROM CHIN TO NOSE

4

step 2

LIKE TEEN
FACE, BROW
IS HIGH

1

SOFT CURLS OF
HAIR SHOW
NICER
CHARACTER
HERE THAN
MORGAN ABOVE

2

GENERALLY,
FROM THIS
VIEW, BACK OF
NECK LINES
UP WITH JAW

3

step 3

PEASANTS

NOW THAT WE'VE LOOKED AT SOME BASIC PHYSICAL TYPES OF HEROES AND HEROINES, LET'S CONSIDER SOME OF THE ROLES THEY CAN PLAY IN CLASSICAL FANTASY STORIES.

WE'LL START WITH THE SIMPLE PEASANT, PARTLY BECAUSE PEASANTS ARE SO POPULAR, AND PARTLY BECAUSE THEY WEAR THE MOST BASIC CLOTHES, WHICH CAN BE ELABORATED ON TO CREATE THE FANCY APPAREL OF KNIGHTS AND LORDS.

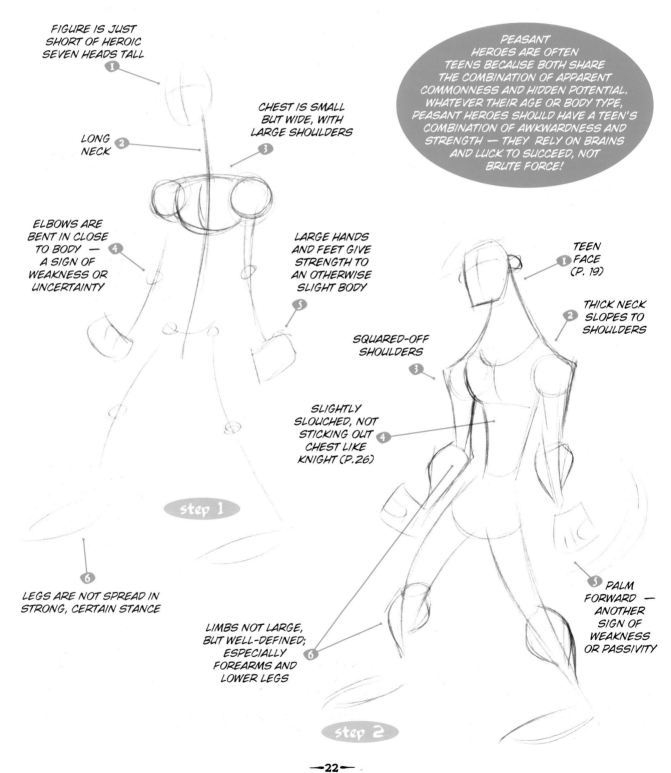

FIGURE IS JUST SHORT OF HEROIC SEVEN HEADS TALL ①

LONG NECK ②

CHEST IS SMALL BUT WIDE, WITH LARGE SHOULDERS ③

ELBOWS ARE BENT IN CLOSE TO BODY — A SIGN OF WEAKNESS OR UNCERTAINTY ④

LARGE HANDS AND FEET GIVE STRENGTH TO AN OTHERWISE SLIGHT BODY ⑤

PEASANT HEROES ARE OFTEN TEENS BECAUSE BOTH SHARE THE COMBINATION OF APPARENT COMMONNESS AND HIDDEN POTENTIAL. WHATEVER THEIR AGE OR BODY TYPE, PEASANT HEROES SHOULD HAVE A TEEN'S COMBINATION OF AWKWARDNESS AND STRENGTH — THEY RELY ON BRAINS AND LUCK TO SUCCEED, NOT BRUTE FORCE!

TEEN FACE (P. 19) ①

THICK NECK SLOPES TO SHOULDERS ②

SQUARED-OFF SHOULDERS ③

SLIGHTLY SLOUCHED, NOT STICKING OUT CHEST LIKE KNIGHT (P.26) ④

LEGS ARE NOT SPREAD IN STRONG, CERTAIN STANCE ⑥

LIMBS NOT LARGE, BUT WELL-DEFINED; ESPECIALLY FOREARMS AND LOWER LEGS ⑥

PALM FORWARD — ANOTHER SIGN OF WEAKNESS OR PASSIVITY ⑤

step 1

step 2

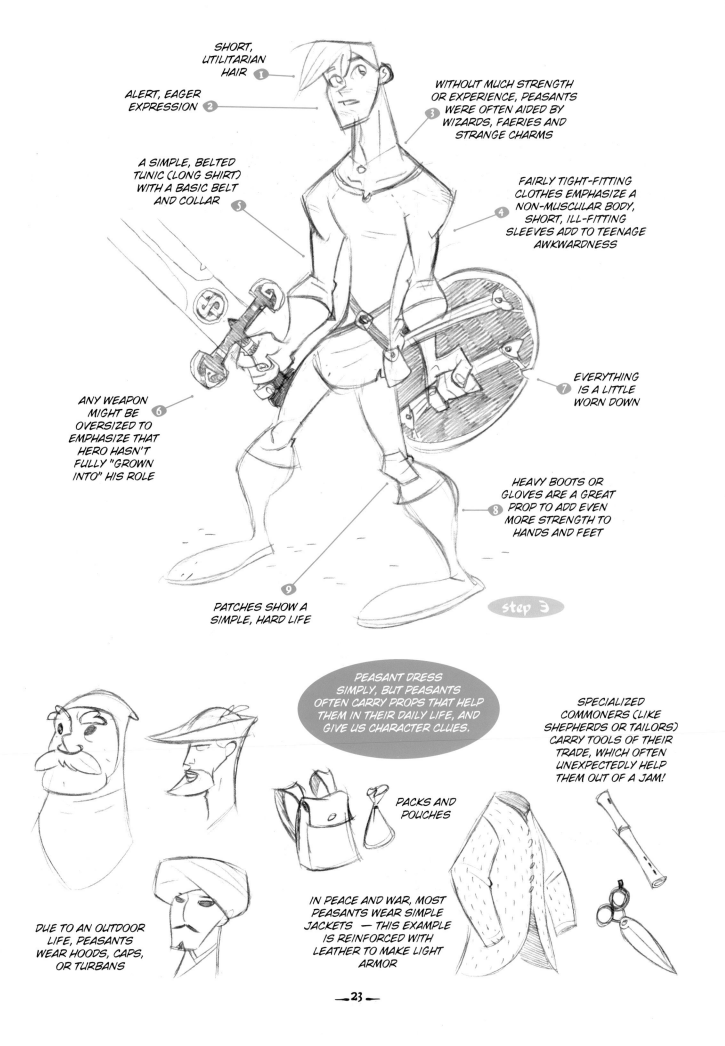

SHORT, UTILITARIAN HAIR ①

ALERT, EAGER EXPRESSION ②

③ WITHOUT MUCH STRENGTH OR EXPERIENCE, PEASANTS WERE OFTEN AIDED BY WIZARDS, FAERIES AND STRANGE CHARMS

A SIMPLE, BELTED TUNIC (LONG SHIRT) WITH A BASIC BELT AND COLLAR ⑤

④ FAIRLY TIGHT-FITTING CLOTHES EMPHASIZE A NON-MUSCULAR BODY, SHORT, ILL-FITTING SLEEVES ADD TO TEENAGE AWKWARDNESS

ANY WEAPON MIGHT BE OVERSIZED TO EMPHASIZE THAT HERO HASN'T FULLY "GROWN INTO" HIS ROLE ⑥

⑦ EVERYTHING IS A LITTLE WORN DOWN

⑧ HEAVY BOOTS OR GLOVES ARE A GREAT PROP TO ADD EVEN MORE STRENGTH TO HANDS AND FEET

step 3

⑨ PATCHES SHOW A SIMPLE, HARD LIFE

PEASANT DRESS SIMPLY, BUT PEASANTS OFTEN CARRY PROPS THAT HELP THEM IN THEIR DAILY LIFE, AND GIVE US CHARACTER CLUES.

SPECIALIZED COMMONERS (LIKE SHEPHERDS OR TAILORS) CARRY TOOLS OF THEIR TRADE, WHICH OFTEN UNEXPECTEDLY HELP THEM OUT OF A JAM!

PACKS AND POUCHES

DUE TO AN OUTDOOR LIFE, PEASANTS WEAR HOODS, CAPS, OR TURBANS

IN PEACE AND WAR, MOST PEASANTS WEAR SIMPLE JACKETS — THIS EXAMPLE IS REINFORCED WITH LEATHER TO MAKE LIGHT ARMOR

PEASANT VARIATIONS

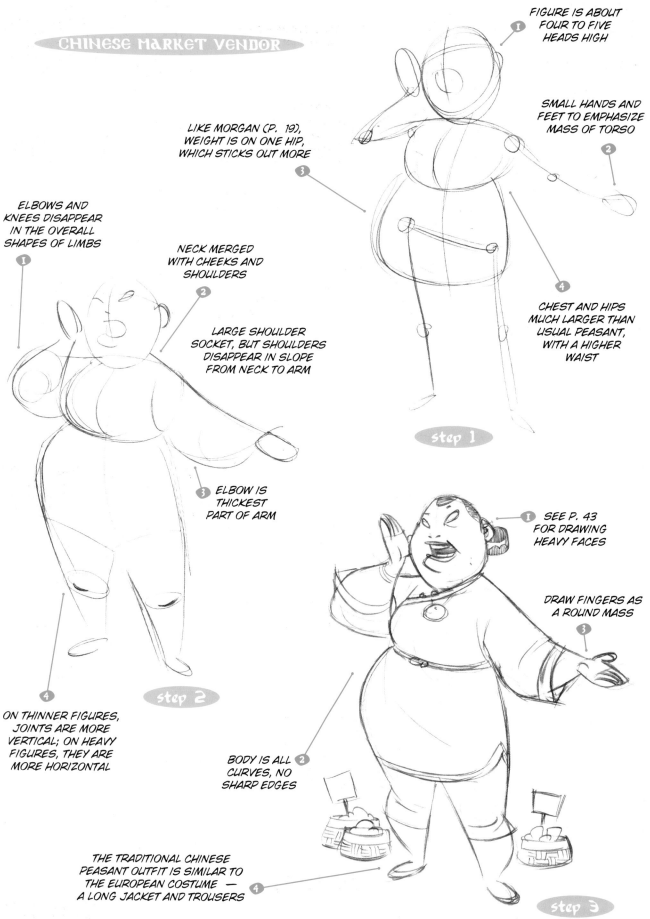

CHINESE MARKET VENDOR

FIGURE IS ABOUT FOUR TO FIVE HEADS HIGH ①

SMALL HANDS AND FEET TO EMPHASIZE MASS OF TORSO ②

LIKE MORGAN (P. 19), WEIGHT IS ON ONE HIP, WHICH STICKS OUT MORE ③

ELBOWS AND KNEES DISAPPEAR IN THE OVERALL SHAPES OF LIMBS ①

NECK MERGED WITH CHEEKS AND SHOULDERS ②

LARGE SHOULDER SOCKET, BUT SHOULDERS DISAPPEAR IN SLOPE FROM NECK TO ARM

④ CHEST AND HIPS MUCH LARGER THAN USUAL PEASANT, WITH A HIGHER WAIST

③ ELBOW IS THICKEST PART OF ARM

step 1

① SEE P. 43 FOR DRAWING HEAVY FACES

DRAW FINGERS AS A ROUND MASS ③

④ ON THINNER FIGURES, JOINTS ARE MORE VERTICAL; ON HEAVY FIGURES, THEY ARE MORE HORIZONTAL

step 2

② BODY IS ALL CURVES, NO SHARP EDGES

THE TRADITIONAL CHINESE PEASANT OUTFIT IS SIMILAR TO THE EUROPEAN COSTUME — A LONG JACKET AND TROUSERS ④

step 3

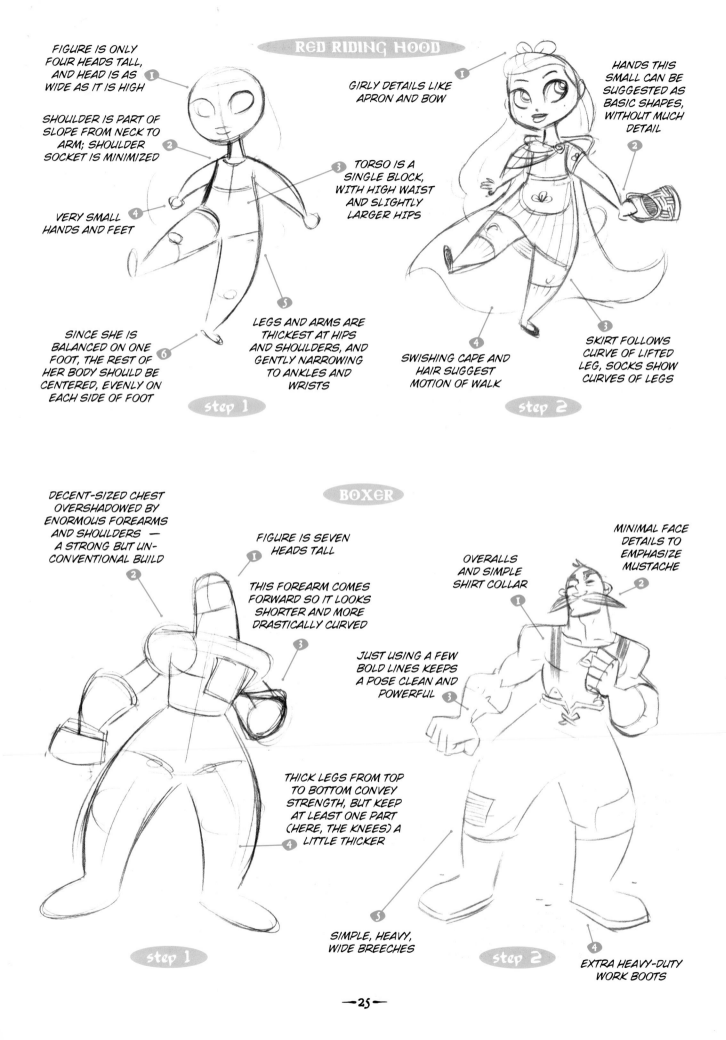

RED RIDING HOOD

FIGURE IS ONLY FOUR HEADS TALL, AND HEAD IS AS WIDE AS IT IS HIGH ①

SHOULDER IS PART OF SLOPE FROM NECK TO ARM; SHOULDER SOCKET IS MINIMIZED ②

VERY SMALL HANDS AND FEET ④

SINCE SHE IS BALANCED ON ONE FOOT, THE REST OF HER BODY SHOULD BE CENTERED, EVENLY ON EACH SIDE OF FOOT ⑥

③ TORSO IS A SINGLE BLOCK, WITH HIGH WAIST AND SLIGHTLY LARGER HIPS

⑤ LEGS AND ARMS ARE THICKEST AT HIPS AND SHOULDERS, AND GENTLY NARROWING TO ANKLES AND WRISTS

step 1

GIRLY DETAILS LIKE APRON AND BOW ①

HANDS THIS SMALL CAN BE SUGGESTED AS BASIC SHAPES, WITHOUT MUCH DETAIL ②

④ SWISHING CAPE AND HAIR SUGGEST MOTION OF WALK

③ SKIRT FOLLOWS CURVE OF LIFTED LEG, SOCKS SHOW CURVES OF LEGS

step 2

BOXER

DECENT-SIZED CHEST OVERSHADOWED BY ENORMOUS FOREARMS AND SHOULDERS — A STRONG BUT UN-CONVENTIONAL BUILD ②

FIGURE IS SEVEN HEADS TALL ①

THIS FOREARM COMES FORWARD SO IT LOOKS SHORTER AND MORE DRASTICALLY CURVED ③

THICK LEGS FROM TOP TO BOTTOM CONVEY STRENGTH, BUT KEEP AT LEAST ONE PART (HERE, THE KNEES) A LITTLE THICKER ④

step 1

OVERALLS AND SIMPLE SHIRT COLLAR ①

MINIMAL FACE DETAILS TO EMPHASIZE MUSTACHE ②

JUST USING A FEW BOLD LINES KEEPS A POSE CLEAN AND POWERFUL ③

SIMPLE, HEAVY, WIDE BREECHES ⑤

EXTRA HEAVY-DUTY WORK BOOTS ④

step 2

KNIGHTS

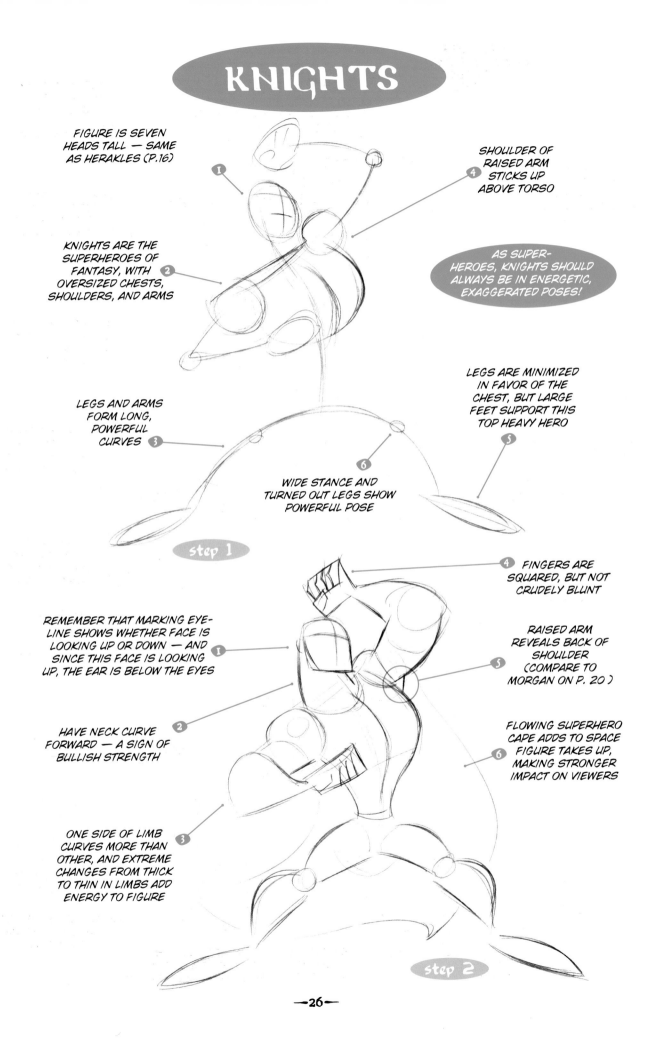

FIGURE IS SEVEN HEADS TALL — SAME AS HERAKLES (P.16)

SHOULDER OF RAISED ARM STICKS UP ABOVE TORSO

KNIGHTS ARE THE SUPERHEROES OF FANTASY, WITH OVERSIZED CHESTS, SHOULDERS, AND ARMS

AS SUPER-HEROES, KNIGHTS SHOULD ALWAYS BE IN ENERGETIC, EXAGGERATED POSES!

LEGS ARE MINIMIZED IN FAVOR OF THE CHEST, BUT LARGE FEET SUPPORT THIS TOP HEAVY HERO

LEGS AND ARMS FORM LONG, POWERFUL CURVES

WIDE STANCE AND TURNED OUT LEGS SHOW POWERFUL POSE

step 1

FINGERS ARE SQUARED, BUT NOT CRUDELY BLUNT

REMEMBER THAT MARKING EYE-LINE SHOWS WHETHER FACE IS LOOKING UP OR DOWN — AND SINCE THIS FACE IS LOOKING UP, THE EAR IS BELOW THE EYES

RAISED ARM REVEALS BACK OF SHOULDER (COMPARE TO MORGAN ON P. 20)

HAVE NECK CURVE FORWARD — A SIGN OF BULLISH STRENGTH

FLOWING SUPERHERO CAPE ADDS TO SPACE FIGURE TAKES UP, MAKING STRONGER IMPACT ON VIEWERS

ONE SIDE OF LIMB CURVES MORE THAN OTHER, AND EXTREME CHANGES FROM THICK TO THIN IN LIMBS ADD ENERGY TO FIGURE

step 2

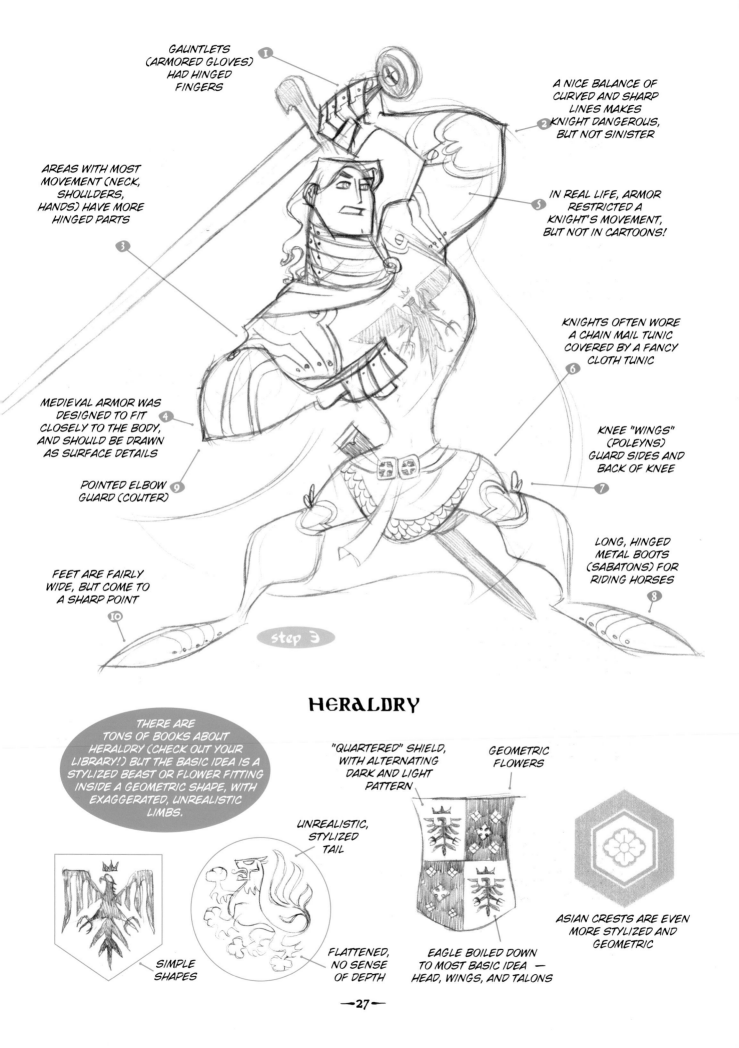

GAUNTLETS
(ARMORED GLOVES)
HAD HINGED
FINGERS

1

A NICE BALANCE OF
CURVED AND SHARP
LINES MAKES
KNIGHT DANGEROUS,
BUT NOT SINISTER

2

AREAS WITH MOST
MOVEMENT (NECK,
SHOULDERS,
HANDS) HAVE MORE
HINGED PARTS

3

5

IN REAL LIFE, ARMOR
RESTRICTED A
KNIGHT'S MOVEMENT,
BUT NOT IN CARTOONS!

KNIGHTS OFTEN WORE
A CHAIN MAIL TUNIC
COVERED BY A FANCY
CLOTH TUNIC

6

MEDIEVAL ARMOR WAS
DESIGNED TO FIT
CLOSELY TO THE BODY,
AND SHOULD BE DRAWN
AS SURFACE DETAILS

4

POINTED ELBOW
GUARD (COUTER)

9

KNEE "WINGS"
(POLEYNS)
GUARD SIDES AND
BACK OF KNEE

7

LONG, HINGED
METAL BOOTS
(SABATONS) FOR
RIDING HORSES

8

FEET ARE FAIRLY
WIDE, BUT COME TO
A SHARP POINT

10

step 3

HERALDRY

THERE ARE
TONS OF BOOKS ABOUT
HERALDRY (CHECK OUT YOUR
LIBRARY!) BUT THE BASIC IDEA IS A
STYLIZED BEAST OR FLOWER FITTING
INSIDE A GEOMETRIC SHAPE, WITH
EXAGGERATED, UNREALISTIC
LIMBS.

"QUARTERED" SHIELD,
WITH ALTERNATING
DARK AND LIGHT
PATTERN

GEOMETRIC
FLOWERS

UNREALISTIC,
STYLIZED
TAIL

SIMPLE
SHAPES

FLATTENED,
NO SENSE
OF DEPTH

EAGLE BOILED DOWN
TO MOST BASIC IDEA —
HEAD, WINGS, AND TALONS

ASIAN CRESTS ARE EVEN
MORE STYLIZED AND
GEOMETRIC

WARLORDS

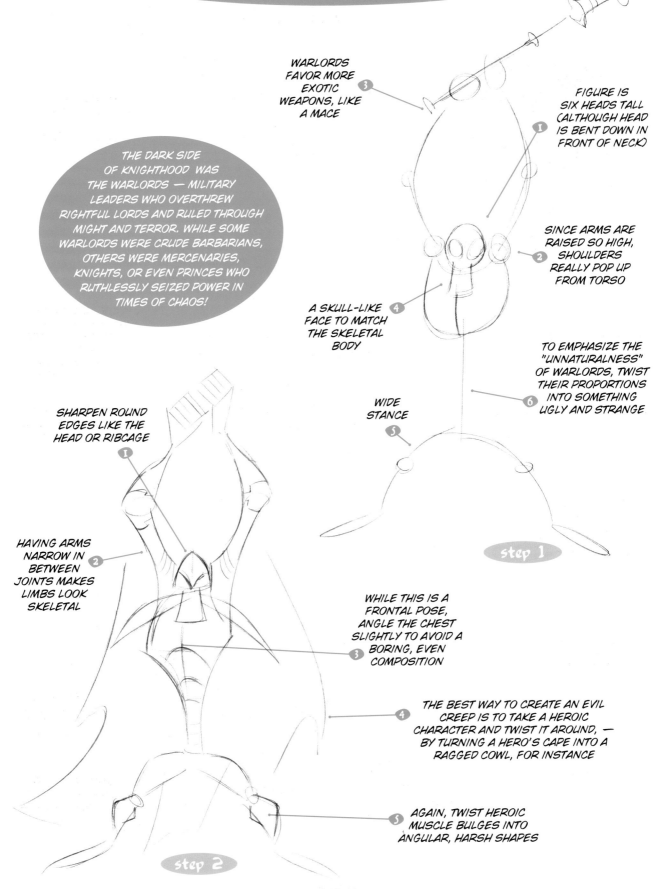

WARLORDS FAVOR MORE EXOTIC WEAPONS, LIKE A MACE

③

FIGURE IS SIX HEADS TALL (ALTHOUGH HEAD IS BENT DOWN IN FRONT OF NECK)

①

SINCE ARMS ARE RAISED SO HIGH, SHOULDERS REALLY POP UP FROM TORSO

②

THE DARK SIDE OF KNIGHTHOOD WAS THE WARLORDS — MILITARY LEADERS WHO OVERTHREW RIGHTFUL LORDS AND RULED THROUGH MIGHT AND TERROR. WHILE SOME WARLORDS WERE CRUDE BARBARIANS, OTHERS WERE MERCENARIES, KNIGHTS, OR EVEN PRINCES WHO RUTHLESSLY SEIZED POWER IN TIMES OF CHAOS!

A SKULL-LIKE FACE TO MATCH THE SKELETAL BODY

④

TO EMPHASIZE THE "UNNATURALNESS" OF WARLORDS, TWIST THEIR PROPORTIONS INTO SOMETHING UGLY AND STRANGE

⑥

WIDE STANCE

⑤

step 1

SHARPEN ROUND EDGES LIKE THE HEAD OR RIBCAGE

①

HAVING ARMS NARROW IN BETWEEN JOINTS MAKES LIMBS LOOK SKELETAL

②

WHILE THIS IS A FRONTAL POSE, ANGLE THE CHEST SLIGHTLY TO AVOID A BORING, EVEN COMPOSITION

③

THE BEST WAY TO CREATE AN EVIL CREEP IS TO TAKE A HEROIC CHARACTER AND TWIST IT AROUND, — BY TURNING A HERO'S CAPE INTO A RAGGED COWL, FOR INSTANCE

④

AGAIN, TWIST HEROIC MUSCLE BULGES INTO ANGULAR, HARSH SHAPES

⑤

step 2

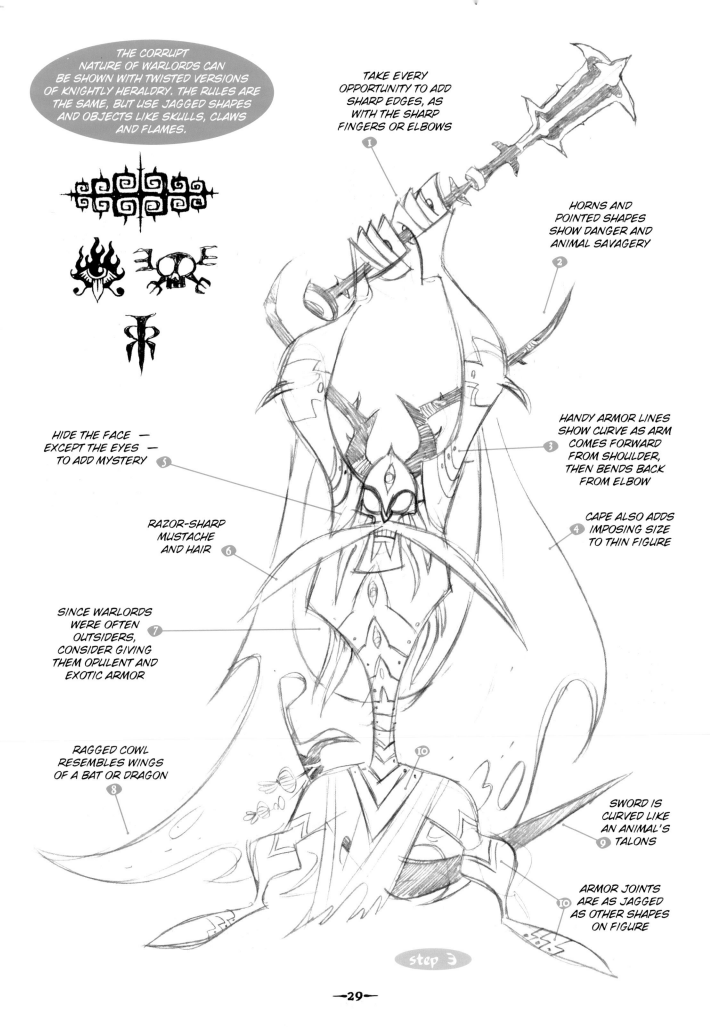

THE CORRUPT NATURE OF WARLORDS CAN BE SHOWN WITH TWISTED VERSIONS OF KNIGHTLY HERALDRY. THE RULES ARE THE SAME, BUT USE JAGGED SHAPES AND OBJECTS LIKE SKULLS, CLAWS AND FLAMES.

TAKE EVERY OPPORTUNITY TO ADD SHARP EDGES, AS WITH THE SHARP FINGERS OR ELBOWS
1

HORNS AND POINTED SHAPES SHOW DANGER AND ANIMAL SAVAGERY
2

HIDE THE FACE — EXCEPT THE EYES — TO ADD MYSTERY
5

HANDY ARMOR LINES SHOW CURVE AS ARM COMES FORWARD FROM SHOULDER, THEN BENDS BACK FROM ELBOW
3

CAPE ALSO ADDS IMPOSING SIZE TO THIN FIGURE
4

RAZOR-SHARP MUSTACHE AND HAIR
6

SINCE WARLORDS WERE OFTEN OUTSIDERS, CONSIDER GIVING THEM OPULENT AND EXOTIC ARMOR
7

RAGGED COWL RESEMBLES WINGS OF A BAT OR DRAGON
8

10

SWORD IS CURVED LIKE AN ANIMAL'S TALONS
9

ARMOR JOINTS ARE AS JAGGED AS OTHER SHAPES ON FIGURE
10

step 3

aMAZONS

AMAZONS WERE THE MYTHICAL WARRIOR ELITE OF THE ANCIENT WORLD. RELATED TO THE NOMADIC SCYTHIANS, THE AMAZONS WERE DOMINATED BY THEIR FIERCE WARRIOR WOMEN. STRONG, GRACEFUL, AND MORE THAN A LITTLE WILD, THE AMAZONS FOUGHT IN THE TROJAN WAR AND AGAINST HERAKLES.

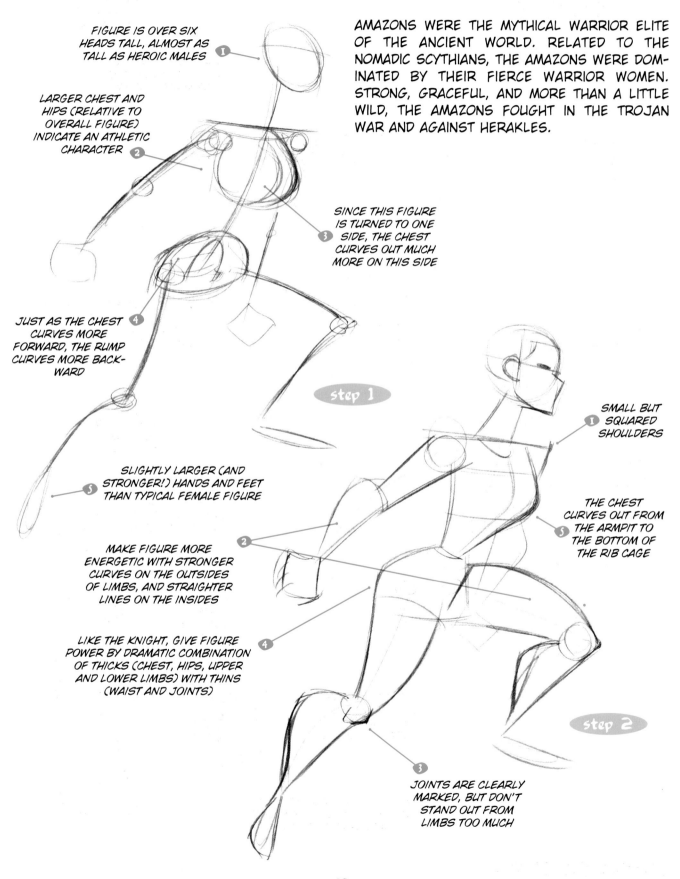

FIGURE IS OVER SIX HEADS TALL, ALMOST AS TALL AS HEROIC MALES

LARGER CHEST AND HIPS (RELATIVE TO OVERALL FIGURE) INDICATE AN ATHLETIC CHARACTER

SINCE THIS FIGURE IS TURNED TO ONE SIDE, THE CHEST CURVES OUT MUCH MORE ON THIS SIDE

JUST AS THE CHEST CURVES MORE FORWARD, THE RUMP CURVES MORE BACKWARD

step 1

SMALL BUT SQUARED SHOULDERS

THE CHEST CURVES OUT FROM THE ARMPIT TO THE BOTTOM OF THE RIB CAGE

SLIGHTLY LARGER (AND STRONGER!) HANDS AND FEET THAN TYPICAL FEMALE FIGURE

MAKE FIGURE MORE ENERGETIC WITH STRONGER CURVES ON THE OUTSIDES OF LIMBS, AND STRAIGHTER LINES ON THE INSIDES

LIKE THE KNIGHT, GIVE FIGURE POWER BY DRAMATIC COMBINATION OF THICKS (CHEST, HIPS, UPPER AND LOWER LIMBS) WITH THINS (WAIST AND JOINTS)

step 2

JOINTS ARE CLEARLY MARKED, BUT DON'T STAND OUT FROM LIMBS TOO MUCH

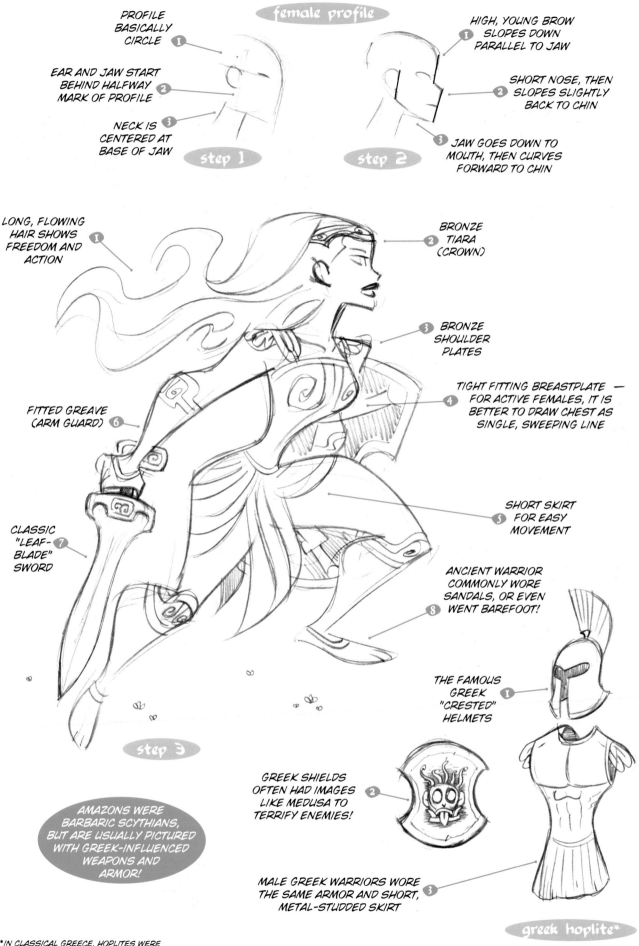

PROFILE BASICALLY CIRCLE ①

EAR AND JAW START BEHIND HALFWAY MARK OF PROFILE ②

NECK IS CENTERED AT BASE OF JAW ③

step 1

HIGH, YOUNG BROW SLOPES DOWN PARALLEL TO JAW ①

SHORT NOSE, THEN SLOPES SLIGHTLY BACK TO CHIN ②

JAW GOES DOWN TO MOUTH, THEN CURVES FORWARD TO CHIN ③

step 2

LONG, FLOWING HAIR SHOWS FREEDOM AND ACTION ①

BRONZE TIARA (CROWN) ②

BRONZE SHOULDER PLATES ③

TIGHT FITTING BREASTPLATE — FOR ACTIVE FEMALES, IT IS BETTER TO DRAW CHEST AS SINGLE, SWEEPING LINE ④

FITTED GREAVE (ARM GUARD) ⑥

SHORT SKIRT FOR EASY MOVEMENT ⑤

CLASSIC "LEAF-BLADE" SWORD ⑦

ANCIENT WARRIOR COMMONLY WORE SANDALS, OR EVEN WENT BAREFOOT! ⑧

step 3

AMAZONS WERE BARBARIC SCYTHIANS, BUT ARE USUALLY PICTURED WITH GREEK-INFLUENCED WEAPONS AND ARMOR!

THE FAMOUS GREEK "CRESTED" HELMETS ①

GREEK SHIELDS OFTEN HAD IMAGES LIKE MEDUSA TO TERRIFY ENEMIES! ②

MALE GREEK WARRIORS WORE THE SAME ARMOR AND SHORT, METAL-STUDDED SKIRT ③

greek hoplite*

*IN CLASSICAL GREECE, HOPLITES WERE WEALTHY CITIZEN-SOLDIERS WHO ARRANGED THEIR OWN TRAINING AND EQUIPMENT

BARBARIANS

SWARMING OVER THE ANCIENT WASTELANDS, BARBARIANS WORE SAVAGE ANIMAL SKINS AND BORE CRUDE WEAPONS. THEIR UNCIVILIZED NATURE CAN BE EXPRESSED WITH MUSCULAR, NON-HEROIC BODIES AND CRUDE GEAR.

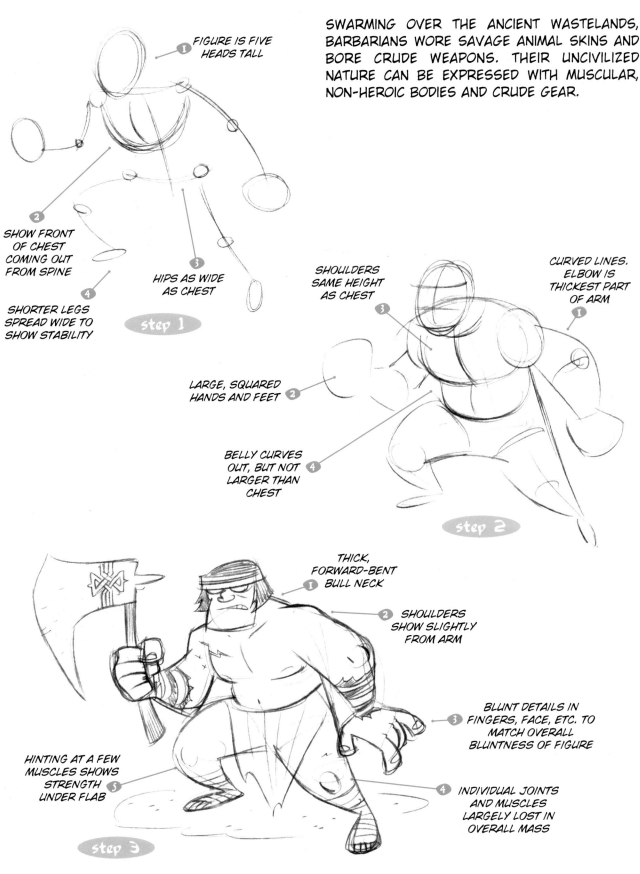

1 FIGURE IS FIVE HEADS TALL

2 SHOW FRONT OF CHEST COMING OUT FROM SPINE

3 HIPS AS WIDE AS CHEST

4 SHORTER LEGS SPREAD WIDE TO SHOW STABILITY

step 1

3 SHOULDERS SAME HEIGHT AS CHEST

1 CURVED LINES. ELBOW IS THICKEST PART OF ARM

2 LARGE, SQUARED HANDS AND FEET

4 BELLY CURVES OUT, BUT NOT LARGER THAN CHEST

step 2

1 THICK, FORWARD-BENT BULL NECK

2 SHOULDERS SHOW SLIGHTLY FROM ARM

3 BLUNT DETAILS IN FINGERS, FACE, ETC. TO MATCH OVERALL BLUNTNESS OF FIGURE

5 HINTING AT A FEW MUSCLES SHOWS STRENGTH UNDER FLAB

4 INDIVIDUAL JOINTS AND MUSCLES LARGELY LOST IN OVERALL MASS

step 3

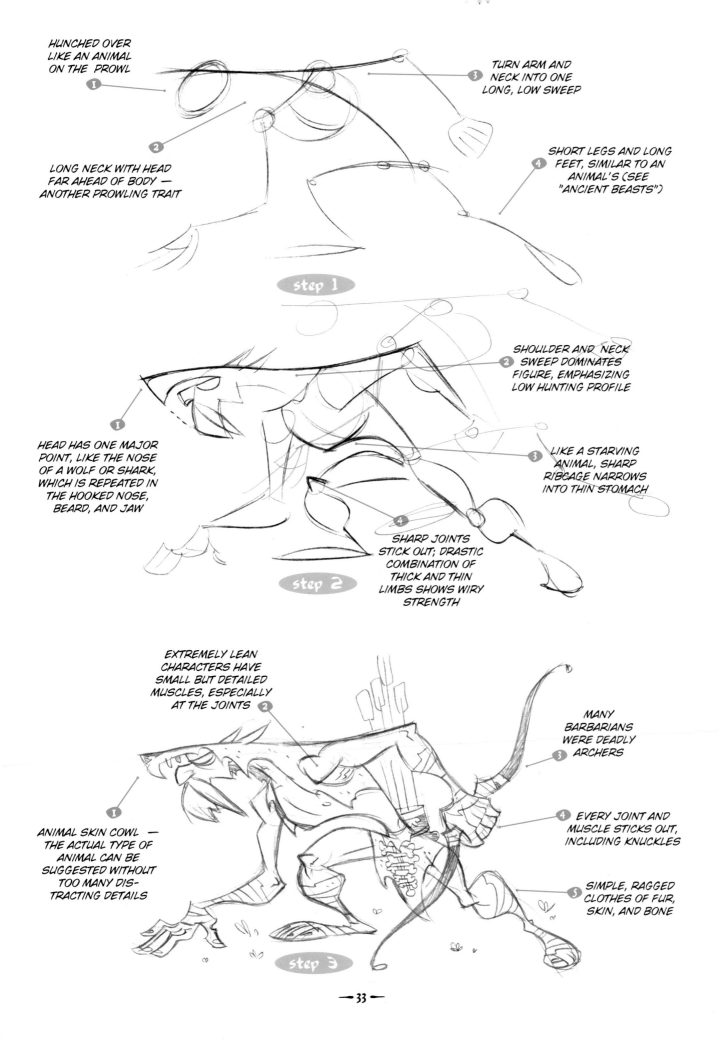

HUNCHED OVER
LIKE AN ANIMAL
ON THE PROWL

1

3 TURN ARM AND
NECK INTO ONE
LONG, LOW SWEEP

2

4 SHORT LEGS AND LONG
FEET, SIMILAR TO AN
ANIMAL'S (SEE
"ANCIENT BEASTS")

LONG NECK WITH HEAD
FAR AHEAD OF BODY —
ANOTHER PROWLING TRAIT

step 1

SHOULDER AND NECK
SWEEP DOMINATES
FIGURE, EMPHASIZING
LOW HUNTING PROFILE

2

1

HEAD HAS ONE MAJOR
POINT, LIKE THE NOSE
OF A WOLF OR SHARK,
WHICH IS REPEATED IN
THE HOOKED NOSE,
BEARD, AND JAW

3 LIKE A STARVING
ANIMAL, SHARP
RIBCAGE NARROWS
INTO THIN STOMACH

4

SHARP JOINTS
STICK OUT; DRASTIC
COMBINATION OF
THICK AND THIN
LIMBS SHOWS WIRY
STRENGTH

step 2

EXTREMELY LEAN
CHARACTERS HAVE
SMALL BUT DETAILED
MUSCLES, ESPECIALLY
AT THE JOINTS

2

MANY
BARBARIANS
WERE DEADLY
3 ARCHERS

1

4 EVERY JOINT AND
MUSCLE STICKS OUT,
INCLUDING KNUCKLES

ANIMAL SKIN COWL —
THE ACTUAL TYPE OF
ANIMAL CAN BE
SUGGESTED WITHOUT
TOO MANY DIS-
TRACTING DETAILS

5 SIMPLE, RAGGED
CLOTHES OF FUR,
SKIN, AND BONE

step 3

BANDITS

BANDITS WERE NOMADIC TROUBLEMAKERS WHO LIVED OUTSIDE THE LAW. THESE "OUTLAWS" RANGED FROM WRONGED DO-GOODERS TO DISGRACED ARISTOCRATS TO THUGGISH CROOKS. A BRIGAND'S CLOTHES WERE OFTEN A MIX OF PEASANT RAGS AND STOLEN FINERY.

AS A SOCIAL REBEL, A BANDIT'S APPEARANCE AND COSTUME SHOULD REFLECT HIS RUGGED, CHAOTIC INDIVIDUALISM. A HARSH LIFE LEAVES MANY WITH A BROKEN NOSE AND BAD TEETH, BUT BRIGANDS COVER UP THEIR DEFECTS WITH EXTRAVAGANT JEWELRY AND BEHAVIOR.

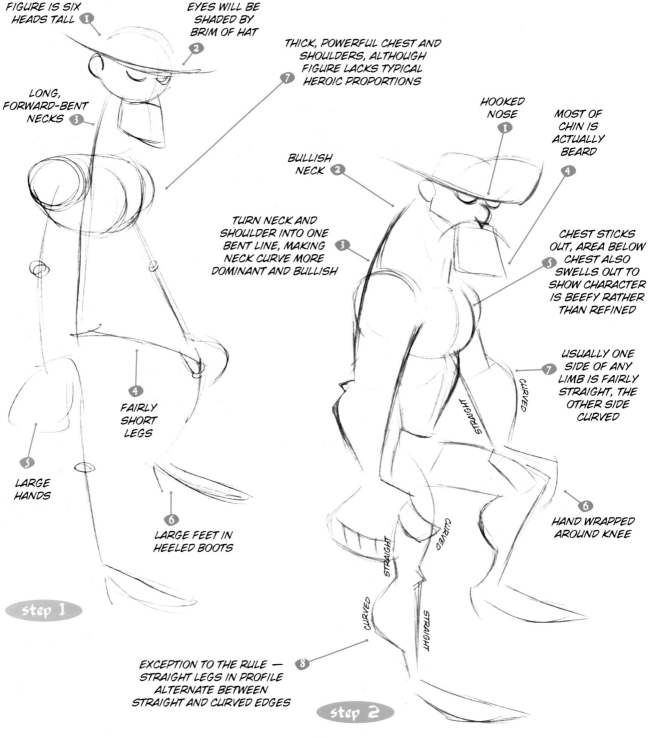

FIGURE IS SIX HEADS TALL ①

EYES WILL BE SHADED BY BRIM OF HAT ②

LONG, FORWARD-BENT NECKS ③

THICK, POWERFUL CHEST AND SHOULDERS, ALTHOUGH FIGURE LACKS TYPICAL HEROIC PROPORTIONS ⑦

HOOKED NOSE ①

MOST OF CHIN IS ACTUALLY BEARD ④

BULLISH NECK ②

TURN NECK AND SHOULDER INTO ONE BENT LINE, MAKING NECK CURVE MORE DOMINANT AND BULLISH ③

CHEST STICKS OUT, AREA BELOW CHEST ALSO SWELLS OUT TO SHOW CHARACTER IS BEEFY RATHER THAN REFINED ⑤

FAIRLY SHORT LEGS ④

USUALLY ONE SIDE OF ANY LIMB IS FAIRLY STRAIGHT, THE OTHER SIDE CURVED ⑦

LARGE HANDS ⑤

LARGE FEET IN HEELED BOOTS ⑥

HAND WRAPPED AROUND KNEE ⑥

step 1

step 2

EXCEPTION TO THE RULE — STRAIGHT LEGS IN PROFILE ALTERNATE BETWEEN STRAIGHT AND CURVED EDGES ⑧

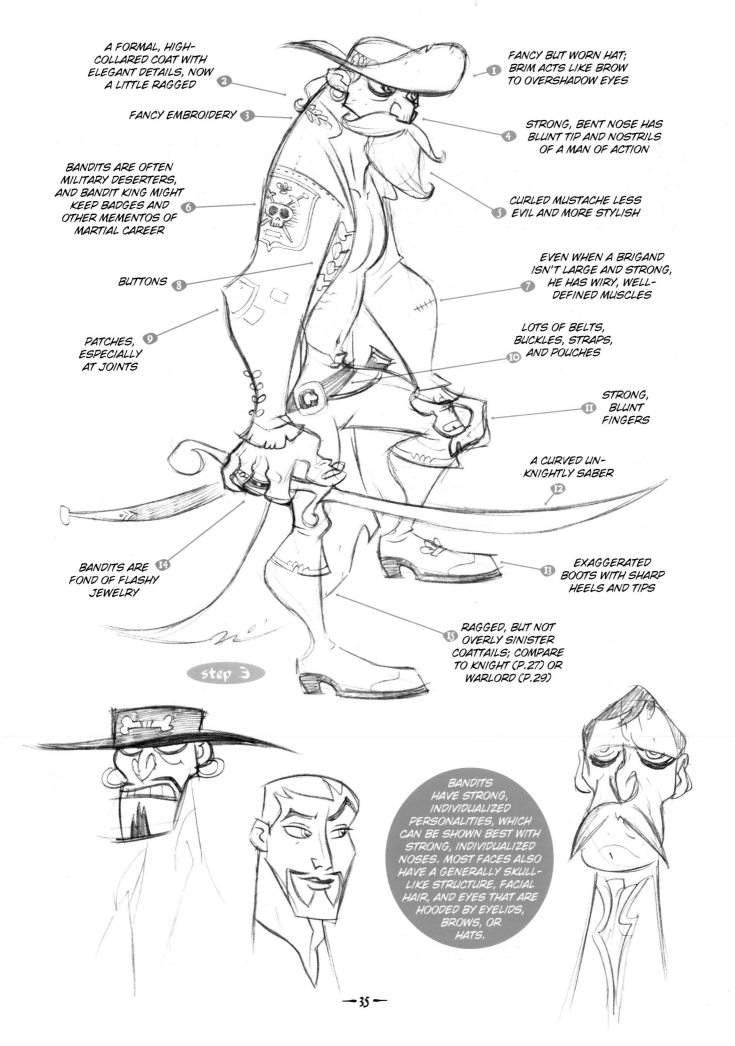

A FORMAL, HIGH-COLLARED COAT WITH ELEGANT DETAILS, NOW A LITTLE RAGGED — 2

FANCY EMBROIDERY — 3

BANDITS ARE OFTEN MILITARY DESERTERS, AND BANDIT KING MIGHT KEEP BADGES AND OTHER MEMENTOS OF MARTIAL CAREER — 6

BUTTONS — 8

PATCHES, ESPECIALLY AT JOINTS — 9

FANCY BUT WORN HAT; BRIM ACTS LIKE BROW TO OVERSHADOW EYES — 1

STRONG, BENT NOSE HAS BLUNT TIP AND NOSTRILS OF A MAN OF ACTION — 4

CURLED MUSTACHE LESS EVIL AND MORE STYLISH — 5

EVEN WHEN A BRIGAND ISN'T LARGE AND STRONG, HE HAS WIRY, WELL-DEFINED MUSCLES — 7

LOTS OF BELTS, BUCKLES, STRAPS, AND POUCHES — 10

STRONG, BLUNT FINGERS — 11

A CURVED UN-KNIGHTLY SABER — 12

BANDITS ARE FOND OF FLASHY JEWELRY — 14

EXAGGERATED BOOTS WITH SHARP HEELS AND TIPS — 13

step 3

RAGGED, BUT NOT OVERLY SINISTER COATTAILS; COMPARE TO KNIGHT (P.27) OR WARLORD (P.29) — 15

BANDITS HAVE STRONG, INDIVIDUALIZED PERSONALITIES, WHICH CAN BE SHOWN BEST WITH STRONG, INDIVIDUALIZED NOSES. MOST FACES ALSO HAVE A GENERALLY SKULL-LIKE STRUCTURE, FACIAL HAIR, AND EYES THAT ARE HOODED BY EYELIDS, BROWS, OR HATS.

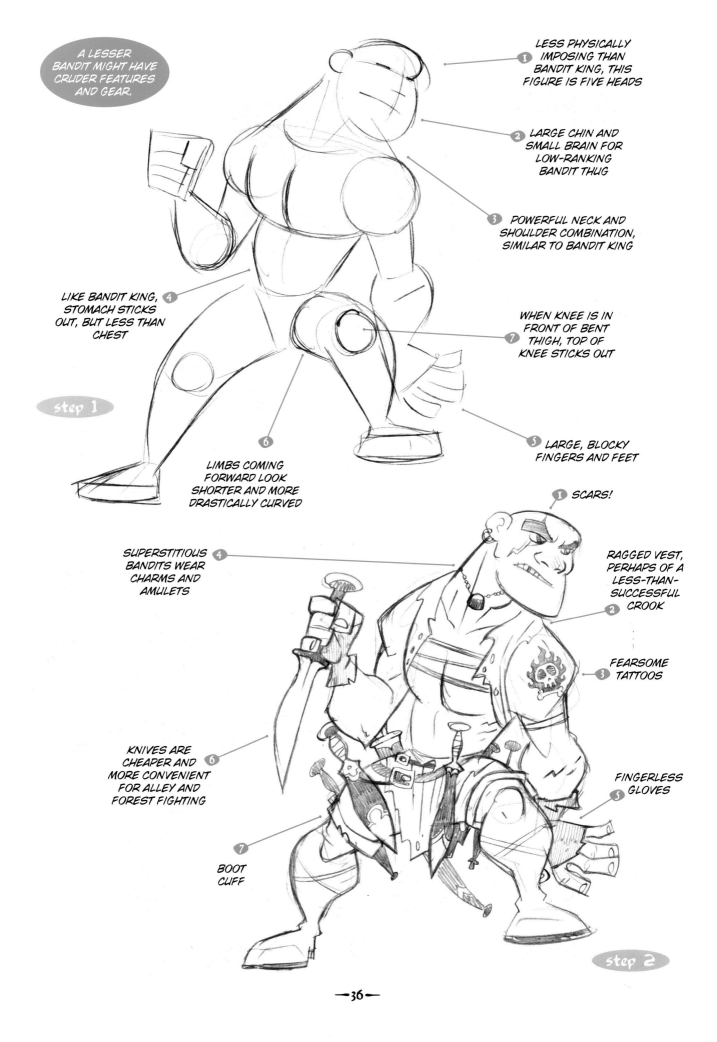

A LESSER BANDIT MIGHT HAVE CRUDER FEATURES AND GEAR.

1 LESS PHYSICALLY IMPOSING THAN BANDIT KING, THIS FIGURE IS FIVE HEADS

2 LARGE CHIN AND SMALL BRAIN FOR LOW-RANKING BANDIT THUG

3 POWERFUL NECK AND SHOULDER COMBINATION, SIMILAR TO BANDIT KING

LIKE BANDIT KING, STOMACH STICKS OUT, BUT LESS THAN CHEST **4**

7 WHEN KNEE IS IN FRONT OF BENT THIGH, TOP OF KNEE STICKS OUT

step 1

6

LIMBS COMING FORWARD LOOK SHORTER AND MORE DRASTICALLY CURVED

5 LARGE, BLOCKY FINGERS AND FEET

1 SCARS!

SUPERSTITIOUS BANDITS WEAR CHARMS AND AMULETS **4**

RAGGED VEST, PERHAPS OF A LESS-THAN-SUCCESSFUL CROOK **2**

3 FEARSOME TATTOOS

KNIVES ARE CHEAPER AND MORE CONVENIENT FOR ALLEY AND FOREST FIGHTING **6**

FINGERLESS GLOVES **5**

7

BOOT CUFF

step 2

NECK GOES UP
RIGHT BETWEEN
EARS (SEE AMAZON
PROFILE ON P. 31)

2

SMALL HANDS
AND FEET

3

ELBOW
THICKEST
PART OF ARM

6

WIDE HIPS FAN
OUT FROM FAIRLY
AVERAGE CHEST
AND WAIST

7

SLIGHTLY MORE
GRACEFUL VERSION
OF PEASANT ON P. 24;
FIGURE IS JUST OVER
FIVE HEADS TALL

1

HEAVY FIGURE WITH
ROUND FACE AND FIGURE,
BUT DISTINCT NECK AND
SHOULDERS

4

5 ROUNDED
SHOULDERS

WANDERING
GYPSIES WERE
CONSIDERED BANDITS
(AND SOMETIMES
WERE!) AND HAD
BANDIT LIKE
STYLES.

ON FEMALE FIGURE, BENT LEGS
ONLY COME HALFWAY UP FROM
HIP TO WAIST — HOWEVER THIN
OR HEAVY THE CHARACTER

8

9 A CURVY FIGURE
SUGGESTS A LIVELY
PERSONALITY

step 1

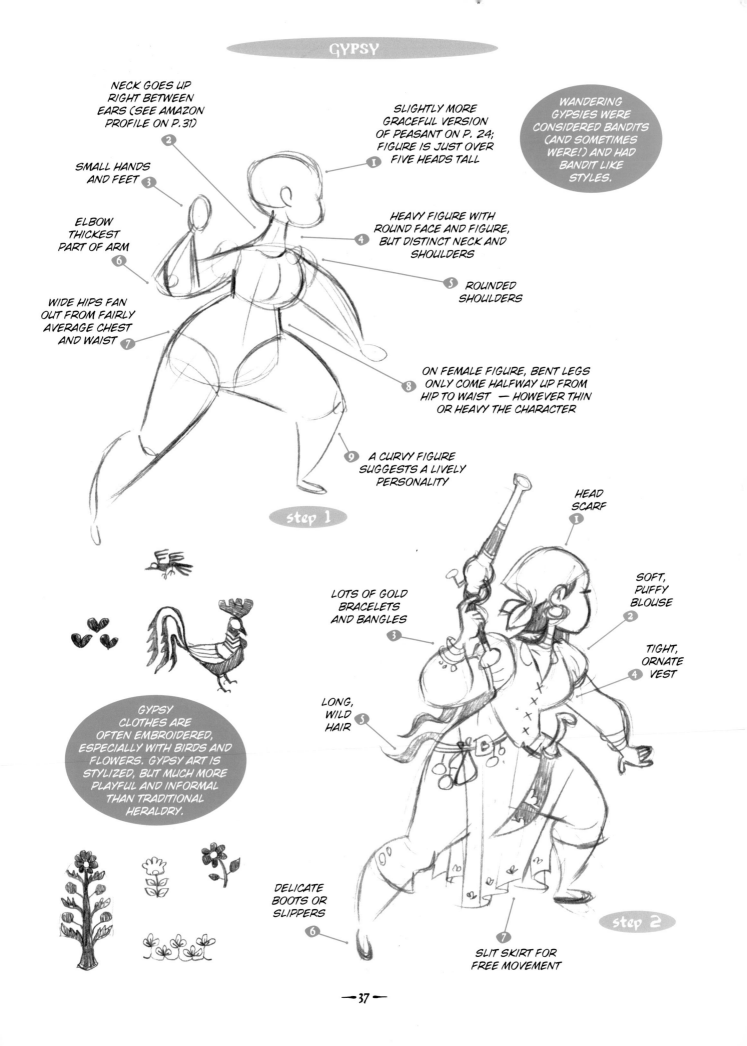

LOTS OF GOLD
BRACELETS
AND BANGLES

3

HEAD
SCARF
1

SOFT,
PUFFY
BLOUSE
2

TIGHT,
ORNATE
VEST
4

LONG,
WILD
HAIR
5

GYPSY
CLOTHES ARE
OFTEN EMBROIDERED,
ESPECIALLY WITH BIRDS AND
FLOWERS. GYPSY ART IS
STYLIZED, BUT MUCH MORE
PLAYFUL AND INFORMAL
THAN TRADITIONAL
HERALDRY.

DELICATE
BOOTS OR
SLIPPERS

6

SLIT SKIRT FOR
FREE MOVEMENT
7

step 2

MAGI

THROUGHOUT THE ANCIENT WORLD, WISE MEN AND WOMEN WERE BELIEVED TO HAVE STRANGE POWERS OVER NATURE, SPIRITS, AND FATE. CALLED MAGI, DRUIDS, WIZARDS AND WITCHES, THEY WERE GENERALLY RECLUSES WHO USED BRAINS RATHER THAN BRAWN. FEW MAGI WERE TRULY EVIL, BUT MOST WERE DANGEROUS AND ALL WERE MYSTERIOUS! LIKE HEROES, MAGI COME IN ALL SHAPES AND SIZES, BUT THEY ARE USUALLY IMAGINED LIKE THIS.

1 — *CLASSIC WIZARDS HAD LONG, THIN FACES AND WERE EIGHT HEADS HIGH*

2 *A HIGH "HOOKED" COLLAR EMPHASIZES THE LONG NECK, AND ALSO ADDS SINISTER SHAPES TO THE FIGURE*

3 *A LONG BEARD SUGGESTS AGE AND WISDOM, AND ALSO LENGTHENS THE NECK*

4 *WIZARDS WERE THE SCIENTISTS OF THE ANCIENT WORLD, AND WERE ESPECIALLY INTERESTED IN ASTRONOMY AND ASTROLOGY*

5 *WHILE THIS WIZARD IS VERY THIN, HE IS NOT SKELETAL — HIS LIMBS AND MUSCLES ARE THINNER THAN USUAL, BUT STILL HAVE THE THICKS AND THINS OF A YOUNGER ADULT*

6 *LONG, THIN FINGERS ARE OLD AND SINISTER — AND PERFECT FOR DELICATE EXPERIMENTS! (SEE P. 45 FOR MORE DETAILS ON THIN HANDS)*

7 *REPEATING SHAPES THROUGHOUT A PICTURE HELP TO VISUALLY PULL ALL THE PIECES TOGETHER*

8 *ALMOST ALL MAGI WERE CONNECTED TO THE NATURAL WORLD IN SOME WAY, AND CARRIED A STAFF OR WAND MADE FROM A SACRED TREE LIKE OAK, HOLLY, OR ASH*

AGE AND PERSONALITY

AS YOU'VE PROBABLY NOTICED IN EARLIER EXAMPLES, CERTAIN SHAPES AND LINES GO A LONG WAY TOWARDS DEFINING A CHARACTER'S PERSONALITY.

BELOW ARE SOME TRICKS TO SHOW CERTAIN COMBINATIONS OF OLD AGE AND PERSONALITY.

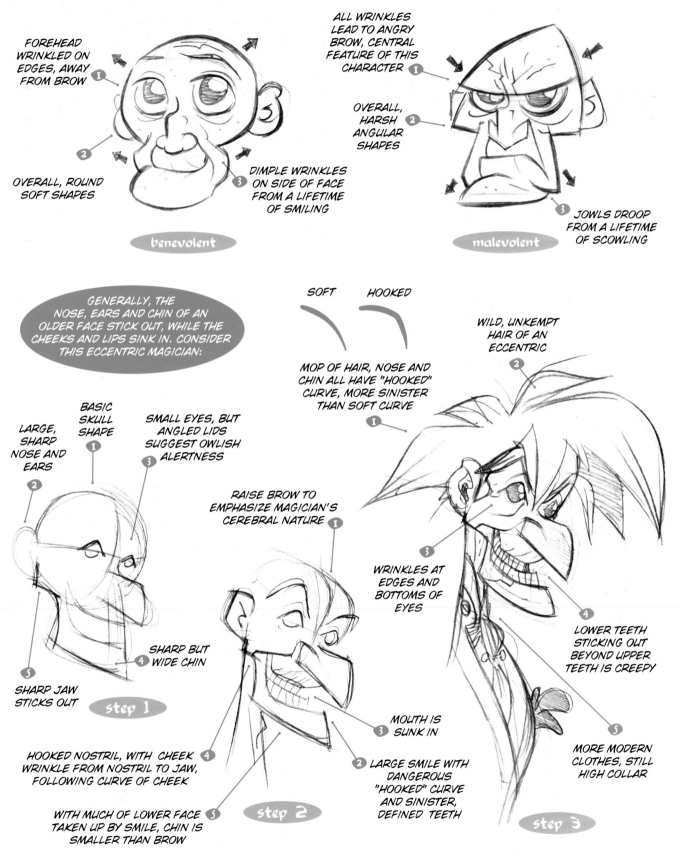

FOREHEAD WRINKLED ON EDGES, AWAY FROM BROW

1

2

OVERALL, ROUND SOFT SHAPES

3

DIMPLE WRINKLES ON SIDE OF FACE FROM A LIFETIME OF SMILING

benevolent

ALL WRINKLES LEAD TO ANGRY BROW, CENTRAL FEATURE OF THIS CHARACTER

1

OVERALL, HARSH ANGULAR SHAPES

2

3

JOWLS DROOP FROM A LIFETIME OF SCOWLING

malevolent

GENERALLY, THE NOSE, EARS AND CHIN OF AN OLDER FACE STICK OUT, WHILE THE CHEEKS AND LIPS SINK IN. CONSIDER THIS ECCENTRIC MAGICIAN:

SOFT HOOKED

MOP OF HAIR, NOSE AND CHIN ALL HAVE "HOOKED" CURVE, MORE SINISTER THAN SOFT CURVE

1

WILD, UNKEMPT HAIR OF AN ECCENTRIC

2

LARGE, SHARP NOSE AND EARS

2

BASIC SKULL SHAPE

1

SMALL EYES, BUT ANGLED LIDS SUGGEST OWLISH ALERTNESS

3

RAISE BROW TO EMPHASIZE MAGICIAN'S CEREBRAL NATURE

1

WRINKLES AT EDGES AND BOTTOMS OF EYES

3

SHARP BUT WIDE CHIN

4

SHARP JAW STICKS OUT

5

step 1

4

LOWER TEETH STICKING OUT BEYOND UPPER TEETH IS CREEPY

MOUTH IS SUNK IN

3

HOOKED NOSTRIL, WITH CHEEK WRINKLE FROM NOSTRIL TO JAW, FOLLOWING CURVE OF CHEEK

4

2 LARGE SMILE WITH DANGEROUS "HOOKED" CURVE AND SINISTER, DEFINED TEETH

5

WITH MUCH OF LOWER FACE TAKEN UP BY SMILE, CHIN IS SMALLER THAN BROW

step 2

5

MORE MODERN CLOTHES, STILL HIGH COLLAR

step 3

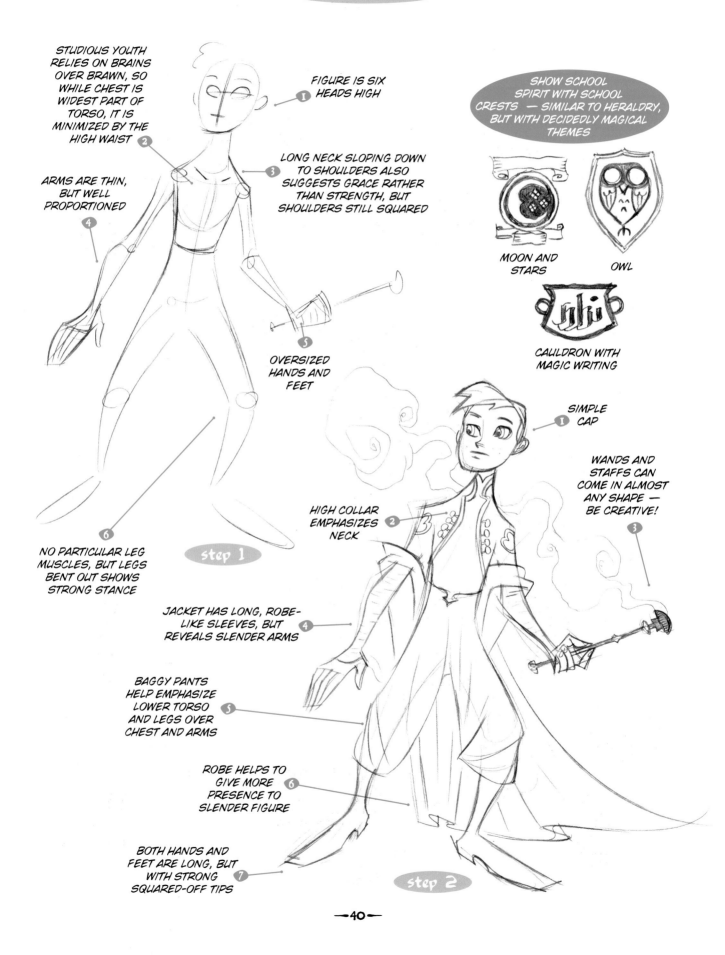

STUDIOUS YOUTH RELIES ON BRAINS OVER BRAWN, SO WHILE CHEST IS WIDEST PART OF TORSO, IT IS MINIMIZED BY THE HIGH WAIST **2**

ARMS ARE THIN, BUT WELL PROPORTIONED **4**

1 FIGURE IS SIX HEADS HIGH

3 LONG NECK SLOPING DOWN TO SHOULDERS ALSO SUGGESTS GRACE RATHER THAN STRENGTH, BUT SHOULDERS STILL SQUARED

SHOW SCHOOL SPIRIT WITH SCHOOL CRESTS — SIMILAR TO HERALDRY, BUT WITH DECIDEDLY MAGICAL THEMES

MOON AND STARS

OWL

CAULDRON WITH MAGIC WRITING

5 OVERSIZED HANDS AND FEET

NO PARTICULAR LEG MUSCLES, BUT LEGS BENT OUT SHOWS STRONG STANCE **6**

step 1

1 SIMPLE CAP

WANDS AND STAFFS CAN COME IN ALMOST ANY SHAPE — BE CREATIVE! **3**

HIGH COLLAR EMPHASIZES NECK **2**

JACKET HAS LONG, ROBE-LIKE SLEEVES, BUT REVEALS SLENDER ARMS **4**

BAGGY PANTS HELP EMPHASIZE LOWER TORSO AND LEGS OVER CHEST AND ARMS **5**

ROBE HELPS TO GIVE MORE PRESENCE TO SLENDER FIGURE **6**

BOTH HANDS AND FEET ARE LONG, BUT WITH STRONG SQUARED-OFF TIPS **7**

step 2

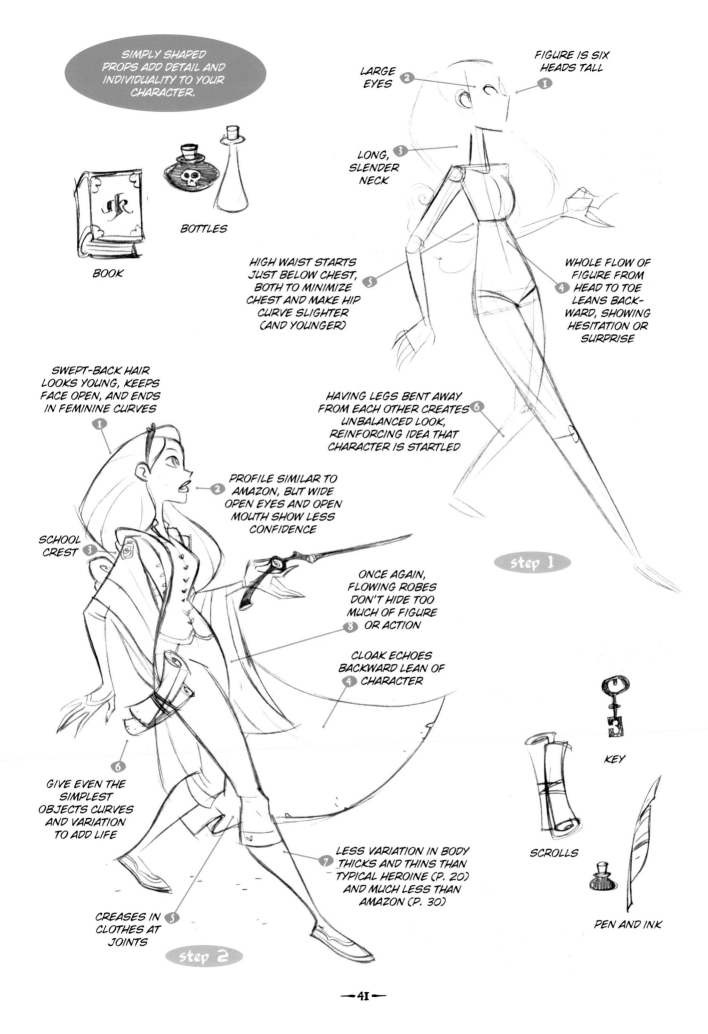

SIMPLY SHAPED PROPS ADD DETAIL AND INDIVIDUALITY TO YOUR CHARACTER.

BOTTLES

BOOK

FIGURE IS SIX HEADS TALL — 1

LARGE EYES — 2

LONG, SLENDER NECK — 3

HIGH WAIST STARTS JUST BELOW CHEST, BOTH TO MINIMIZE CHEST AND MAKE HIP CURVE SLIGHTER (AND YOUNGER) — 5

WHOLE FLOW OF FIGURE FROM HEAD TO TOE LEANS BACKWARD, SHOWING HESITATION OR SURPRISE — 4

HAVING LEGS BENT AWAY FROM EACH OTHER CREATES UNBALANCED LOOK, REINFORCING IDEA THAT CHARACTER IS STARTLED — 6

step 1

SWEPT-BACK HAIR LOOKS YOUNG, KEEPS FACE OPEN, AND ENDS IN FEMININE CURVES — 1

PROFILE SIMILAR TO AMAZON, BUT WIDE OPEN EYES AND OPEN MOUTH SHOW LESS CONFIDENCE — 2

SCHOOL CREST — 3

ONCE AGAIN, FLOWING ROBES DON'T HIDE TOO MUCH OF FIGURE OR ACTION — 8

CLOAK ECHOES BACKWARD LEAN OF CHARACTER — 4

GIVE EVEN THE SIMPLEST OBJECTS CURVES AND VARIATION TO ADD LIFE — 6

LESS VARIATION IN BODY THICKS AND THINS THAN TYPICAL HEROINE (P. 20) AND MUCH LESS THAN AMAZON (P. 30) — 7

CREASES IN CLOTHES AT JOINTS — 5

step 2

KEY

SCROLLS

PEN AND INK

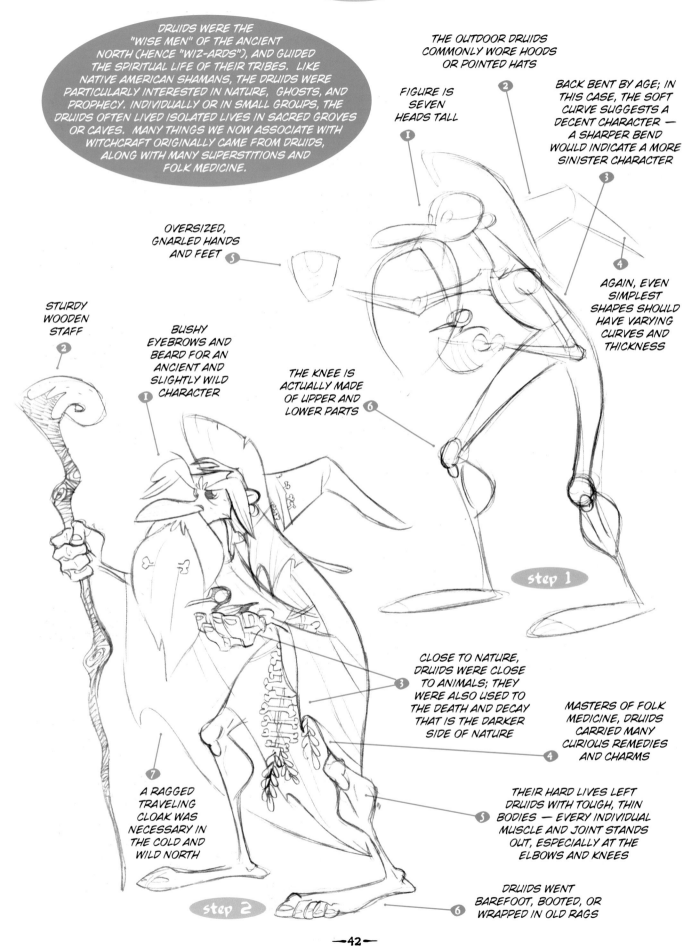

DRUIDS WERE THE "WISE MEN" OF THE ANCIENT NORTH (HENCE "WIZ-ARDS"), AND GUIDED THE SPIRITUAL LIFE OF THEIR TRIBES. LIKE NATIVE AMERICAN SHAMANS, THE DRUIDS WERE PARTICULARLY INTERESTED IN NATURE, GHOSTS, AND PROPHECY. INDIVIDUALLY OR IN SMALL GROUPS, THE DRUIDS OFTEN LIVED ISOLATED LIVES IN SACRED GROVES OR CAVES. MANY THINGS WE NOW ASSOCIATE WITH WITCHCRAFT ORIGINALLY CAME FROM DRUIDS, ALONG WITH MANY SUPERSTITIONS AND FOLK MEDICINE.

THE OUTDOOR DRUIDS COMMONLY WORE HOODS OR POINTED HATS

FIGURE IS SEVEN HEADS TALL ①

②

BACK BENT BY AGE; IN THIS CASE, THE SOFT CURVE SUGGESTS A DECENT CHARACTER — A SHARPER BEND WOULD INDICATE A MORE SINISTER CHARACTER ③

④

OVERSIZED, GNARLED HANDS AND FEET ⑤

AGAIN, EVEN SIMPLEST SHAPES SHOULD HAVE VARYING CURVES AND THICKNESS

STURDY WOODEN STAFF ②

BUSHY EYEBROWS AND BEARD FOR AN ANCIENT AND SLIGHTLY WILD CHARACTER ①

THE KNEE IS ACTUALLY MADE OF UPPER AND LOWER PARTS ⑥

step 1

CLOSE TO NATURE, DRUIDS WERE CLOSE TO ANIMALS; THEY WERE ALSO USED TO THE DEATH AND DECAY THAT IS THE DARKER SIDE OF NATURE ③

MASTERS OF FOLK MEDICINE, DRUIDS CARRIED MANY CURIOUS REMEDIES AND CHARMS ④

A RAGGED TRAVELING CLOAK WAS NECESSARY IN THE COLD AND WILD NORTH ⑦

THEIR HARD LIVES LEFT DRUIDS WITH TOUGH, THIN BODIES — EVERY INDIVIDUAL MUSCLE AND JOINT STANDS OUT, ESPECIALLY AT THE ELBOWS AND KNEES ⑤

step 2

DRUIDS WENT BAREFOOT, BOOTED, OR WRAPPED IN OLD RAGS ⑥

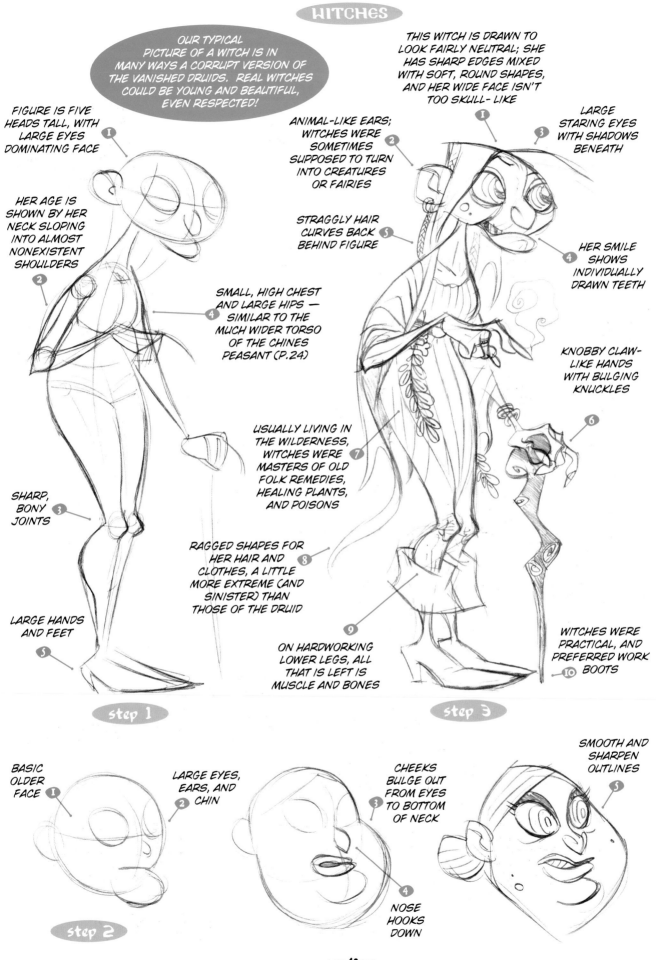

OUR TYPICAL PICTURE OF A WITCH IS IN MANY WAYS A CORRUPT VERSION OF THE VANISHED DRUIDS. REAL WITCHES COULD BE YOUNG AND BEAUTIFUL, EVEN RESPECTED!

THIS WITCH IS DRAWN TO LOOK FAIRLY NEUTRAL; SHE HAS SHARP EDGES MIXED WITH SOFT, ROUND SHAPES, AND HER WIDE FACE ISN'T TOO SKULL-LIKE

FIGURE IS FIVE HEADS TALL, WITH LARGE EYES DOMINATING FACE

ANIMAL-LIKE EARS; WITCHES WERE SOMETIMES SUPPOSED TO TURN INTO CREATURES OR FAIRIES

LARGE STARING EYES WITH SHADOWS BENEATH

HER AGE IS SHOWN BY HER NECK SLOPING INTO ALMOST NONEXISTENT SHOULDERS

STRAGGLY HAIR CURVES BACK BEHIND FIGURE

HER SMILE SHOWS INDIVIDUALLY DRAWN TEETH

SMALL, HIGH CHEST AND LARGE HIPS — SIMILAR TO THE MUCH WIDER TORSO OF THE CHINES PEASANT (P.24)

KNOBBY CLAW-LIKE HANDS WITH BULGING KNUCKLES

USUALLY LIVING IN THE WILDERNESS, WITCHES WERE MASTERS OF OLD FOLK REMEDIES, HEALING PLANTS, AND POISONS

SHARP, BONY JOINTS

RAGGED SHAPES FOR HER HAIR AND CLOTHES, A LITTLE MORE EXTREME (AND SINISTER) THAN THOSE OF THE DRUID

LARGE HANDS AND FEET

ON HARDWORKING LOWER LEGS, ALL THAT IS LEFT IS MUSCLE AND BONES

WITCHES WERE PRACTICAL, AND PREFERRED WORK BOOTS

step 1

step 3

BASIC OLDER FACE

LARGE EYES, EARS, AND CHIN

CHEEKS BULGE OUT FROM EYES TO BOTTOM OF NECK

SMOOTH AND SHARPEN OUTLINES

NOSE HOOKS DOWN

step 2

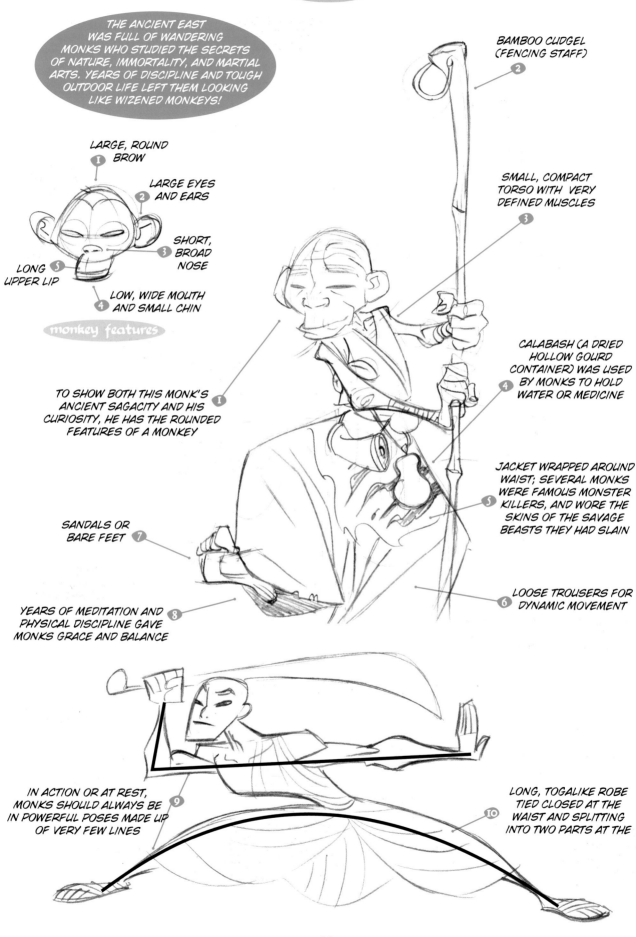

THE ANCIENT EAST WAS FULL OF WANDERING MONKS WHO STUDIED THE SECRETS OF NATURE, IMMORTALITY, AND MARTIAL ARTS. YEARS OF DISCIPLINE AND TOUGH OUTDOOR LIFE LEFT THEM LOOKING LIKE WIZENED MONKEYS!

BAMBOO CUDGEL (FENCING STAFF)
2

LARGE, ROUND BROW
1

LARGE EYES AND EARS
2

SHORT, BROAD NOSE
3

LONG UPPER LIP
5

LOW, WIDE MOUTH AND SMALL CHIN
4

monkey features

SMALL, COMPACT TORSO WITH VERY DEFINED MUSCLES
3

CALABASH (A DRIED HOLLOW GOURD CONTAINER) WAS USED BY MONKS TO HOLD WATER OR MEDICINE
4

TO SHOW BOTH THIS MONK'S ANCIENT SAGACITY AND HIS CURIOSITY, HE HAS THE ROUNDED FEATURES OF A MONKEY
1

JACKET WRAPPED AROUND WAIST; SEVERAL MONKS WERE FAMOUS MONSTER KILLERS, AND WORE THE SKINS OF THE SAVAGE BEASTS THEY HAD SLAIN
5

SANDALS OR BARE FEET
7

LOOSE TROUSERS FOR DYNAMIC MOVEMENT
6

YEARS OF MEDITATION AND PHYSICAL DISCIPLINE GAVE MONKS GRACE AND BALANCE
8

IN ACTION OR AT REST, MONKS SHOULD ALWAYS BE IN POWERFUL POSES MADE UP OF VERY FEW LINES
9

LONG, TOGALIKE ROBE TIED CLOSED AT THE WAIST AND SPLITTING INTO TWO PARTS AT THE
10

NECROMANCERS

WORKING AT NIGHT, NECROMANCERS SPECIALIZE IN THE EVIL ARTS OF MANIPULATION, DESTRUCTION, AND DEATH. THEIR BODIES ARE USUALLY WITHERED FROM THEIR ILL-FOUND KNOWLEDGE.

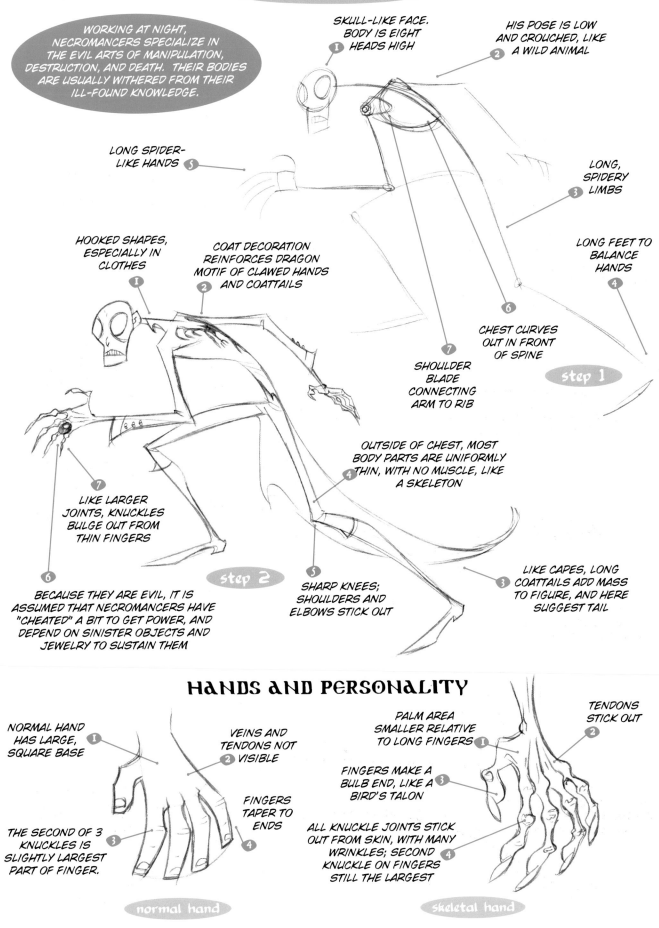

SKULL-LIKE FACE. BODY IS EIGHT HEADS HIGH ①

HIS POSE IS LOW AND CROUCHED, LIKE A WILD ANIMAL ②

LONG SPIDER-LIKE HANDS ⑤

LONG, SPIDERY LIMBS ③

LONG FEET TO BALANCE HANDS ④

HOOKED SHAPES, ESPECIALLY IN CLOTHES ①

COAT DECORATION REINFORCES DRAGON MOTIF OF CLAWED HANDS AND COATTAILS ②

⑦ SHOULDER BLADE CONNECTING ARM TO RIB

⑥ CHEST CURVES OUT IN FRONT OF SPINE

step 1

⑦ LIKE LARGER JOINTS, KNUCKLES BULGE OUT FROM THIN FINGERS

⑥

step 2

④ OUTSIDE OF CHEST, MOST BODY PARTS ARE UNIFORMLY THIN, WITH NO MUSCLE, LIKE A SKELETON

⑤ SHARP KNEES; SHOULDERS AND ELBOWS STICK OUT

③ LIKE CAPES, LONG COATTAILS ADD MASS TO FIGURE, AND HERE SUGGEST TAIL

BECAUSE THEY ARE EVIL, IT IS ASSUMED THAT NECROMANCERS HAVE "CHEATED" A BIT TO GET POWER, AND DEPEND ON SINISTER OBJECTS AND JEWELRY TO SUSTAIN THEM

HANDS AND PERSONALITY

NORMAL HAND HAS LARGE, SQUARE BASE ①

VEINS AND TENDONS NOT VISIBLE ②

FINGERS TAPER TO ENDS ④

THE SECOND OF 3 KNUCKLES IS SLIGHTLY LARGEST PART OF FINGER. ③

PALM AREA SMALLER RELATIVE TO LONG FINGERS ①

TENDONS STICK OUT ②

FINGERS MAKE A BULB END, LIKE A BIRD'S TALON ③

ALL KNUCKLE JOINTS STICK OUT FROM SKIN, WITH MANY WRINKLES; SECOND KNUCKLE ON FINGERS STILL THE LARGEST ④

normal hand

skeletal hand

—45—

LORDS and LADIES

BELOW ARE VERY GENERAL COSTUMES FOR ARISTOCRATS; THEIR WEALTH ALLOWED THEM TO WEAR A DAZZLING VARIETY OF CLOTHES OVER TIME AND THROUGHOUT THE WORLD.

BUT THE BASIC IDEA IN DRESSING LORDS AND LADIES IS TO GIVE THEM OUTFITS THAT ARE DELICATE, LONG AND FLOWING, AND CLOSE FITTING (AND THEREFORE VERY EXPENSIVE!), WITH LOTS OF DELICATE DETAILS.

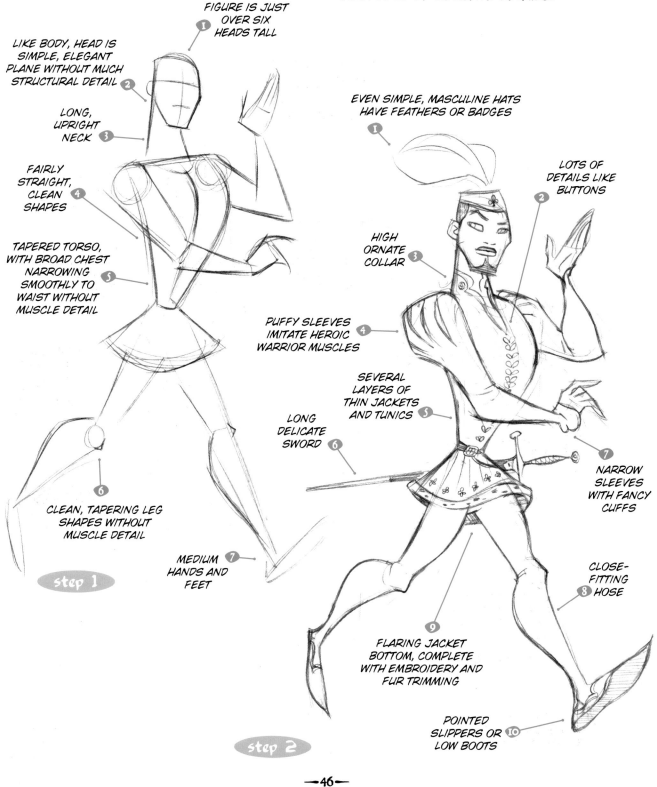

FIGURE IS JUST OVER SIX HEADS TALL ①

LIKE BODY, HEAD IS SIMPLE, ELEGANT PLANE WITHOUT MUCH STRUCTURAL DETAIL ②

LONG, UPRIGHT NECK ③

FAIRLY STRAIGHT, CLEAN SHAPES ④

TAPERED TORSO, WITH BROAD CHEST NARROWING SMOOTHLY TO WAIST WITHOUT MUSCLE DETAIL ⑤

CLEAN, TAPERING LEG SHAPES WITHOUT MUSCLE DETAIL ⑥

MEDIUM HANDS AND FEET ⑦

step 1

EVEN SIMPLE, MASCULINE HATS HAVE FEATHERS OR BADGES ①

LOTS OF DETAILS LIKE BUTTONS ②

HIGH ORNATE COLLAR ③

PUFFY SLEEVES IMITATE HEROIC WARRIOR MUSCLES ④

SEVERAL LAYERS OF THIN JACKETS AND TUNICS ⑤

LONG DELICATE SWORD ⑥

NARROW SLEEVES WITH FANCY CUFFS ⑦

CLOSE-FITTING HOSE ⑧

FLARING JACKET BOTTOM, COMPLETE WITH EMBROIDERY AND FUR TRIMMING ⑨

POINTED SLIPPERS OR LOW BOOTS ⑩

step 2

—46—

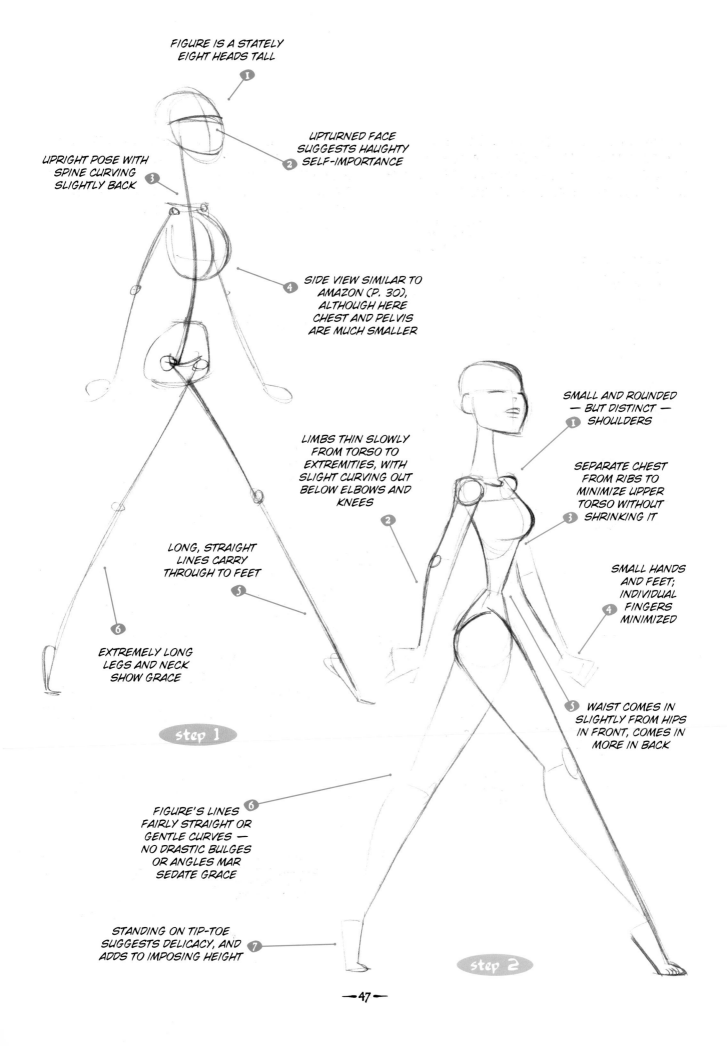

FIGURE IS A STATELY
EIGHT HEADS TALL

1

UPTURNED FACE
SUGGESTS HAUGHTY
SELF-IMPORTANCE

2

UPRIGHT POSE WITH
SPINE CURVING
SLIGHTLY BACK

3

SIDE VIEW SIMILAR TO
AMAZON (P. 30),
ALTHOUGH HERE
CHEST AND PELVIS
ARE MUCH SMALLER

4

LIMBS THIN SLOWLY
FROM TORSO TO
EXTREMITIES, WITH
SLIGHT CURVING OUT
BELOW ELBOWS AND
KNEES

2

LONG, STRAIGHT
LINES CARRY
THROUGH TO FEET

5

EXTREMELY LONG
LEGS AND NECK
SHOW GRACE

6

step 1

SMALL AND ROUNDED
— BUT DISTINCT —
SHOULDERS

1

SEPARATE CHEST
FROM RIBS TO
MINIMIZE UPPER
TORSO WITHOUT
SHRINKING IT

3

SMALL HANDS
AND FEET;
INDIVIDUAL
FINGERS
MINIMIZED

4

WAIST COMES IN
SLIGHTLY FROM HIPS
IN FRONT, COMES IN
MORE IN BACK

5

FIGURE'S LINES
FAIRLY STRAIGHT OR
GENTLE CURVES —
NO DRASTIC BULGES
OR ANGLES MAR
SEDATE GRACE

6

STANDING ON TIP-TOE
SUGGESTS DELICACY, AND
ADDS TO IMPOSING HEIGHT

7

step 2

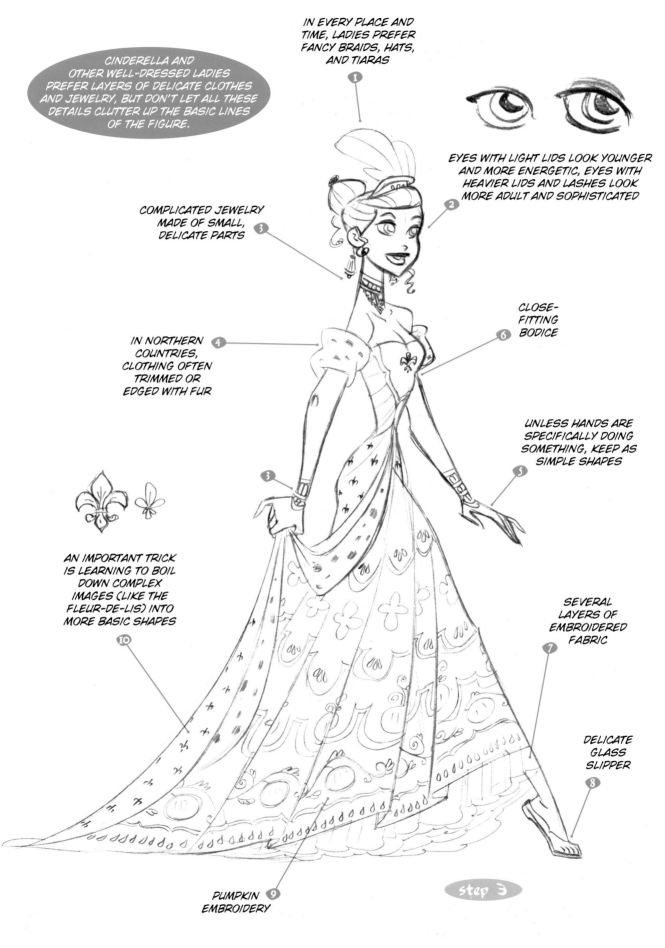

CINDERELLA AND OTHER WELL-DRESSED LADIES PREFER LAYERS OF DELICATE CLOTHES AND JEWELRY, BUT DON'T LET ALL THESE DETAILS CLUTTER UP THE BASIC LINES OF THE FIGURE.

IN EVERY PLACE AND TIME, LADIES PREFER FANCY BRAIDS, HATS, AND TIARAS
1

EYES WITH LIGHT LIDS LOOK YOUNGER AND MORE ENERGETIC, EYES WITH HEAVIER LIDS AND LASHES LOOK MORE ADULT AND SOPHISTICATED
2

COMPLICATED JEWELRY MADE OF SMALL, DELICATE PARTS
3

CLOSE-FITTING BODICE
6

IN NORTHERN COUNTRIES, CLOTHING OFTEN TRIMMED OR EDGED WITH FUR
4

UNLESS HANDS ARE SPECIFICALLY DOING SOMETHING, KEEP AS SIMPLE SHAPES
5

3

AN IMPORTANT TRICK IS LEARNING TO BOIL DOWN COMPLEX IMAGES (LIKE THE FLEUR-DE-LIS) INTO MORE BASIC SHAPES
10

SEVERAL LAYERS OF EMBROIDERED FABRIC
7

DELICATE GLASS SLIPPER
8

PUMPKIN EMBROIDERY
9

step 3

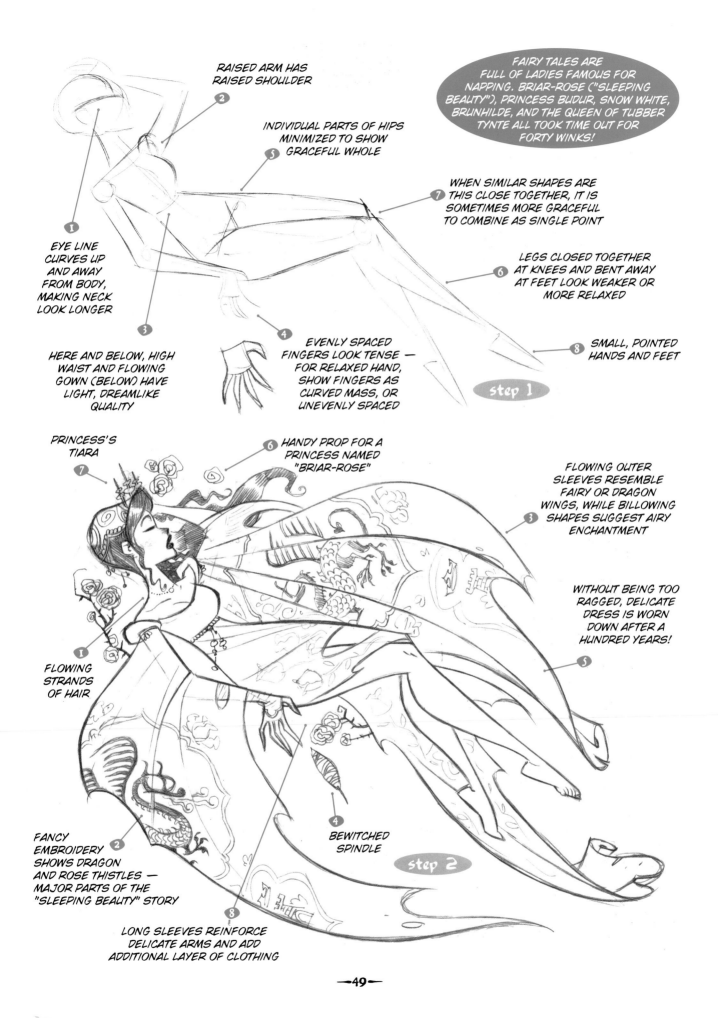

RAISED ARM HAS
RAISED SHOULDER

2

INDIVIDUAL PARTS OF HIPS
MINIMIZED TO SHOW
GRACEFUL WHOLE

5

FAIRY TALES ARE
FULL OF LADIES FAMOUS FOR
NAPPING. BRIAR-ROSE ("SLEEPING
BEAUTY"), PRINCESS BUDUR, SNOW WHITE,
BRUNHILDE, AND THE QUEEN OF TUBBER
TYNTE ALL TOOK TIME OUT FOR
FORTY WINKS!

7 WHEN SIMILAR SHAPES ARE
THIS CLOSE TOGETHER, IT IS
SOMETIMES MORE GRACEFUL
TO COMBINE AS SINGLE POINT

1

EYE LINE
CURVES UP
AND AWAY
FROM BODY,
MAKING NECK
LOOK LONGER

3

HERE AND BELOW, HIGH
WAIST AND FLOWING
GOWN (BELOW) HAVE
LIGHT, DREAMLIKE
QUALITY

4 EVENLY SPACED
FINGERS LOOK TENSE —
FOR RELAXED HAND,
SHOW FINGERS AS
CURVED MASS, OR
UNEVENLY SPACED

6 LEGS CLOSED TOGETHER
AT KNEES AND BENT AWAY
AT FEET LOOK WEAKER OR
MORE RELAXED

8 SMALL, POINTED
HANDS AND FEET

step 1

PRINCESS'S
TIARA

7

6 HANDY PROP FOR A
PRINCESS NAMED
"BRIAR-ROSE"

3 FLOWING OUTER
SLEEVES RESEMBLE
FAIRY OR DRAGON
WINGS, WHILE BILLOWING
SHAPES SUGGEST AIRY
ENCHANTMENT

WITHOUT BEING TOO
RAGGED, DELICATE
DRESS IS WORN
DOWN AFTER A
HUNDRED YEARS!

1

FLOWING
STRANDS
OF HAIR

5

FANCY
EMBROIDERY
SHOWS DRAGON
AND ROSE THISTLES —
MAJOR PARTS OF THE
"SLEEPING BEAUTY" STORY

2

4 BEWITCHED
SPINDLE

step 2

8 LONG SLEEVES REINFORCE
DELICATE ARMS AND ADD
ADDITIONAL LAYER OF CLOTHING

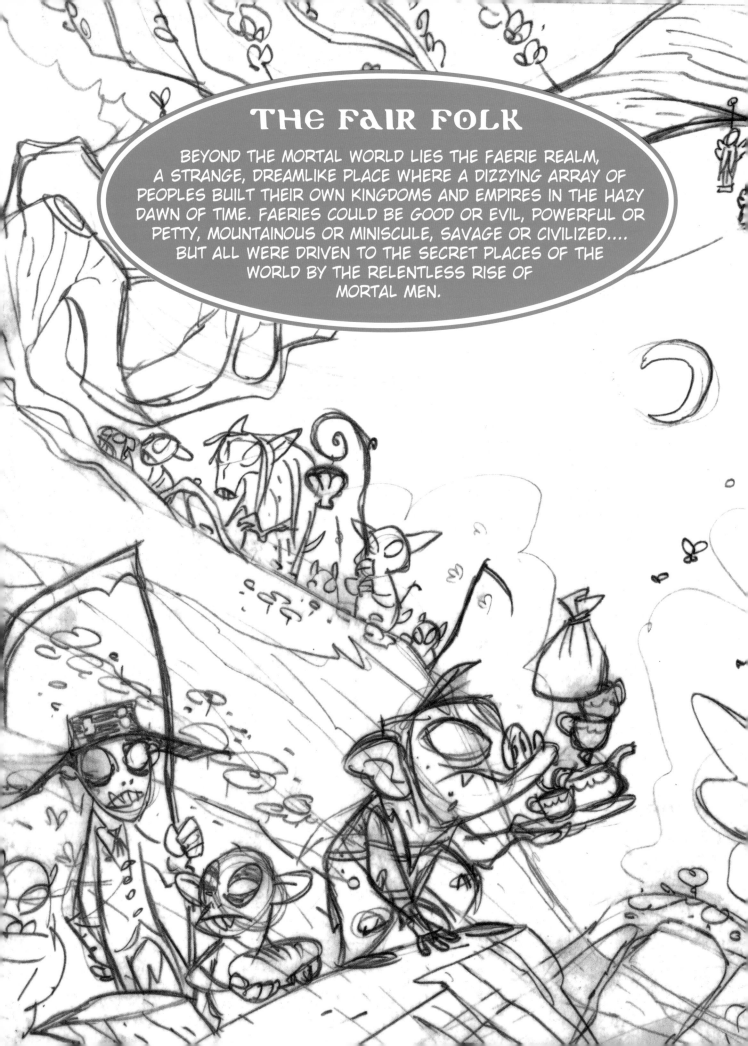

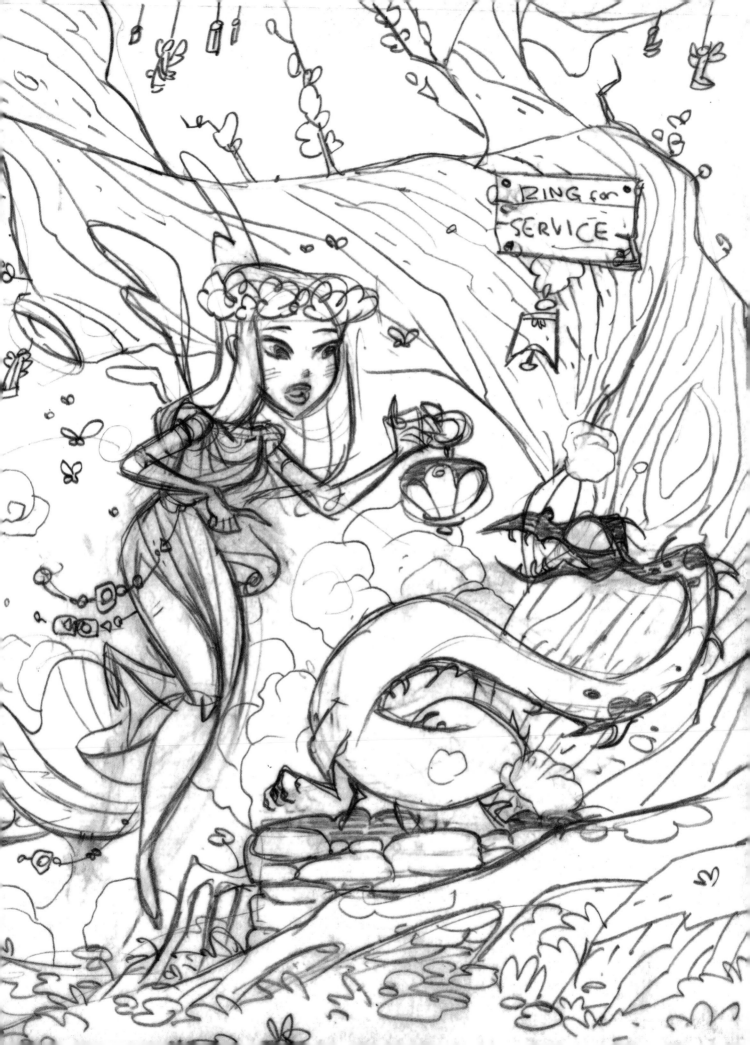

THE SIDHE

UNLIKE THE CUTE PIXIES ON MODERN POSTCARDS, THE SIDHE (OR "SITH" OR "TUATHA DE DANAAN") WERE AN ANCIENT, ELEGANT RACE. THEY RULED SYLVAN FAERIE KINGDOMS, BUT WERE ULTIMATELY DRIVEN UNDER THE HILLS AND OVER THE SEAS BY THE NEW EMPIRES OF MAN.

THE SIDHE ARE LORDLY AND BEAUTIFUL (AND JUST A LITTLE SINISTER), AND WEAR ELEGANT JEWELRY, WEAPONS AND CLOTHES.

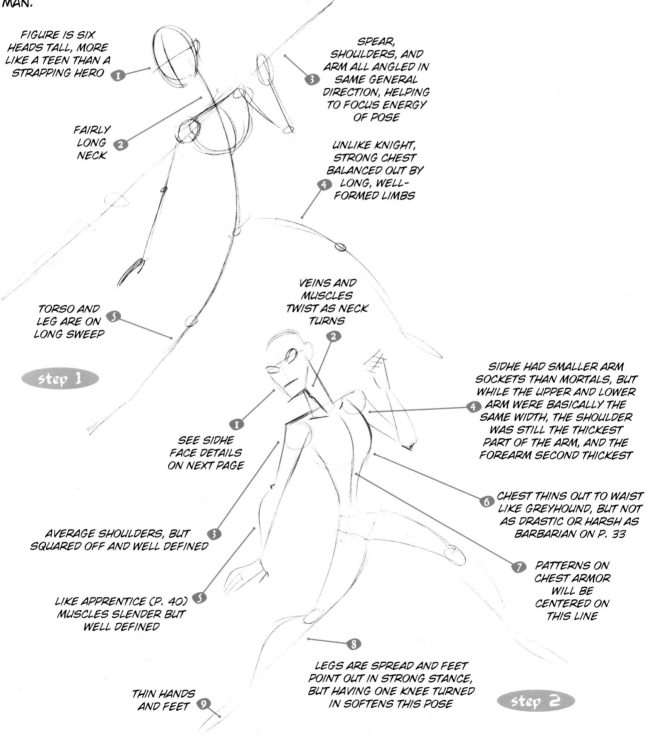

FIGURE IS SIX HEADS TALL, MORE LIKE A TEEN THAN A STRAPPING HERO **1**

FAIRLY LONG NECK **2**

SPEAR, SHOULDERS, AND ARM ALL ANGLED IN SAME GENERAL DIRECTION, HELPING TO FOCUS ENERGY OF POSE **3**

UNLIKE KNIGHT, STRONG CHEST BALANCED OUT BY LONG, WELL-FORMED LIMBS **4**

TORSO AND LEG ARE ON LONG SWEEP **5**

step 1

VEINS AND MUSCLES TWIST AS NECK TURNS **2**

SIDHE HAD SMALLER ARM SOCKETS THAN MORTALS, BUT WHILE THE UPPER AND LOWER ARM WERE BASICALLY THE SAME WIDTH, THE SHOULDER WAS STILL THE THICKEST PART OF THE ARM, AND THE FOREARM SECOND THICKEST **4**

SEE SIDHE FACE DETAILS ON NEXT PAGE **1**

CHEST THINS OUT TO WAIST LIKE GREYHOUND, BUT NOT AS DRASTIC OR HARSH AS BARBARIAN ON P. 33 **6**

AVERAGE SHOULDERS, BUT SQUARED OFF AND WELL DEFINED **3**

PATTERNS ON CHEST ARMOR WILL BE CENTERED ON THIS LINE **7**

LIKE APPRENTICE (P. 40) MUSCLES SLENDER BUT WELL DEFINED **5**

LEGS ARE SPREAD AND FEET POINT OUT IN STRONG STANCE, BUT HAVING ONE KNEE TURNED IN SOFTENS THIS POSE **8**

THIN HANDS AND FEET **9**

step 2

OVE
EYES
L
AN

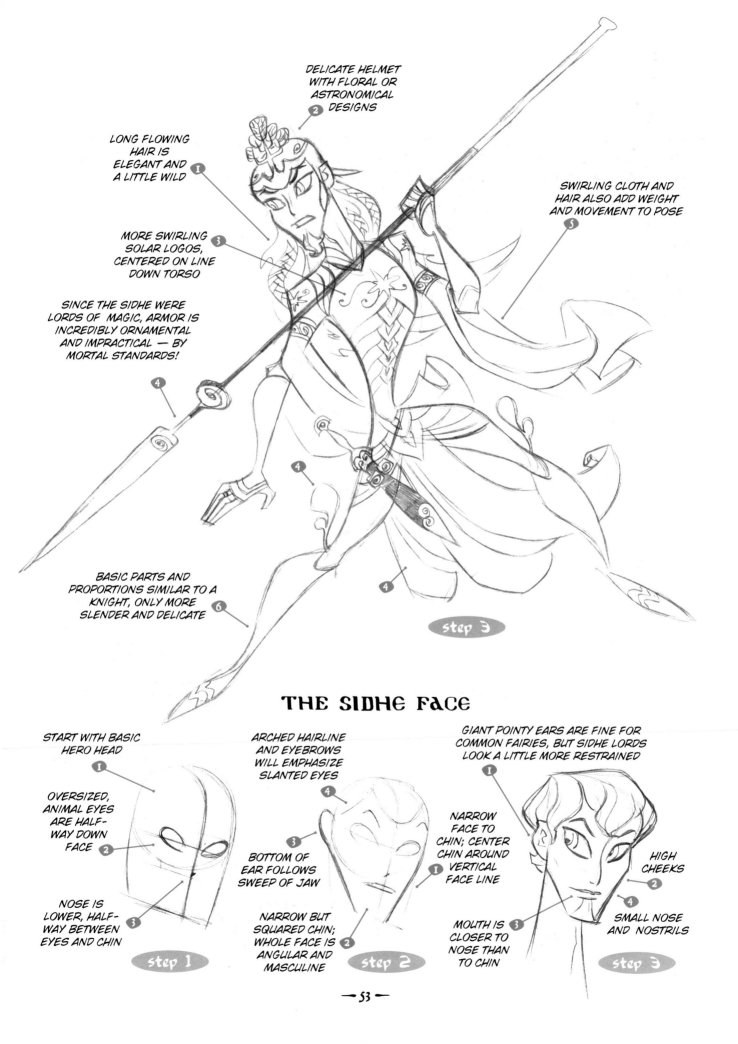

DELICATE HELMET WITH FLORAL OR ASTRONOMICAL DESIGNS ②

LONG FLOWING HAIR IS ELEGANT AND A LITTLE WILD ①

SWIRLING CLOTH AND HAIR ALSO ADD WEIGHT AND MOVEMENT TO POSE ⑤

MORE SWIRLING SOLAR LOGOS, CENTERED ON LINE DOWN TORSO ③

SINCE THE SIDHE WERE LORDS OF MAGIC, ARMOR IS INCREDIBLY ORNAMENTAL AND IMPRACTICAL — BY MORTAL STANDARDS! ④

④

④

BASIC PARTS AND PROPORTIONS SIMILAR TO A KNIGHT, ONLY MORE SLENDER AND DELICATE ⑥

step 3

THE SIDHE FACE

START WITH BASIC HERO HEAD ①

OVERSIZED, ANIMAL EYES ARE HALF-WAY DOWN FACE ②

NOSE IS LOWER, HALF-WAY BETWEEN EYES AND CHIN ③

ARCHED HAIRLINE AND EYEBROWS WILL EMPHASIZE SLANTED EYES ④

③

BOTTOM OF EAR FOLLOWS SWEEP OF JAW

NARROW BUT SQUARED CHIN; WHOLE FACE IS ANGULAR AND MASCULINE ②

step 1

step 2

GIANT POINTY EARS ARE FINE FOR COMMON FAIRIES, BUT SIDHE LORDS LOOK A LITTLE MORE RESTRAINED ①

NARROW FACE TO CHIN; CENTER CHIN AROUND VERTICAL FACE LINE ①

HIGH CHEEKS ②

MOUTH IS CLOSER TO NOSE THAN TO CHIN ③

SMALL NOSE AND NOSTRILS ④

step 3

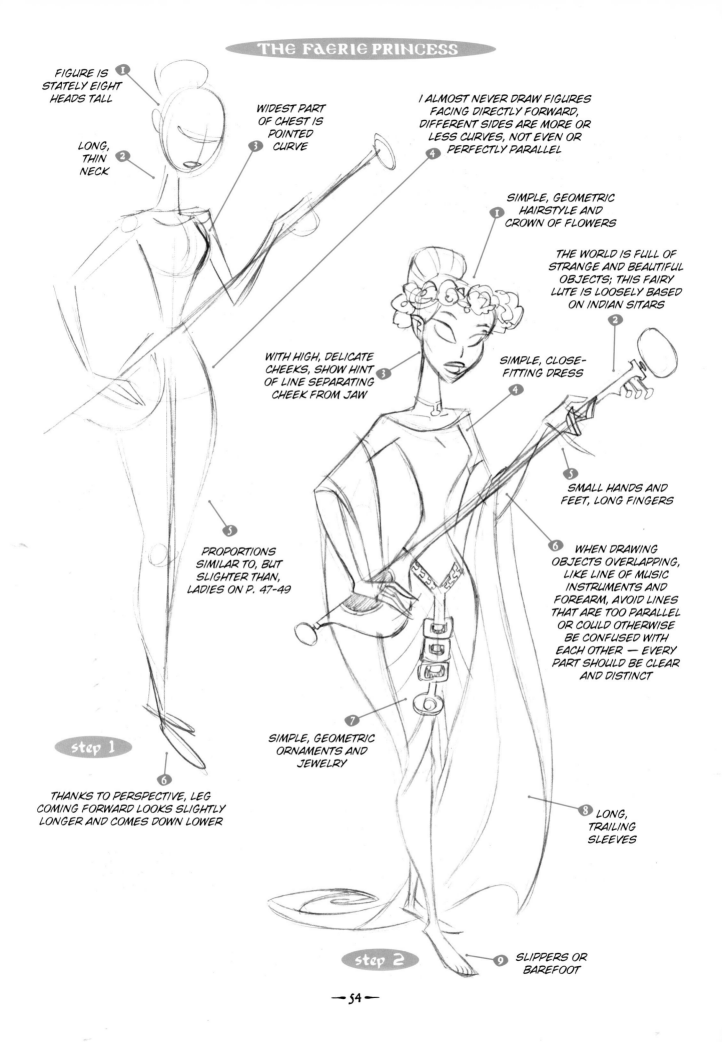

FIGURE IS STATELY EIGHT HEADS TALL ①

LONG, THIN NECK ②

WIDEST PART OF CHEST IS POINTED CURVE ③

I ALMOST NEVER DRAW FIGURES FACING DIRECTLY FORWARD, DIFFERENT SIDES ARE MORE OR LESS CURVES, NOT EVEN OR PERFECTLY PARALLEL ④

SIMPLE, GEOMETRIC HAIRSTYLE AND CROWN OF FLOWERS ①

THE WORLD IS FULL OF STRANGE AND BEAUTIFUL OBJECTS; THIS FAIRY LUTE IS LOOSELY BASED ON INDIAN SITARS ②

WITH HIGH, DELICATE CHEEKS, SHOW HINT OF LINE SEPARATING CHEEK FROM JAW ③

SIMPLE, CLOSE-FITTING DRESS ④

SMALL HANDS AND FEET, LONG FINGERS ⑤

PROPORTIONS SIMILAR TO, BUT SLIGHTER THAN, LADIES ON P. 47-49 ⑤

WHEN DRAWING OBJECTS OVERLAPPING, LIKE LINE OF MUSIC INSTRUMENTS AND FOREARM, AVOID LINES THAT ARE TOO PARALLEL OR COULD OTHERWISE BE CONFUSED WITH EACH OTHER — EVERY PART SHOULD BE CLEAR AND DISTINCT ⑥

SIMPLE, GEOMETRIC ORNAMENTS AND JEWELRY ⑦

step 1

step 2

THANKS TO PERSPECTIVE, LEG COMING FORWARD LOOKS SLIGHTLY LONGER AND COMES DOWN LOWER ⑥

LONG, TRAILING SLEEVES ⑧

SLIPPERS OR BAREFOOT ⑨

HATER FAERIES

THERE WERE SEVERAL "LESSER" FAERIES, INCLUDING THE WILD SPIRITS OF RIVERS, LAKES, AND WELLS. THE NYADS (TO USE THEIR GREEK NAME) WERE WILDER, LESS REGAL AND MORE CHILDLIKE THAN THE SIDHE ARISTOCRACY.

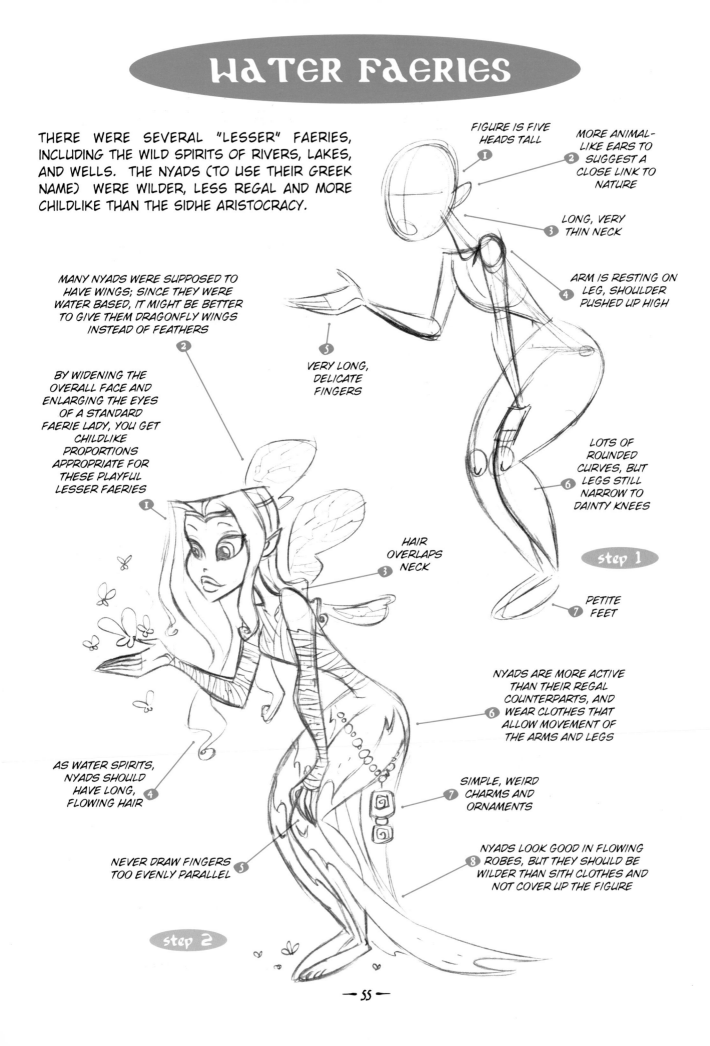

FIGURE IS FIVE HEADS TALL
①

MORE ANIMAL-LIKE EARS TO SUGGEST A CLOSE LINK TO NATURE
②

LONG, VERY THIN NECK
③

ARM IS RESTING ON LEG, SHOULDER PUSHED UP HIGH
④

MANY NYADS WERE SUPPOSED TO HAVE WINGS; SINCE THEY WERE WATER BASED, IT MIGHT BE BETTER TO GIVE THEM DRAGONFLY WINGS INSTEAD OF FEATHERS
②

VERY LONG, DELICATE FINGERS
⑤

LOTS OF ROUNDED CURVES, BUT LEGS STILL NARROW TO DAINTY KNEES
⑥

BY WIDENING THE OVERALL FACE AND ENLARGING THE EYES OF A STANDARD FAERIE LADY, YOU GET CHILDLIKE PROPORTIONS APPROPRIATE FOR THESE PLAYFUL LESSER FAERIES
①

step 1

PETITE FEET
⑦

HAIR OVERLAPS NECK
③

NYADS ARE MORE ACTIVE THAN THEIR REGAL COUNTERPARTS, AND WEAR CLOTHES THAT ALLOW MOVEMENT OF THE ARMS AND LEGS
⑥

AS WATER SPIRITS, NYADS SHOULD HAVE LONG, FLOWING HAIR
④

SIMPLE, WEIRD CHARMS AND ORNAMENTS
⑦

NEVER DRAW FINGERS TOO EVENLY PARALLEL
⑤

NYADS LOOK GOOD IN FLOWING ROBES, BUT THEY SHOULD BE WILDER THAN SITH CLOTHES AND NOT COVER UP THE FIGURE
⑧

step 2

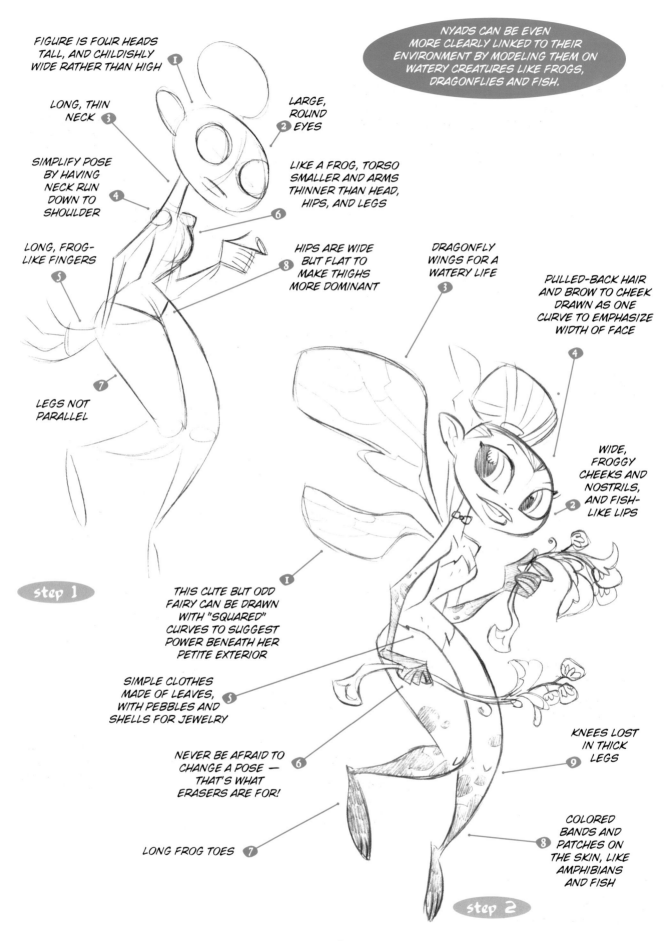

FIGURE IS FOUR HEADS TALL, AND CHILDISHLY WIDE RATHER THAN HIGH ①

LONG, THIN NECK ③

LARGE, ROUND EYES ②

SIMPLIFY POSE BY HAVING NECK RUN DOWN TO SHOULDER ④

LIKE A FROG, TORSO SMALLER AND ARMS THINNER THAN HEAD, HIPS, AND LEGS ⑥

LONG, FROG-LIKE FINGERS ⑤

HIPS ARE WIDE BUT FLAT TO MAKE THIGHS MORE DOMINANT ⑧

LEGS NOT PARALLEL ⑦

NYADS CAN BE EVEN MORE CLEARLY LINKED TO THEIR ENVIRONMENT BY MODELING THEM ON WATERY CREATURES LIKE FROGS, DRAGONFLIES AND FISH.

DRAGONFLY WINGS FOR A WATERY LIFE ③

PULLED-BACK HAIR AND BROW TO CHEEK DRAWN AS ONE CURVE TO EMPHASIZE WIDTH OF FACE ④

WIDE, FROGGY CHEEKS AND NOSTRILS, AND FISH-LIKE LIPS ②

step 1

THIS CUTE BUT ODD FAIRY CAN BE DRAWN WITH "SQUARED" CURVES TO SUGGEST POWER BENEATH HER PETITE EXTERIOR ①

SIMPLE CLOTHES MADE OF LEAVES, WITH PEBBLES AND SHELLS FOR JEWELRY ⑤

NEVER BE AFRAID TO CHANGE A POSE — THAT'S WHAT ERASERS ARE FOR! ⑥

KNEES LOST IN THICK LEGS ⑨

COLORED BANDS AND PATCHES ON THE SKIN, LIKE AMPHIBIANS AND FISH ⑧

LONG FROG TOES ⑦

step 2

SYLVAN FAERIES

THE WILD FAERIES OF THE FORESTS AND FIELDS (THE GREEK DRYADS) WERE EVEN MORE ROBUST AND ANIMAL-LIKE. SOME WERE PART ANIMAL, WHILE OTHERS WERE ACTUAL ANIMALS WITH SUPERNATURAL ABILITIES.

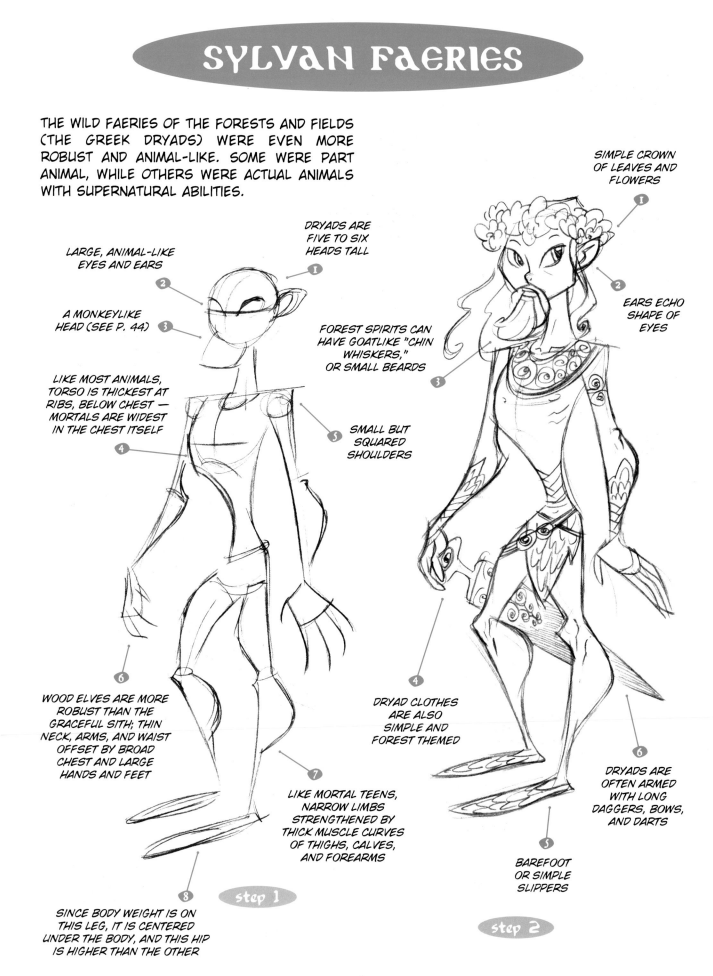

SIMPLE CROWN OF LEAVES AND FLOWERS

DRYADS ARE FIVE TO SIX HEADS TALL

LARGE, ANIMAL-LIKE EYES AND EARS

A MONKEYLIKE HEAD (SEE P. 44)

FOREST SPIRITS CAN HAVE GOATLIKE "CHIN WHISKERS," OR SMALL BEARDS

EARS ECHO SHAPE OF EYES

LIKE MOST ANIMALS, TORSO IS THICKEST AT RIBS, BELOW CHEST — MORTALS ARE WIDEST IN THE CHEST ITSELF

SMALL BUT SQUARED SHOULDERS

WOOD ELVES ARE MORE ROBUST THAN THE GRACEFUL SITH; THIN NECK, ARMS, AND WAIST OFFSET BY BROAD CHEST AND LARGE HANDS AND FEET

DRYAD CLOTHES ARE ALSO SIMPLE AND FOREST THEMED

DRYADS ARE OFTEN ARMED WITH LONG DAGGERS, BOWS, AND DARTS

LIKE MORTAL TEENS, NARROW LIMBS STRENGTHENED BY THICK MUSCLE CURVES OF THIGHS, CALVES, AND FOREARMS

BAREFOOT OR SIMPLE SLIPPERS

step 1

step 2

SINCE BODY WEIGHT IS ON THIS LEG, IT IS CENTERED UNDER THE BODY, AND THIS HIP IS HIGHER THAN THE OTHER

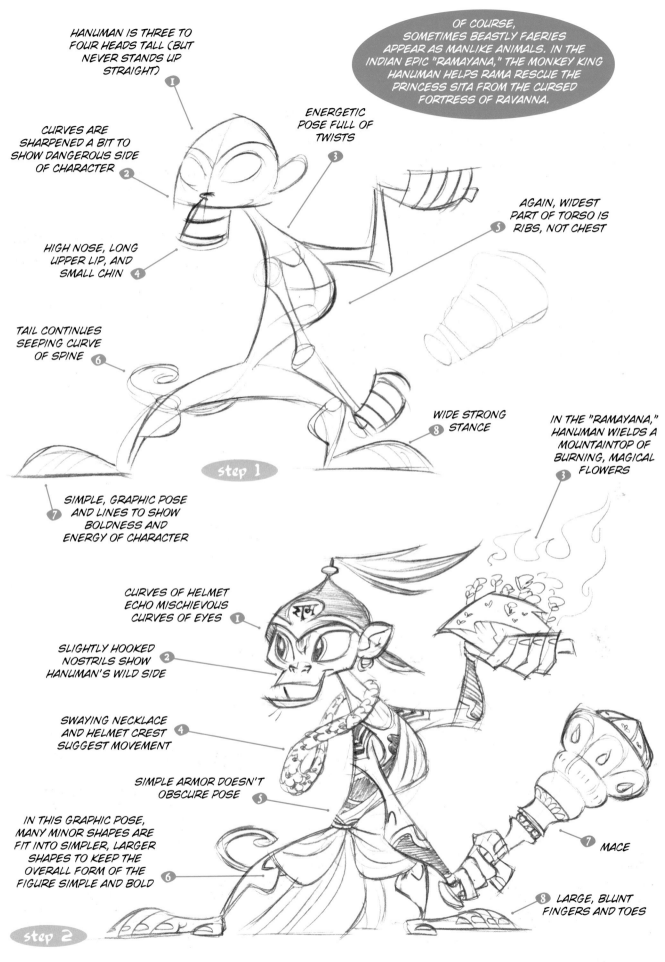

HANUMAN IS THREE TO FOUR HEADS TALL (BUT NEVER STANDS UP STRAIGHT) **1**

CURVES ARE SHARPENED A BIT TO SHOW DANGEROUS SIDE OF CHARACTER **2**

ENERGETIC POSE FULL OF TWISTS **3**

OF COURSE, SOMETIMES BEASTLY FAERIES APPEAR AS MANLIKE ANIMALS. IN THE INDIAN EPIC "RAMAYANA," THE MONKEY KING HANUMAN HELPS RAMA RESCUE THE PRINCESS SITA FROM THE CURSED FORTRESS OF RAVANNA.

AGAIN, WIDEST PART OF TORSO IS RIBS, NOT CHEST **5**

HIGH NOSE, LONG UPPER LIP, AND SMALL CHIN **4**

TAIL CONTINUES SEEPING CURVE OF SPINE **6**

WIDE STRONG STANCE **8**

IN THE "RAMAYANA," HANUMAN WIELDS A MOUNTAINTOP OF BURNING, MAGICAL FLOWERS **3**

step 1

SIMPLE, GRAPHIC POSE AND LINES TO SHOW BOLDNESS AND ENERGY OF CHARACTER **7**

CURVES OF HELMET ECHO MISCHIEVOUS CURVES OF EYES **1**

SLIGHTLY HOOKED NOSTRILS SHOW HANUMAN'S WILD SIDE **2**

SWAYING NECKLACE AND HELMET CREST SUGGEST MOVEMENT **4**

SIMPLE ARMOR DOESN'T OBSCURE POSE **5**

IN THIS GRAPHIC POSE, MANY MINOR SHAPES ARE FIT INTO SIMPLER, LARGER SHAPES TO KEEP THE OVERALL FORM OF THE FIGURE SIMPLE AND BOLD **6**

MACE **7**

LARGE, BLUNT FINGERS AND TOES **8**

step 2

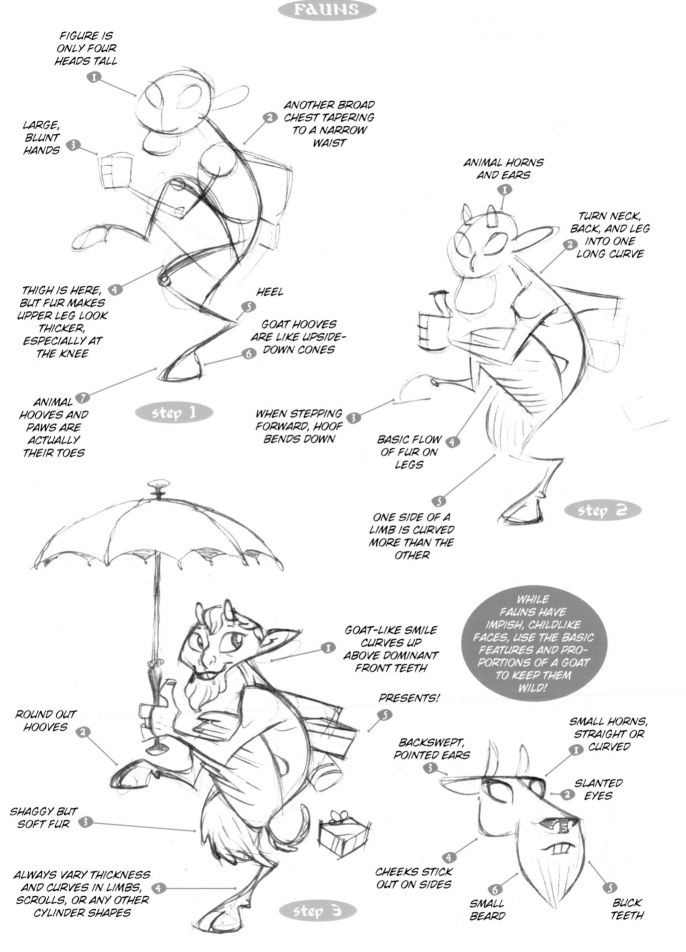

FIGURE IS ONLY FOUR HEADS TALL ①

ANOTHER BROAD CHEST TAPERING TO A NARROW WAIST ②

LARGE, BLUNT HANDS ③

THIGH IS HERE, BUT FUR MAKES UPPER LEG LOOK THICKER, ESPECIALLY AT THE KNEE ④

HEEL ⑤

GOAT HOOVES ARE LIKE UPSIDE-DOWN CONES ⑥

ANIMAL HOOVES AND PAWS ARE ACTUALLY THEIR TOES ⑦

step 1

WHEN STEPPING FORWARD, HOOF BENDS DOWN

ANIMAL HORNS AND EARS ①

TURN NECK, BACK, AND LEG INTO ONE LONG CURVE ②

BASIC FLOW OF FUR ON LEGS ④

③

ONE SIDE OF A LIMB IS CURVED MORE THAN THE OTHER ⑤

step 2

GOAT-LIKE SMILE CURVES UP ABOVE DOMINANT FRONT TEETH ①

PRESENTS! ⑤

ROUND OUT HOOVES ②

SHAGGY BUT SOFT FUR ③

ALWAYS VARY THICKNESS AND CURVES IN LIMBS, SCROLLS, OR ANY OTHER CYLINDER SHAPES ④

step 3

WHILE FAUNS HAVE IMPISH, CHILDLIKE FACES, USE THE BASIC FEATURES AND PRO-PORTIONS OF A GOAT TO KEEP THEM WILD!

BACKSWEPT, POINTED EARS ③

SMALL HORNS, STRAIGHT OR CURVED ①

SLANTED EYES ②

CHEEKS STICK OUT ON SIDES ④

SMALL BEARD ⑥

BUCK TEETH ⑤

GOBLINS

GOBLINS ARE THE DARK SIDE OF THE FAERIE WORLD. WHILE IT'S NOT ALWAYS CLEAR WHAT SEPARATES GOBLINS FROM FAERIES — SOME OF WHICH ARE QUITE NASTY — GOBLINS TEND TO BE MORE UGLY AND ANIMAL-LIKE THAN OTHER FAIR FOLK.

YOU CAN START GOBLIN FACES WITH THE BASIC ANIMAL HEAD AT RIGHT, OR A MORE SPECIFIC ANIMAL TYPE LIKE PIGS OR FERRETS, THEN TWIST THE SHAPES AND DETAILS TO MORE SINISTER ENDS.

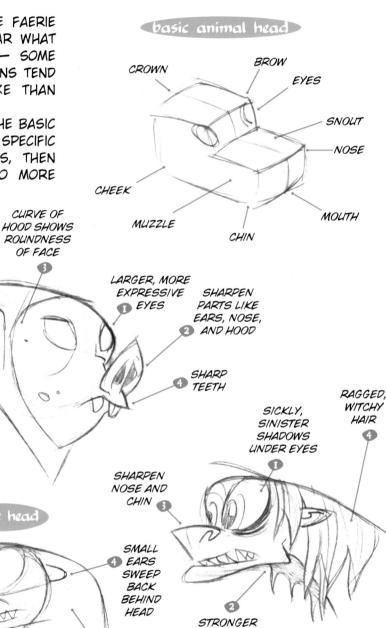

basic animal head

CROWN

BROW

EYES

SNOUT

NOSE

MOUTH

CHEEK

MUZZLE

CHIN

pig head

BASICALLY, CIRCLE WITH SMALL SNOUT — 1

SMALL EYES HALFWAY DOWN HEAD — 2

CURVE OF HOOD SHOWS ROUNDNESS OF FACE — 3

LARGER, MORE EXPRESSIVE EYES — 1

SHARPEN PARTS LIKE EARS, NOSE, AND HOOD — 2

SHARP TEETH — 4

FAT CHEEKS — 4

UPPER LIP STICKS OUT — 5

LARGE, UPTURNED NOSE — 3

RAGGED, WITCHY HAIR — 4

SICKLY, SINISTER SHADOWS UNDER EYES — 1

ferret head

HUGE, PROWLING EYES TAKE UP TOP FRONT OF HEAD — 1

SHORT, BLUNT SNOUT TAKES UP BOTTOM HALF OF FACE, AND IS LARGER AT NOSE THAN CHEEKS — 2

CHIN STICKS OUT LESS THAN NOSE — 3

SMALL EARS SWEEP BACK BEHIND HEAD — 4

NECK COMES BACK FROM HEAD, AND IS SAME THICKNESS AS HEAD — 5

SHARPEN NOSE AND CHIN — 3

STRONGER JAW — 2

human head

ANOTHER APPROACH IS TO TWIST HUMAN FEATURES INTO A MORE GROTESQUE AND SKULL-LIKE FORM, AND ESPECIALLY TO EMPHASIZE HARSHER PARTS OF FACE LIKE BROW, JOWLS AND NOSTRILS.

CROWN

EYES

TEETH

JOWLS

CHIN

POINTED CROWN IS SHARP AND FERAL — 3

LARGER FOREHEAD OF TRICKIER GOBLIN — 5

WIDE, STARING GHOST EYES — 4

HARSH JOWLS, SMALL CHIN — 1

SMALL, SHARP TEETH EMPHASIZED BY LIPS — 2

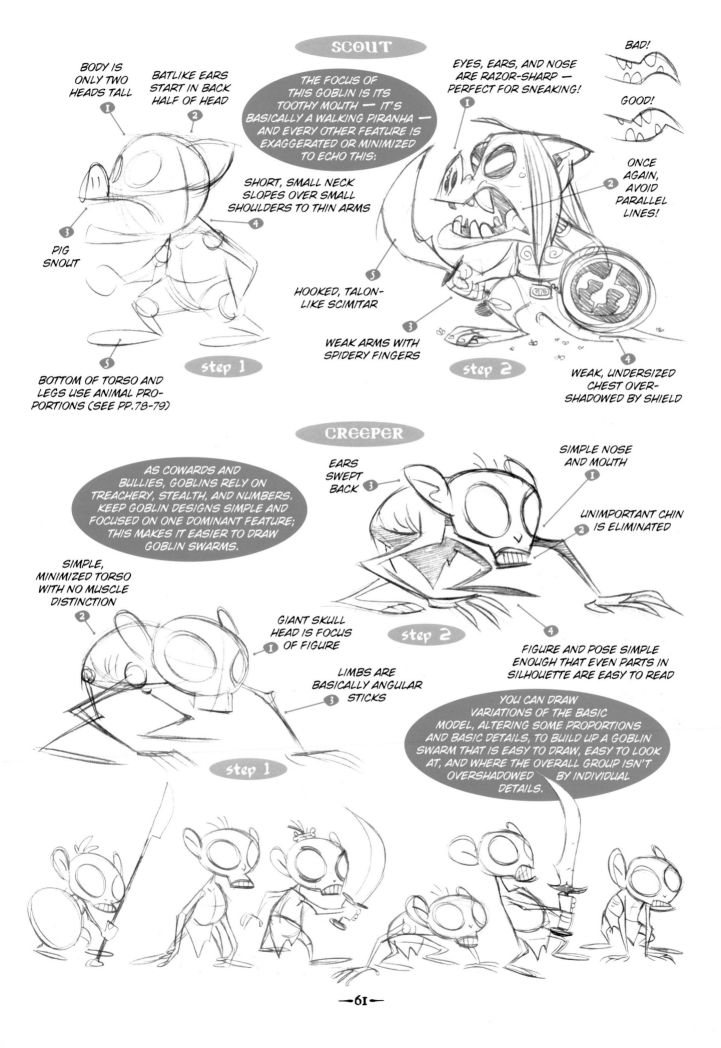

SCOUT

BODY IS ONLY TWO HEADS TALL ①

BATLIKE EARS START IN BACK HALF OF HEAD ②

THE FOCUS OF THIS GOBLIN IS ITS TOOTHY MOUTH — IT'S BASICALLY A WALKING PIRANHA — AND EVERY OTHER FEATURE IS EXAGGERATED OR MINIMIZED TO ECHO THIS:

EYES, EARS, AND NOSE ARE RAZOR-SHARP — PERFECT FOR SNEAKING! ①

BAD!

GOOD!

ONCE AGAIN, AVOID PARALLEL LINES! ②

③ PIG SNOUT

SHORT, SMALL NECK SLOPES OVER SMALL SHOULDERS TO THIN ARMS ④

HOOKED, TALON-LIKE SCIMITAR ⑤

WEAK ARMS WITH SPIDERY FINGERS ③

step 1

step 2

⑤ BOTTOM OF TORSO AND LEGS USE ANIMAL PRO-PORTIONS (SEE PP.78-79)

WEAK, UNDERSIZED CHEST OVER-SHADOWED BY SHIELD ④

CREEPER

AS COWARDS AND BULLIES, GOBLINS RELY ON TREACHERY, STEALTH, AND NUMBERS. KEEP GOBLIN DESIGNS SIMPLE AND FOCUSED ON ONE DOMINANT FEATURE; THIS MAKES IT EASIER TO DRAW GOBLIN SWARMS.

EARS SWEPT BACK ③

SIMPLE NOSE AND MOUTH ①

UNIMPORTANT CHIN IS ELIMINATED ②

SIMPLE, MINIMIZED TORSO WITH NO MUSCLE DISTINCTION ②

GIANT SKULL HEAD IS FOCUS OF FIGURE ①

LIMBS ARE BASICALLY ANGULAR STICKS ③

step 2

FIGURE AND POSE SIMPLE ENOUGH THAT EVEN PARTS IN SILHOUETTE ARE EASY TO READ ④

step 1

YOU CAN DRAW VARIATIONS OF THE BASIC MODEL, ALTERING SOME PROPORTIONS AND BASIC DETAILS, TO BUILD UP A GOBLIN SWARM THAT IS EASY TO DRAW, EASY TO LOOK AT, AND WHERE THE OVERALL GROUP ISN'T OVERSHADOWED BY INDIVIDUAL DETAILS.

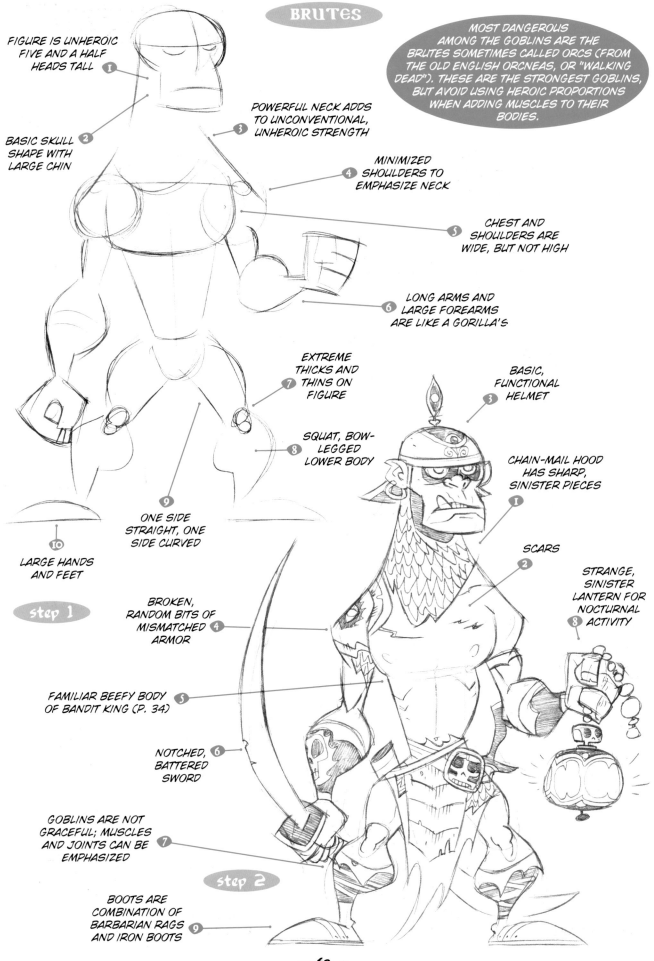

BRUTES

MOST DANGEROUS AMONG THE GOBLINS ARE THE BRUTES SOMETIMES CALLED ORCS (FROM THE OLD ENGLISH ORCNEAS, OR "WALKING DEAD"). THESE ARE THE STRONGEST GOBLINS, BUT AVOID USING HEROIC PROPORTIONS WHEN ADDING MUSCLES TO THEIR BODIES.

FIGURE IS UNHEROIC FIVE AND A HALF HEADS TALL ①

② BASIC SKULL SHAPE WITH LARGE CHIN

③ POWERFUL NECK ADDS TO UNCONVENTIONAL, UNHEROIC STRENGTH

④ MINIMIZED SHOULDERS TO EMPHASIZE NECK

⑤ CHEST AND SHOULDERS ARE WIDE, BUT NOT HIGH

⑥ LONG ARMS AND LARGE FOREARMS ARE LIKE A GORILLA'S

⑦ EXTREME THICKS AND THINS ON FIGURE

⑧ SQUAT, BOW-LEGGED LOWER BODY

⑨ ONE SIDE STRAIGHT, ONE SIDE CURVED

⑩ LARGE HANDS AND FEET

step 1

③ BASIC, FUNCTIONAL HELMET

① CHAIN-MAIL HOOD HAS SHARP, SINISTER PIECES

② SCARS

⑧ STRANGE, SINISTER LANTERN FOR NOCTURNAL ACTIVITY

④ BROKEN, RANDOM BITS OF MISMATCHED ARMOR

⑤ FAMILIAR BEEFY BODY OF BANDIT KING (P. 34)

⑥ NOTCHED, BATTERED SWORD

⑦ GOBLINS ARE NOT GRACEFUL; MUSCLES AND JOINTS CAN BE EMPHASIZED

⑨ BOOTS ARE COMBINATION OF BARBARIAN RAGS AND IRON BOOTS

step 2

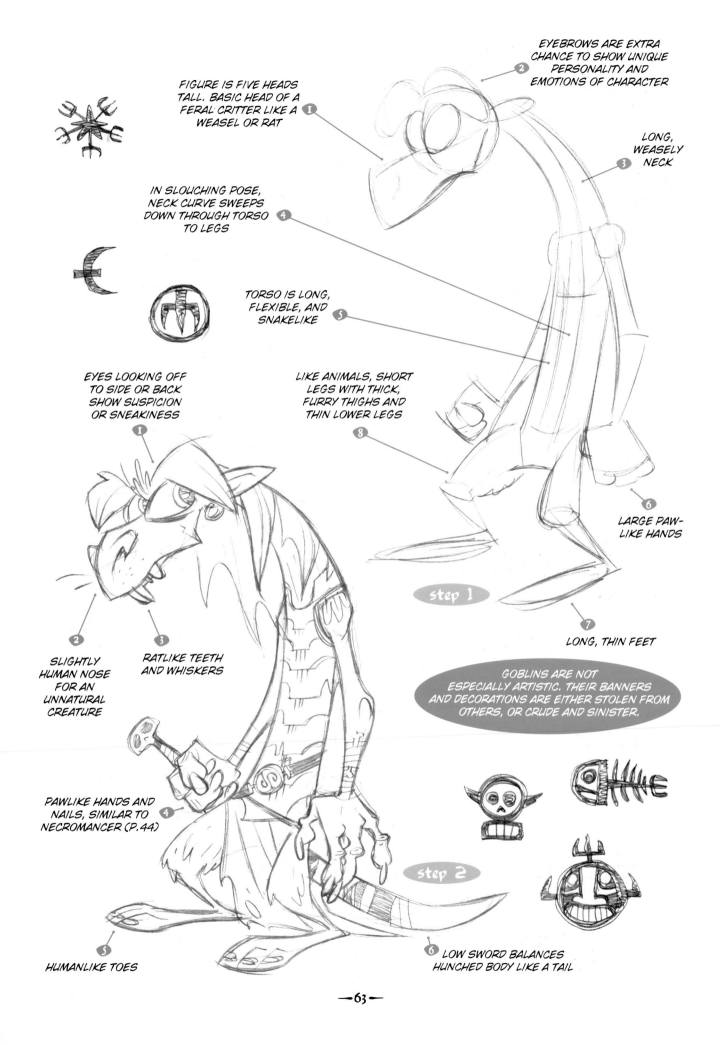

FIGURE IS FIVE HEADS TALL. BASIC HEAD OF A FERAL CRITTER LIKE A WEASEL OR RAT ①

EYEBROWS ARE EXTRA CHANCE TO SHOW UNIQUE PERSONALITY AND EMOTIONS OF CHARACTER ②

LONG, WEASELY NECK ③

IN SLOUCHING POSE, NECK CURVE SWEEPS DOWN THROUGH TORSO TO LEGS ④

TORSO IS LONG, FLEXIBLE, AND SNAKELIKE ⑤

EYES LOOKING OFF TO SIDE OR BACK SHOW SUSPICION OR SNEAKINESS ①

LIKE ANIMALS, SHORT LEGS WITH THICK, FURRY THIGHS AND THIN LOWER LEGS ⑧

LARGE PAW-LIKE HANDS ⑥

step 1

⑦ LONG, THIN FEET

SLIGHTLY HUMAN NOSE FOR AN UNNATURAL CREATURE ②

RATLIKE TEETH AND WHISKERS ③

GOBLINS ARE NOT ESPECIALLY ARTISTIC. THEIR BANNERS AND DECORATIONS ARE EITHER STOLEN FROM OTHERS, OR CRUDE AND SINISTER.

PAWLIKE HANDS AND NAILS, SIMILAR TO NECROMANCER (P.44) ④

step 2

HUMANLIKE TOES ⑤

⑥ LOW SWORD BALANCES HUNCHED BODY LIKE A TAIL

—63—

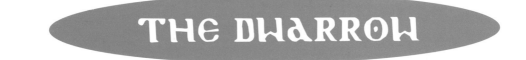

THE DWARROW

THE DWARROW ARE EARTHY FAERIES THAT OFTEN LIVE AND WORK UNDERGROUND. TOUGH AND SKILLED, THE DWARROW ARE ALSO SHORT; THIS IS THE ORIGIN OF THE WORD "DWARF." SOME ARE KIND AND SOME ARE DANGEROUS, BUT ALL ARE CRAFTY AND STUBBORN.

DWARROW LIVED ALL OVER THE WORLD, BUT WERE MOST POPULOUS IN THE FROZEN VIKING LANDS. CONSIDER USING VIKING AND GERMAN ART, ESPECIALLY BRAIDED PATTERNS AND GEOMETRIC SHAPES, FOR YOUR DWARROW (BELOW AND BOTTOM LEFT).

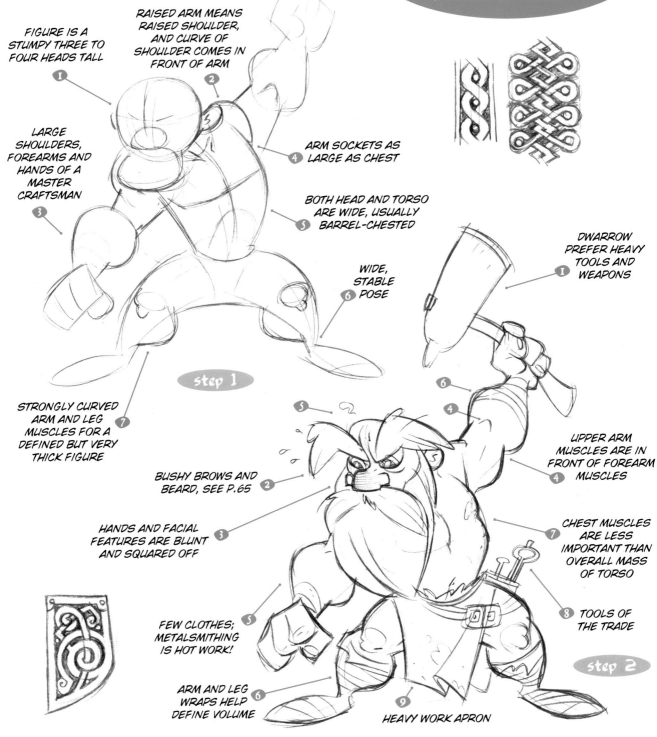

FIGURE IS A STUMPY THREE TO FOUR HEADS TALL
1

RAISED ARM MEANS RAISED SHOULDER, AND CURVE OF SHOULDER COMES IN FRONT OF ARM
2

LARGE SHOULDERS, FOREARMS AND HANDS OF A MASTER CRAFTSMAN
3

ARM SOCKETS AS LARGE AS CHEST
4

BOTH HEAD AND TORSO ARE WIDE, USUALLY BARREL-CHESTED
5

WIDE, STABLE POSE
6

STRONGLY CURVED ARM AND LEG MUSCLES FOR A DEFINED BUT VERY THICK FIGURE
7

step 1

DWARROW PREFER HEAVY TOOLS AND WEAPONS
1

BUSHY BROWS AND BEARD, SEE P.65
2

HANDS AND FACIAL FEATURES ARE BLUNT AND SQUARED OFF
3

UPPER ARM MUSCLES ARE IN FRONT OF FOREARM MUSCLES
4

CHEST MUSCLES ARE LESS IMPORTANT THAN OVERALL MASS OF TORSO
7

TOOLS OF THE TRADE
8

FEW CLOTHES; METALSMITHING IS HOT WORK!
5

ARM AND LEG WRAPS HELP DEFINE VOLUME
6

HEAVY WORK APRON
9

step 2

THE DWARF HEAD

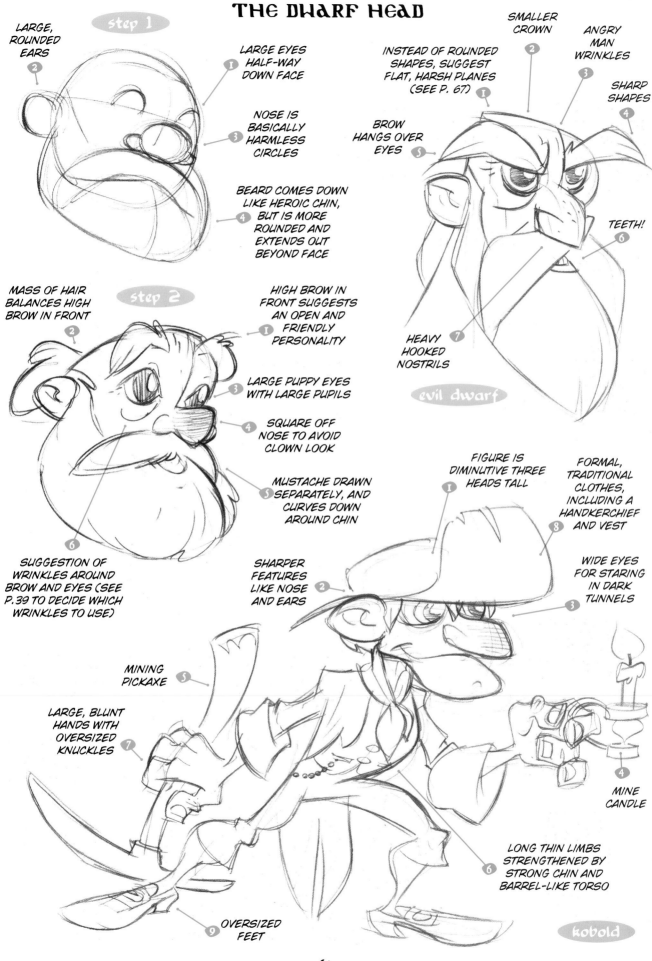

step 1

LARGE, ROUNDED EARS ②

LARGE EYES HALF-WAY DOWN FACE ①

NOSE IS BASICALLY HARMLESS CIRCLES ③

BEARD COMES DOWN LIKE HEROIC CHIN, BUT IS MORE ROUNDED AND EXTENDS OUT BEYOND FACE ④

step 2

MASS OF HAIR BALANCES HIGH BROW IN FRONT ②

HIGH BROW IN FRONT SUGGESTS AN OPEN AND FRIENDLY PERSONALITY ①

LARGE PUPPY EYES WITH LARGE PUPILS ③

SQUARE OFF NOSE TO AVOID CLOWN LOOK ④

MUSTACHE DRAWN SEPARATELY, AND CURVES DOWN AROUND CHIN ⑤

SUGGESTION OF WRINKLES AROUND BROW AND EYES (SEE P.39 TO DECIDE WHICH WRINKLES TO USE) ⑥

SMALLER CROWN ②

ANGRY MAN WRINKLES ③

SHARP SHAPES ④

INSTEAD OF ROUNDED SHAPES, SUGGEST FLAT, HARSH PLANES (SEE P. 67) ①

BROW HANGS OVER EYES ⑤

TEETH! ⑥

HEAVY HOOKED NOSTRILS ⑦

evil dwarf

FIGURE IS DIMINUTIVE THREE HEADS TALL ①

FORMAL, TRADITIONAL CLOTHES, INCLUDING A HANDKERCHIEF AND VEST ⑧

WIDE EYES FOR STARING IN DARK TUNNELS ③

SHARPER FEATURES LIKE NOSE AND EARS ②

MINING PICKAXE ⑤

LARGE, BLUNT HANDS WITH OVERSIZED KNUCKLES ⑦

MINE CANDLE ④

LONG THIN LIMBS STRENGTHENED BY STRONG CHIN AND BARREL-LIKE TORSO ⑥

OVERSIZED FEET ⑨

kobold

GIANTS

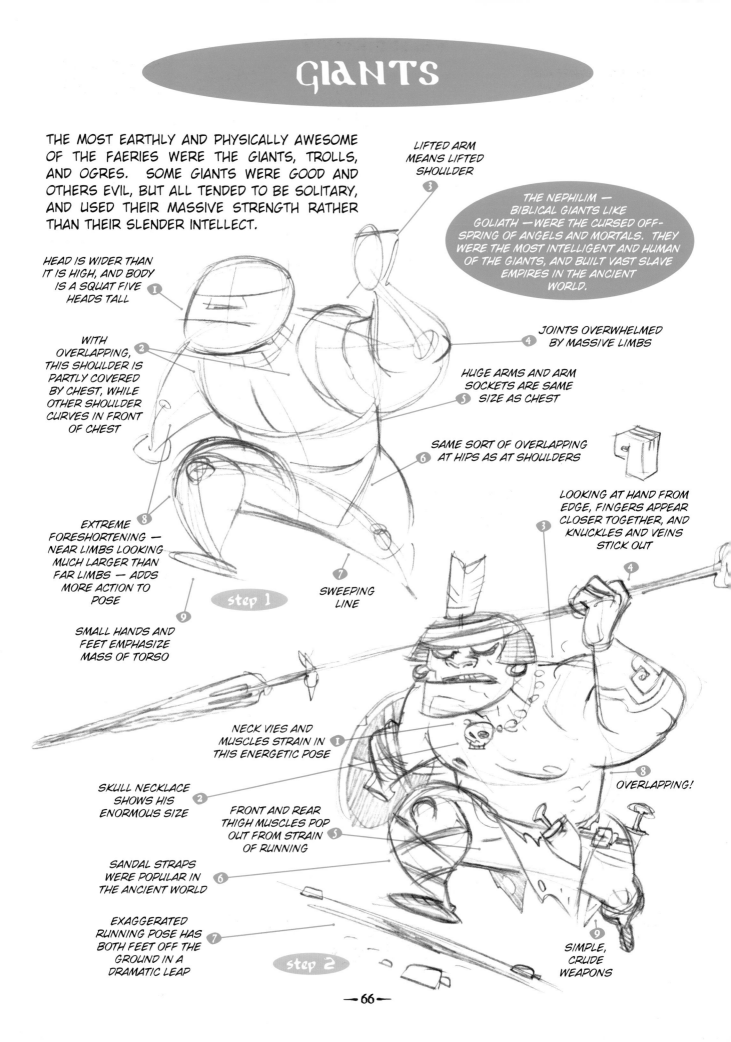

THE MOST EARTHLY AND PHYSICALLY AWESOME OF THE FAERIES WERE THE GIANTS, TROLLS, AND OGRES. SOME GIANTS WERE GOOD AND OTHERS EVIL, BUT ALL TENDED TO BE SOLITARY, AND USED THEIR MASSIVE STRENGTH RATHER THAN THEIR SLENDER INTELLECT.

LIFTED ARM MEANS LIFTED SHOULDER ③

THE NEPHILIM — BIBLICAL GIANTS LIKE GOLIATH —WERE THE CURSED OFFSPRING OF ANGELS AND MORTALS. THEY WERE THE MOST INTELLIGENT AND HUMAN OF THE GIANTS, AND BUILT VAST SLAVE EMPIRES IN THE ANCIENT WORLD.

HEAD IS WIDER THAN IT IS HIGH, AND BODY IS A SQUAT FIVE HEADS TALL ①

WITH OVERLAPPING, THIS SHOULDER IS PARTLY COVERED BY CHEST, WHILE OTHER SHOULDER CURVES IN FRONT OF CHEST ②

JOINTS OVERWHELMED ④ BY MASSIVE LIMBS

HUGE ARMS AND ARM SOCKETS ARE SAME ⑤ SIZE AS CHEST

SAME SORT OF OVERLAPPING ⑥ AT HIPS AS AT SHOULDERS

LOOKING AT HAND FROM EDGE, FINGERS APPEAR CLOSER TOGETHER, AND KNUCKLES AND VEINS STICK OUT ③

EXTREME FORESHORTENING — NEAR LIMBS LOOKING MUCH LARGER THAN FAR LIMBS — ADDS MORE ACTION TO POSE ⑧

⑨

SMALL HANDS AND FEET EMPHASIZE MASS OF TORSO

⑦ SWEEPING LINE

step 1

④

NECK VIES AND MUSCLES STRAIN IN THIS ENERGETIC POSE ①

SKULL NECKLACE SHOWS HIS ENORMOUS SIZE ②

FRONT AND REAR THIGH MUSCLES POP OUT FROM STRAIN OF RUNNING ⑤

③

⑧ OVERLAPPING!

SANDAL STRAPS WERE POPULAR IN THE ANCIENT WORLD ⑥

EXAGGERATED RUNNING POSE HAS BOTH FEET OFF THE GROUND IN A DRAMATIC LEAP ⑦

step 2

⑨ SIMPLE, CRUDE WEAPONS

GIANT FACES

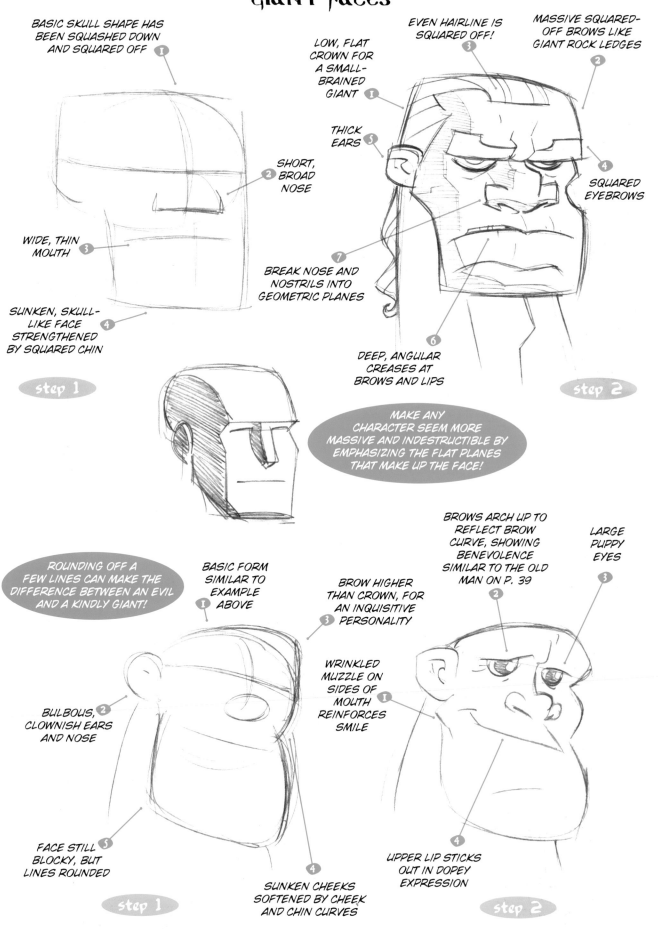

BASIC SKULL SHAPE HAS BEEN SQUASHED DOWN AND SQUARED OFF ①

SHORT, BROAD NOSE ②

WIDE, THIN MOUTH ③

SUNKEN, SKULL-LIKE FACE STRENGTHENED BY SQUARED CHIN ④

step 1

LOW, FLAT CROWN FOR A SMALL-BRAINED GIANT ①

EVEN HAIRLINE IS SQUARED OFF! ③

MASSIVE SQUARED-OFF BROWS LIKE GIANT ROCK LEDGES ②

THICK EARS ⑤

SQUARED EYEBROWS ④

BREAK NOSE AND NOSTRILS INTO GEOMETRIC PLANES ⑦

DEEP, ANGULAR CREASES AT BROWS AND LIPS ⑥

step 2

MAKE ANY CHARACTER SEEM MORE MASSIVE AND INDESTRUCTIBLE BY EMPHASIZING THE FLAT PLANES THAT MAKE UP THE FACE!

ROUNDING OFF A FEW LINES CAN MAKE THE DIFFERENCE BETWEEN AN EVIL AND A KINDLY GIANT!

BASIC FORM SIMILAR TO EXAMPLE ABOVE ①

BULBOUS, CLOWNISH EARS AND NOSE ②

FACE STILL BLOCKY, BUT LINES ROUNDED ⑤

SUNKEN CHEEKS SOFTENED BY CHEEK AND CHIN CURVES ④

step 1

BROWS ARCH UP TO REFLECT BROW CURVE, SHOWING BENEVOLENCE SIMILAR TO THE OLD MAN ON P. 39 ②

LARGE PUPPY EYES ③

BROW HIGHER THAN CROWN, FOR AN INQUISITIVE PERSONALITY ③

WRINKLED MUZZLE ON SIDES OF MOUTH REINFORCES SMILE ①

UPPER LIP STICKS OUT IN DOPEY EXPRESSION ④

step 2

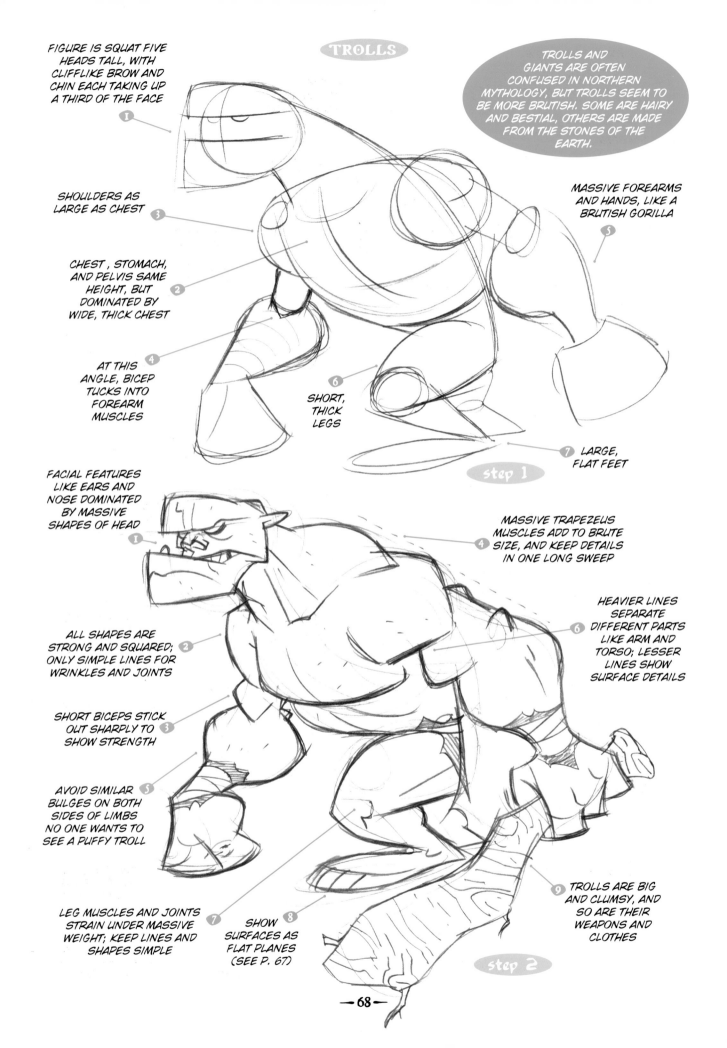

TROLLS

TROLLS AND GIANTS ARE OFTEN CONFUSED IN NORTHERN MYTHOLOGY, BUT TROLLS SEEM TO BE MORE BRUTISH. SOME ARE HAIRY AND BESTIAL, OTHERS ARE MADE FROM THE STONES OF THE EARTH.

Step 1

1. FIGURE IS SQUAT FIVE HEADS TALL, WITH CLIFFLIKE BROW AND CHIN EACH TAKING UP A THIRD OF THE FACE

3. SHOULDERS AS LARGE AS CHEST

2. CHEST, STOMACH, AND PELVIS SAME HEIGHT, BUT DOMINATED BY WIDE, THICK CHEST

4. AT THIS ANGLE, BICEP TUCKS INTO FOREARM MUSCLES

5. MASSIVE FOREARMS AND HANDS, LIKE A BRUTISH GORILLA

6. SHORT, THICK LEGS

7. LARGE, FLAT FEET

Step 2

1. FACIAL FEATURES LIKE EARS AND NOSE DOMINATED BY MASSIVE SHAPES OF HEAD

4. MASSIVE TRAPEZEUS MUSCLES ADD TO BRUTE SIZE, AND KEEP DETAILS IN ONE LONG SWEEP

2. ALL SHAPES ARE STRONG AND SQUARED; ONLY SIMPLE LINES FOR WRINKLES AND JOINTS

6. HEAVIER LINES SEPARATE DIFFERENT PARTS LIKE ARM AND TORSO; LESSER LINES SHOW SURFACE DETAILS

3. SHORT BICEPS STICK OUT SHARPLY TO SHOW STRENGTH

5. AVOID SIMILAR BULGES ON BOTH SIDES OF LIMBS NO ONE WANTS TO SEE A PUFFY TROLL

7. LEG MUSCLES AND JOINTS STRAIN UNDER MASSIVE WEIGHT; KEEP LINES AND SHAPES SIMPLE

8. SHOW SURFACES AS FLAT PLANES (SEE P. 67)

9. TROLLS ARE BIG AND CLUMSY, AND SO ARE THEIR WEAPONS AND CLOTHES

DESPITE OBVIOUS DIFFERENCES LIKE HORNS AND FUR, MOST ANIMALS HAVE THE SAME BASIC HEAD THAT WE SAW ON P. 60.
BY LENGTHENING THE SNOUT, RAISING THE BROW, OR MAKING OTHER ADJUSTMENTS TO SPECIFIC PARTS OF THE HEAD, YOU CAN SUGGEST A CERTAIN ANIMAL EVEN BEFORE YOU ADD THE SURFACE DETAILS.

basic animal head

CROWN

BROW

EYES

SNOUT

NOSE

CHEEK

MOUTH

MUZZLE

CHIN

example 1

LOW BROW ①

EYEBROWLIKE RIDGES STICK OUT IN MANY REPTILES ②

LONG, CROOKED SNOUT ③

SEPARATE NOSTRILS STICK OUT ⑤

MANY CREATURES HAVE BUMP ON TOP OF SNOUT ⑥

LARGE JAW ④

GULLET (THROAT) HANGS DOWN BELOW JAW ⑦

⑧ ZIG-ZAG LINE FOR MOUTH

example 2

LOW, FLAT CROWN ①

EYES FAR APART ②

SHORT, BROAD SNOUT ⑤

FULL, SHARP CHEEKS ③

④

⑥ WIDE CHIN

NARROW JAW

CROWN AND SNOUT ALMOST SINGLE PLANE ⑦

TRIANGLE NOSE ⑧

STRONG MUZZLE ⑨

⑩ MOUTH DOES NOT GO FAR BACK IN SNOUT

example 3

HIGH CROWN ①

SMALL EYES ON SIDES, WHERE BROW MEETS SNOUT ③

NOSTRILS FAR APART, STICK OUT ②

FLAT CHEEKS DROOP DOWN ④

OVERHANGING UPPER LIP ⑤

EARS STICK OUT TO SIDES ⑥

FAIRLY SMALL MOUTH, ALMOST NO CHIN ⑦

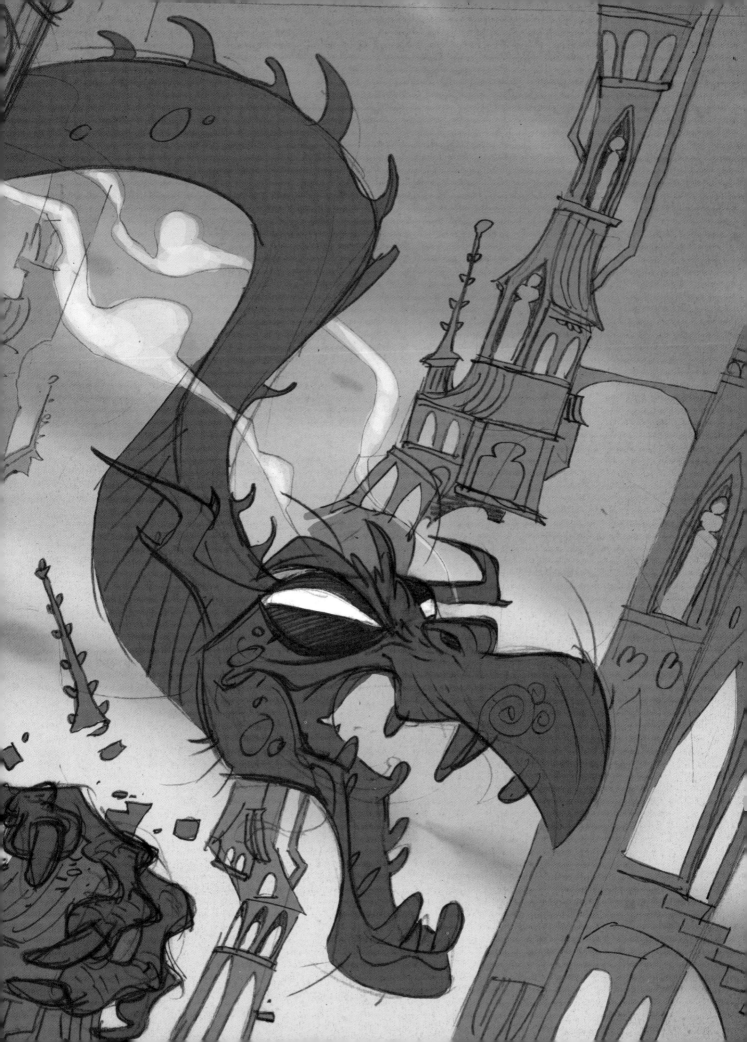

ANCIENT BEASTS

FANTASY STRIVES TO RESTORE THE "NATURAL" ORDER OF THE WORLD; TALKING ANIMALS AND WALKING TREES HELP ADVENTURERS, WHILE CURSES CAN BLIGHT THE LAND WITH ETERNAL WINTERS THAT ONLY A MORTAL HERO CAN UNDO. BUT THE DESTRUCTIVE SIDE OF NATURE IS UNLEASHED IN NATURAL FORMS THAT ARE CORRUPTED; HIDEOUS WEREWOLVES AND GHOUL-FILLED FORESTS... AND THE NIGHTMARISH LORDS OF CREATION AND DESTRUCTION, THE ANCIENT DRAGONS.

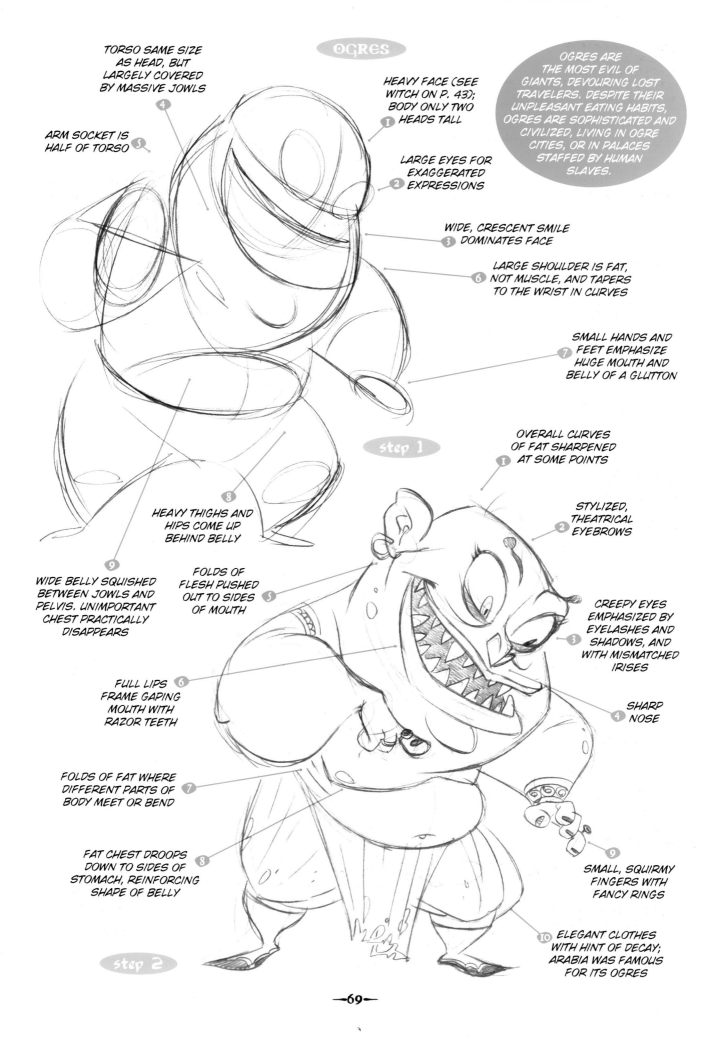

OGRES

OGRES ARE THE MOST EVIL OF GIANTS, DEVOURING LOST TRAVELERS. DESPITE THEIR UNPLEASANT EATING HABITS, OGRES ARE SOPHISTICATED AND CIVILIZED, LIVING IN OGRE CITIES, OR IN PALACES STAFFED BY HUMAN SLAVES.

TORSO SAME SIZE AS HEAD, BUT LARGELY COVERED BY MASSIVE JOWLS
4

ARM SOCKET IS HALF OF TORSO
5

HEAVY FACE (SEE WITCH ON P. 43); BODY ONLY TWO HEADS TALL
1

LARGE EYES FOR EXAGGERATED EXPRESSIONS
2

WIDE, CRESCENT SMILE DOMINATES FACE
3

LARGE SHOULDER IS FAT, NOT MUSCLE, AND TAPERS TO THE WRIST IN CURVES
6

SMALL HANDS AND FEET EMPHASIZE HUGE MOUTH AND BELLY OF A GLUTTON
7

step 1

OVERALL CURVES OF FAT SHARPENED AT SOME POINTS
1

STYLIZED, THEATRICAL EYEBROWS
2

HEAVY THIGHS AND HIPS COME UP BEHIND BELLY
8

WIDE BELLY SQUISHED BETWEEN JOWLS AND PELVIS. UNIMPORTANT CHEST PRACTICALLY DISAPPEARS
9

FOLDS OF FLESH PUSHED OUT TO SIDES OF MOUTH
5

CREEPY EYES EMPHASIZED BY EYELASHES AND SHADOWS, AND WITH MISMATCHED IRISES
3

SHARP NOSE
4

FULL LIPS FRAME GAPING MOUTH WITH RAZOR TEETH
6

FOLDS OF FAT WHERE DIFFERENT PARTS OF BODY MEET OR BEND
7

FAT CHEST DROOPS DOWN TO SIDES OF STOMACH, REINFORCING SHAPE OF BELLY
8

SMALL, SQUIRMY FINGERS WITH FANCY RINGS
9

ELEGANT CLOTHES WITH HINT OF DECAY; ARABIA WAS FAMOUS FOR ITS OGRES
10

step 2

ANIMAL BODIES AND PERSONALITY

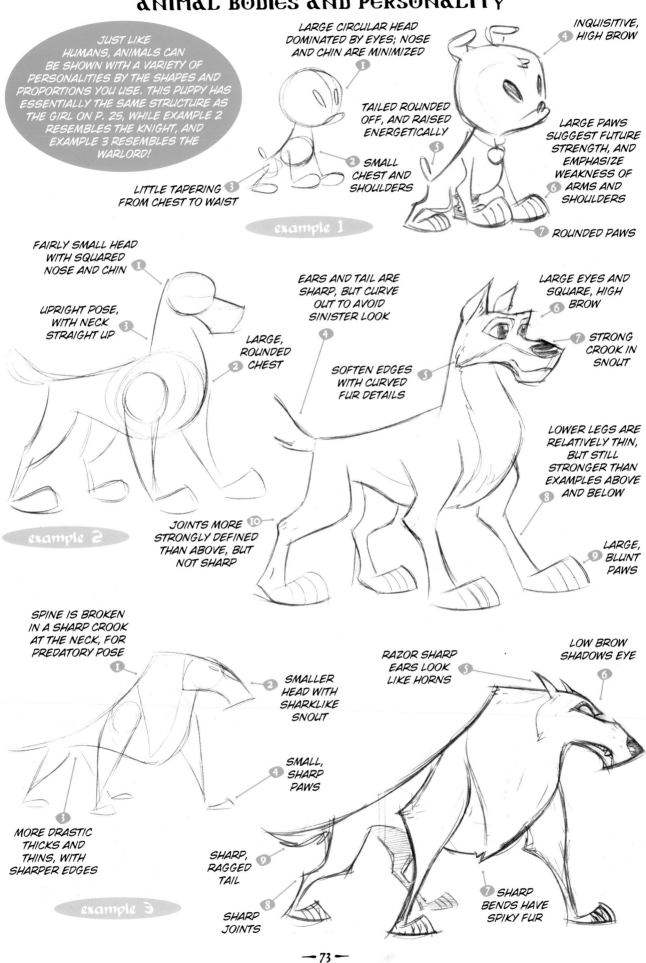

JUST LIKE HUMANS, ANIMALS CAN BE SHOWN WITH A VARIETY OF PERSONALITIES BY THE SHAPES AND PROPORTIONS YOU USE. THIS PUPPY HAS ESSENTIALLY THE SAME STRUCTURE AS THE GIRL ON P. 25, WHILE EXAMPLE 2 RESEMBLES THE KNIGHT, AND EXAMPLE 3 RESEMBLES THE WARLORD!

LARGE CIRCULAR HEAD DOMINATED BY EYES; NOSE AND CHIN ARE MINIMIZED — 1

INQUISITIVE, HIGH BROW — 4

TAILED ROUNDED OFF, AND RAISED ENERGETICALLY — 5

LARGE PAWS SUGGEST FUTURE STRENGTH, AND EMPHASIZE WEAKNESS OF ARMS AND SHOULDERS — 6

ROUNDED PAWS — 7

SMALL CHEST AND SHOULDERS — 2

LITTLE TAPERING FROM CHEST TO WAIST — 3

example 1

FAIRLY SMALL HEAD WITH SQUARED NOSE AND CHIN — 1

UPRIGHT POSE, WITH NECK STRAIGHT UP — 3

LARGE, ROUNDED CHEST — 2

EARS AND TAIL ARE SHARP, BUT CURVE OUT TO AVOID SINISTER LOOK — 4

SOFTEN EDGES WITH CURVED FUR DETAILS — 5

LARGE EYES AND SQUARE, HIGH BROW — 6

STRONG CROOK IN SNOUT — 7

LOWER LEGS ARE RELATIVELY THIN, BUT STILL STRONGER THAN EXAMPLES ABOVE AND BELOW — 8

LARGE, BLUNT PAWS — 9

JOINTS MORE STRONGLY DEFINED THAN ABOVE, BUT NOT SHARP — 10

example 2

SPINE IS BROKEN IN A SHARP CROOK AT THE NECK, FOR PREDATORY POSE — 1

SMALLER HEAD WITH SHARKLIKE SNOUT — 2

MORE DRASTIC THICKS AND THINS, WITH SHARPER EDGES — 3

SMALL, SHARP PAWS — 4

RAZOR SHARP EARS LOOK LIKE HORNS — 5

LOW BROW SHADOWS EYE — 6

SHARP BENDS HAVE SPIKY FUR — 7

SHARP, RAGGED TAIL — 9

SHARP JOINTS — 8

example 3

WOODLAND CRITTERS

LET'S START WITH SOME RELATIVELY SIMPLE ANIMALS: SQUIRRELS, RABBITS, AND OTHER WOODLAND CRITTERS. THEY OFTEN HAVE PLAYFUL, CHILDLIKE PERSONALITIES AND THEY AID WANDERERS, DRUIDS, AND FAERIES.

GENERALLY THESE ANIMALS ARE ABOUT SPEED AND WARINESS, RATHER THAN STRENGTH. MINIMIZE CHEST AND SHOULDERS, AND EMPHASIZE THE HEAD AND ESPECIALLY THE WIDE, ALERT EYES.

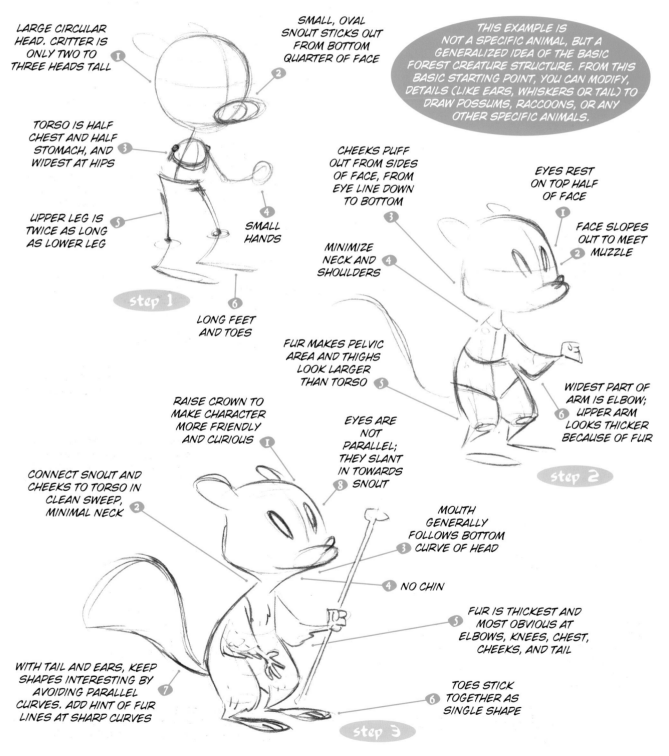

LARGE CIRCULAR HEAD. CRITTER IS ONLY TWO TO THREE HEADS TALL

SMALL, OVAL SNOUT STICKS OUT FROM BOTTOM QUARTER OF FACE

THIS EXAMPLE IS NOT A SPECIFIC ANIMAL, BUT A GENERALIZED IDEA OF THE BASIC FOREST CREATURE STRUCTURE. FROM THIS BASIC STARTING POINT, YOU CAN MODIFY, DETAILS (LIKE EARS, WHISKERS OR TAIL) TO DRAW POSSUMS, RACCOONS, OR ANY OTHER SPECIFIC ANIMALS.

TORSO IS HALF CHEST AND HALF STOMACH, AND WIDEST AT HIPS

CHEEKS PUFF OUT FROM SIDES OF FACE, FROM EYE LINE DOWN TO BOTTOM

EYES REST ON TOP HALF OF FACE

FACE SLOPES OUT TO MEET MUZZLE

UPPER LEG IS TWICE AS LONG AS LOWER LEG

MINIMIZE NECK AND SHOULDERS

SMALL HANDS

step 1

LONG FEET AND TOES

FUR MAKES PELVIC AREA AND THIGHS LOOK LARGER THAN TORSO

WIDEST PART OF ARM IS ELBOW; UPPER ARM LOOKS THICKER BECAUSE OF FUR

RAISE CROWN TO MAKE CHARACTER MORE FRIENDLY AND CURIOUS

EYES ARE NOT PARALLEL; THEY SLANT IN TOWARDS SNOUT

MOUTH GENERALLY FOLLOWS BOTTOM CURVE OF HEAD

step 2

CONNECT SNOUT AND CHEEKS TO TORSO IN CLEAN SWEEP, MINIMAL NECK

NO CHIN

FUR IS THICKEST AND MOST OBVIOUS AT ELBOWS, KNEES, CHEST, CHEEKS, AND TAIL

WITH TAIL AND EARS, KEEP SHAPES INTERESTING BY AVOIDING PARALLEL CURVES. ADD HINT OF FUR LINES AT SHARP CURVES

TOES STICK TOGETHER AS SINGLE SHAPE

step 3

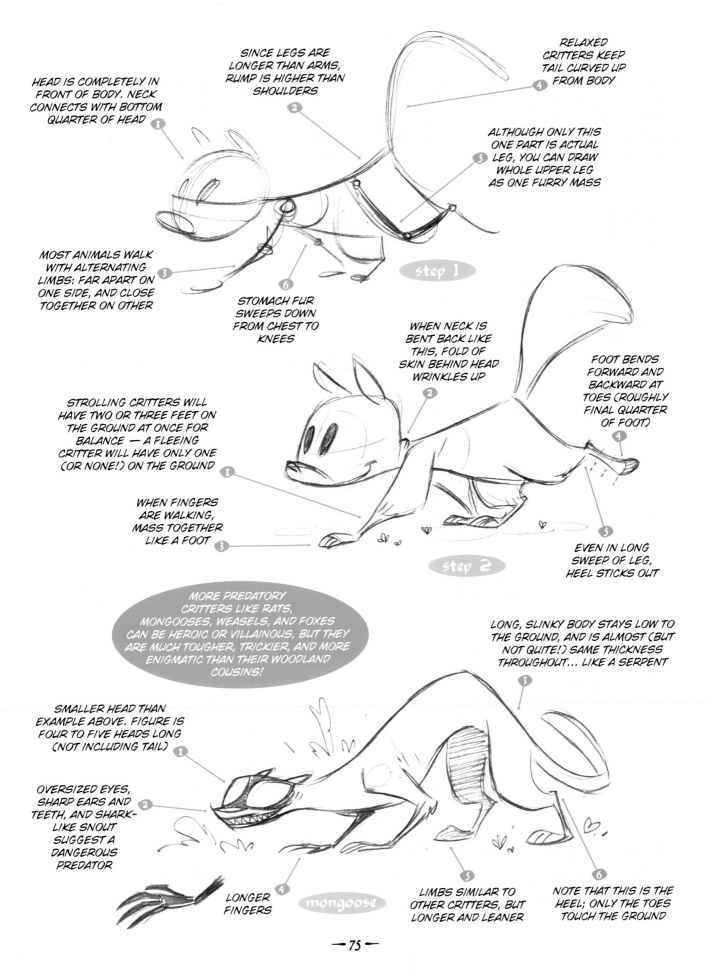

HEAD IS COMPLETELY IN FRONT OF BODY. NECK CONNECTS WITH BOTTOM QUARTER OF HEAD ①

SINCE LEGS ARE LONGER THAN ARMS, RUMP IS HIGHER THAN SHOULDERS ②

RELAXED CRITTERS KEEP TAIL CURVED UP FROM BODY ④

ALTHOUGH ONLY THIS ONE PART IS ACTUAL LEG, YOU CAN DRAW WHOLE UPPER LEG AS ONE FURRY MASS ⑤

MOST ANIMALS WALK WITH ALTERNATING LIMBS: FAR APART ON ONE SIDE, AND CLOSE TOGETHER ON OTHER ③

STOMACH FUR SWEEPS DOWN FROM CHEST TO KNEES ⑥

step 1

WHEN NECK IS BENT BACK LIKE THIS, FOLD OF SKIN BEHIND HEAD WRINKLES UP ②

FOOT BENDS FORWARD AND BACKWARD AT TOES (ROUGHLY FINAL QUARTER OF FOOT) ④

STROLLING CRITTERS WILL HAVE TWO OR THREE FEET ON THE GROUND AT ONCE FOR BALANCE — A FLEEING CRITTER WILL HAVE ONLY ONE (OR NONE!) ON THE GROUND ①

WHEN FINGERS ARE WALKING, MASS TOGETHER LIKE A FOOT ③

EVEN IN LONG SWEEP OF LEG, HEEL STICKS OUT ⑤

step 2

MORE PREDATORY CRITTERS LIKE RATS, MONGOOSES, WEASELS, AND FOXES CAN BE HEROIC OR VILLAINOUS, BUT THEY ARE MUCH TOUGHER, TRICKIER, AND MORE ENIGMATIC THAN THEIR WOODLAND COUSINS!

LONG, SLINKY BODY STAYS LOW TO THE GROUND, AND IS ALMOST (BUT NOT QUITE!) SAME THICKNESS THROUGHOUT... LIKE A SERPENT ③

SMALLER HEAD THAN EXAMPLE ABOVE. FIGURE IS FOUR TO FIVE HEADS LONG (NOT INCLUDING TAIL) ①

OVERSIZED EYES, SHARP EARS AND TEETH, AND SHARK-LIKE SNOUT SUGGEST A DANGEROUS PREDATOR ②

LONGER FINGERS ④

mongoose

LIMBS SIMILAR TO OTHER CRITTERS, BUT LONGER AND LEANER ⑤

NOTE THAT THIS IS THE HEEL; ONLY THE TOES TOUCH THE GROUND ⑥

FELINES

RANGING FROM ALLEY CATS TO REGAL LIONS, FELINES ARE LONGER, SLINKIER, AND MORE POWERFUL THAN WOODLAND CRITTERS.

GENERALLY, FELINES ARE MORE CURVY THAN THEIR CANINE RELATIVES, ALTHOUGH THE LARGER CATS ARE MORE POWERFULLY BUILT!

FELINE HEAD

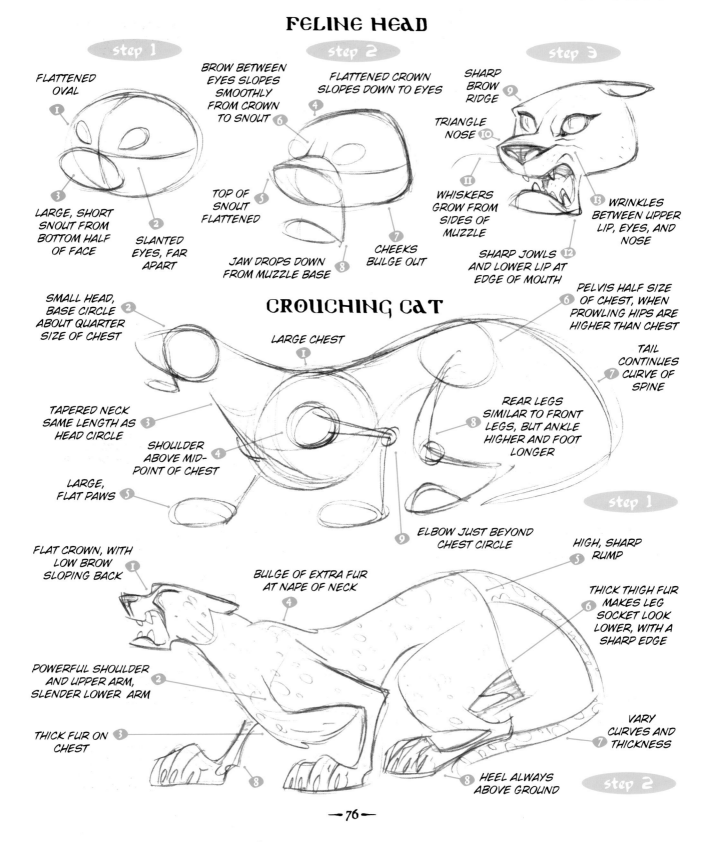

step 1

FLATTENED OVAL

LARGE, SHORT SNOUT FROM BOTTOM HALF OF FACE

SLANTED EYES, FAR APART

step 2

BROW BETWEEN EYES SLOPES SMOOTHLY FROM CROWN TO SNOUT

FLATTENED CROWN SLOPES DOWN TO EYES

TOP OF SNOUT FLATTENED

JAW DROPS DOWN FROM MUZZLE BASE

CHEEKS BULGE OUT

step 3

SHARP BROW RIDGE

TRIANGLE NOSE

WHISKERS GROW FROM SIDES OF MUZZLE

SHARP JOWLS AND LOWER LIP AT EDGE OF MOUTH

WRINKLES BETWEEN UPPER LIP, EYES, AND NOSE

CROUCHING CAT

SMALL HEAD, BASE CIRCLE ABOUT QUARTER SIZE OF CHEST

LARGE CHEST

PELVIS HALF SIZE OF CHEST, WHEN PROWLING HIPS ARE HIGHER THAN CHEST

TAIL CONTINUES CURVE OF SPINE

TAPERED NECK SAME LENGTH AS HEAD CIRCLE

SHOULDER ABOVE MID-POINT OF CHEST

REAR LEGS SIMILAR TO FRONT LEGS, BUT ANKLE HIGHER AND FOOT LONGER

LARGE, FLAT PAWS

ELBOW JUST BEYOND CHEST CIRCLE

step 1

FLAT CROWN, WITH LOW BROW SLOPING BACK

BULGE OF EXTRA FUR AT NAPE OF NECK

HIGH, SHARP RUMP

THICK THIGH FUR MAKES LEG SOCKET LOOK LOWER, WITH A SHARP EDGE

POWERFUL SHOULDER AND UPPER ARM, SLENDER LOWER ARM

THICK FUR ON CHEST

VARY CURVES AND THICKNESS

HEEL ALWAYS ABOVE GROUND

step 2

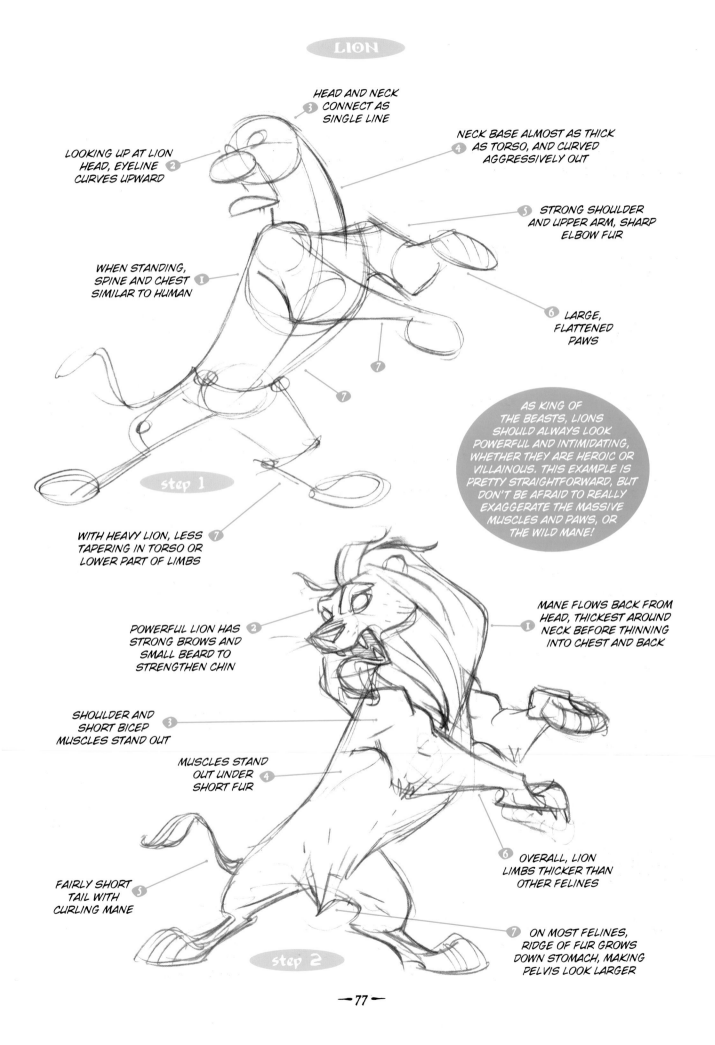

HEAD AND NECK
CONNECT AS
SINGLE LINE

3

LOOKING UP AT LION
HEAD, EYELINE
CURVES UPWARD
2

NECK BASE ALMOST AS THICK
AS TORSO, AND CURVED
AGGRESSIVELY OUT
4

STRONG SHOULDER
AND UPPER ARM, SHARP
ELBOW FUR
5

WHEN STANDING,
SPINE AND CHEST
SIMILAR TO HUMAN
1

LARGE,
FLATTENED
PAWS
6

7

7

AS KING OF
THE BEASTS, LIONS
SHOULD ALWAYS LOOK
POWERFUL AND INTIMIDATING,
WHETHER THEY ARE HEROIC OR
VILLAINOUS. THIS EXAMPLE IS
PRETTY STRAIGHTFORWARD, BUT
DON'T BE AFRAID TO REALLY
EXAGGERATE THE MASSIVE
MUSCLES AND PAWS, OR
THE WILD MANE!

step 1

WITH HEAVY LION, LESS
TAPERING IN TORSO OR
LOWER PART OF LIMBS
7

POWERFUL LION HAS
STRONG BROWS AND
SMALL BEARD TO
STRENGTHEN CHIN
2

MANE FLOWS BACK FROM
HEAD, THICKEST AROUND
NECK BEFORE THINNING
INTO CHEST AND BACK
1

SHOULDER AND
SHORT BICEP
MUSCLES STAND OUT
3

MUSCLES STAND
OUT UNDER
SHORT FUR
4

FAIRLY SHORT
TAIL WITH
CURLING MANE
5

OVERALL, LION
LIMBS THICKER THAN
OTHER FELINES
6

ON MOST FELINES,
RIDGE OF FUR GROWS
DOWN STOMACH, MAKING
PELVIS LOOK LARGER
7

step 2

—77—

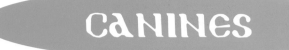

CANINES

CANINES — DOGS, WOLVES AND THE LIKE — ARE ROUGHLY SIMILAR TO FELINES, BUT ARE GENERALLY MORE ANGULAR, WITH LONGER HEADS AND STRONGLY TAPERED TORSOS.
WHILE THERE ARE A WIDE VARIETY OF CANINES, FANTASY TENDS TO FAVOR HOUNDS AND WOLVES. HERE ARE NOTES ON A WOLFLIKE CANINE, PERHAPS A WEREWOLF WITH TRACES OF ITS HUMAN SELF.

WOLVES AND WEREWOLVES ARE DANGEROUS, BUT NOT ALWAYS EVIL. ANCIENT VIKING WARRIORS WERE SUPPOSED TO TAKE ON WOLF FORM IN BATTLE, AND IN 1692 A BALTIC FARMER CLAIMED THAT HE AND FELLOW WEREWOLVES WERE ENGAGED IN A GREAT WAR WITH EVIL WITCHES!

CANINE HEAD

RUNNING WEREWOLF

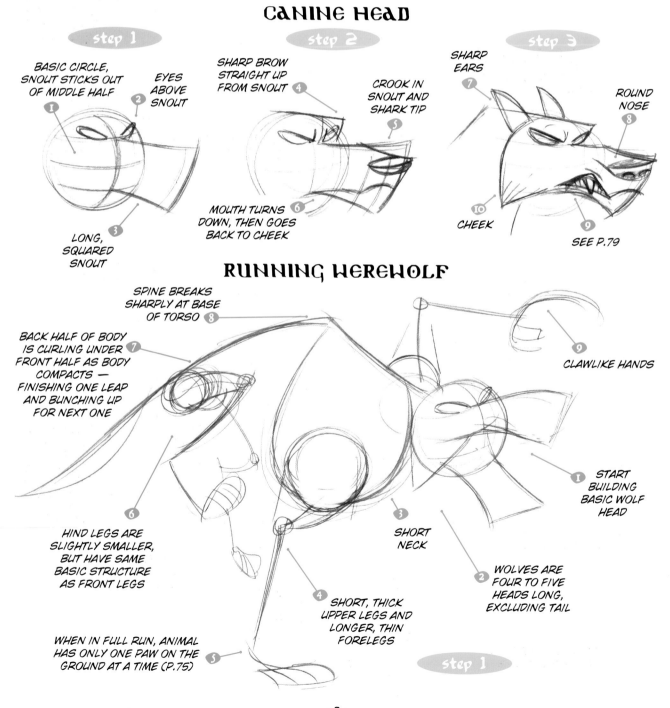

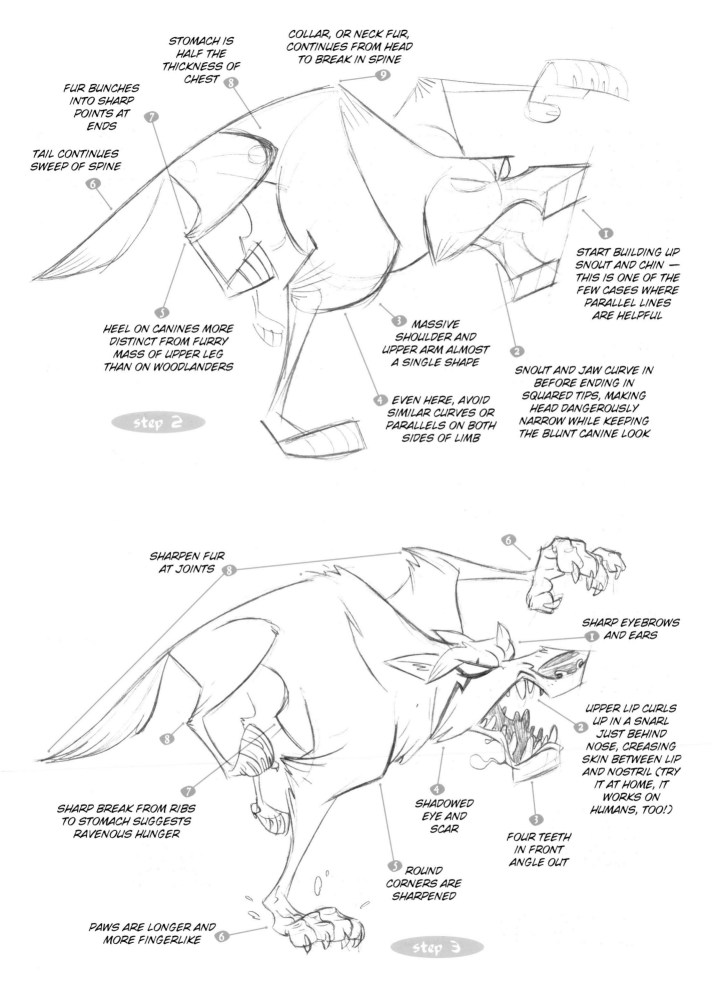

STOMACH IS HALF THE THICKNESS OF CHEST **8**

COLLAR, OR NECK FUR, CONTINUES FROM HEAD TO BREAK IN SPINE **9**

FUR BUNCHES INTO SHARP POINTS AT ENDS **7**

TAIL CONTINUES SWEEP OF SPINE **6**

START BUILDING UP SNOUT AND CHIN — THIS IS ONE OF THE FEW CASES WHERE PARALLEL LINES ARE HELPFUL **1**

5 HEEL ON CANINES MORE DISTINCT FROM FURRY MASS OF UPPER LEG THAN ON WOODLANDERS

3 MASSIVE SHOULDER AND UPPER ARM ALMOST A SINGLE SHAPE

2 SNOUT AND JAW CURVE IN BEFORE ENDING IN SQUARED TIPS, MAKING HEAD DANGEROUSLY NARROW WHILE KEEPING THE BLUNT CANINE LOOK

4 EVEN HERE, AVOID SIMILAR CURVES OR PARALLELS ON BOTH SIDES OF LIMB

step 2

SHARPEN FUR AT JOINTS **8**

6

SHARP EYEBROWS AND EARS **1**

8

UPPER LIP CURLS UP IN A SNARL JUST BEHIND NOSE, CREASING SKIN BETWEEN LIP AND NOSTRIL (TRY IT AT HOME, IT WORKS ON HUMANS, TOO!) **2**

7

SHARP BREAK FROM RIBS TO STOMACH SUGGESTS RAVENOUS HUNGER

4 SHADOWED EYE AND SCAR

FOUR TEETH IN FRONT ANGLE OUT **3**

5 ROUND CORNERS ARE SHARPENED

PAWS ARE LONGER AND MORE FINGERLIKE **6**

step 3

HORSES

AS BOTH THE MAIN SOURCE OF TRANS-PORTATION AND THE MOST POWERFUL WEAPON IN ANY FANTASY ARMY, THE HORSE IS ONE OF THE MOST IMPORTANT AND UNDERAPPRECIATED ANIMALS.

THEIR COMBINATION OF STRENGTH AND GRACE MAKE HORSES DIFFICULT TO DRAW, ESPECIALLY IN ACTION. A FAIRLY TYPICAL HORSE HAS THE FOLLOWING PROPORTIONS:

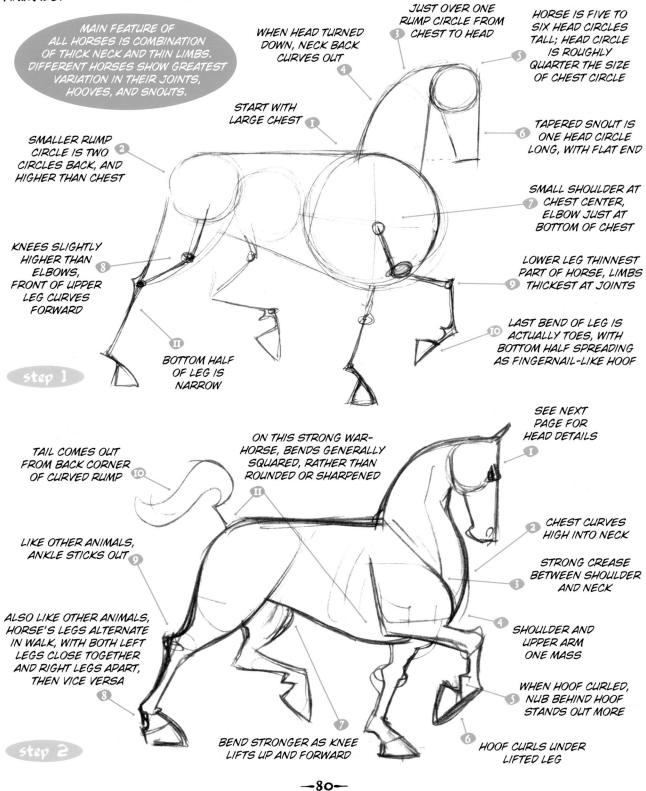

MAIN FEATURE OF ALL HORSES IS COMBINATION OF THICK NECK AND THIN LIMBS. DIFFERENT HORSES SHOW GREATEST VARIATION IN THEIR JOINTS, HOOVES, AND SNOUTS.

WHEN HEAD TURNED DOWN, NECK BACK CURVES OUT

JUST OVER ONE RUMP CIRCLE FROM CHEST TO HEAD

HORSE IS FIVE TO SIX HEAD CIRCLES TALL; HEAD CIRCLE IS ROUGHLY QUARTER THE SIZE OF CHEST CIRCLE

START WITH LARGE CHEST

TAPERED SNOUT IS ONE HEAD CIRCLE LONG, WITH FLAT END

SMALLER RUMP CIRCLE IS TWO CIRCLES BACK, AND HIGHER THAN CHEST

SMALL SHOULDER AT CHEST CENTER, ELBOW JUST AT BOTTOM OF CHEST

KNEES SLIGHTLY HIGHER THAN ELBOWS, FRONT OF UPPER LEG CURVES FORWARD

LOWER LEG THINNEST PART OF HORSE, LIMBS THICKEST AT JOINTS

LAST BEND OF LEG IS ACTUALLY TOES, WITH BOTTOM HALF SPREADING AS FINGERNAIL-LIKE HOOF

BOTTOM HALF OF LEG IS NARROW

step 1

TAIL COMES OUT FROM BACK CORNER OF CURVED RUMP

ON THIS STRONG WAR-HORSE, BENDS GENERALLY SQUARED, RATHER THAN ROUNDED OR SHARPENED

SEE NEXT PAGE FOR HEAD DETAILS

LIKE OTHER ANIMALS, ANKLE STICKS OUT

CHEST CURVES HIGH INTO NECK

STRONG CREASE BETWEEN SHOULDER AND NECK

ALSO LIKE OTHER ANIMALS, HORSE'S LEGS ALTERNATE IN WALK, WITH BOTH LEFT LEGS CLOSE TOGETHER AND RIGHT LEGS APART, THEN VICE VERSA

SHOULDER AND UPPER ARM ONE MASS

WHEN HOOF CURLED, NUB BEHIND HOOF STANDS OUT MORE

BEND STRONGER AS KNEE LIFTS UP AND FORWARD

HOOF CURLS UNDER LIFTED LEG

step 2

THE HORSE HEAD

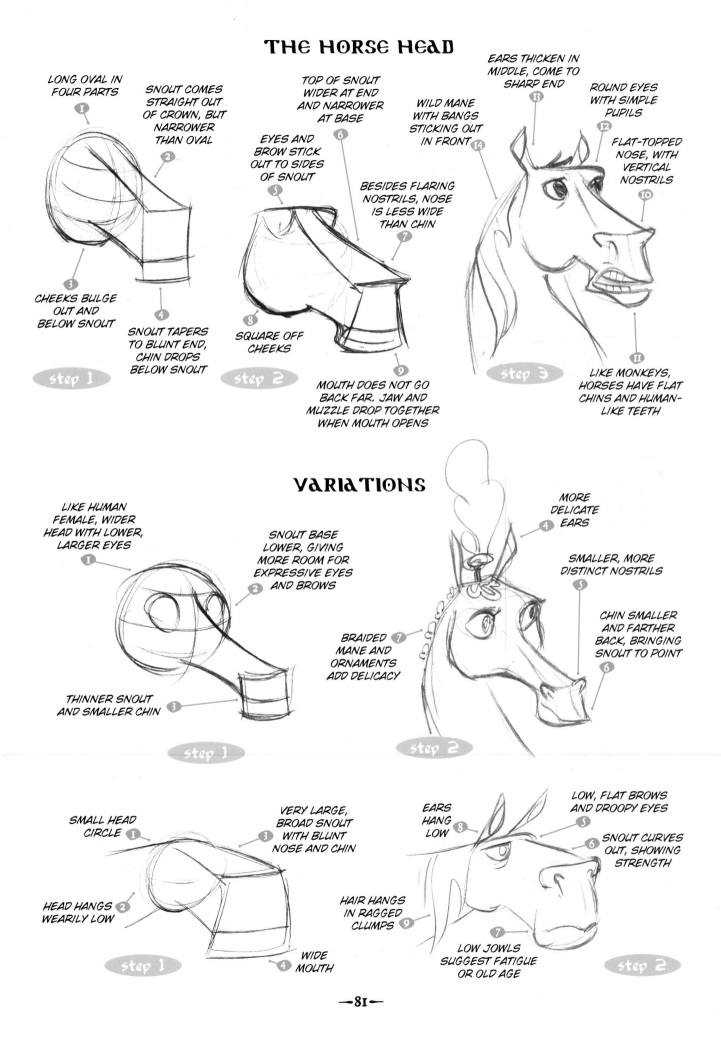

LONG OVAL IN FOUR PARTS ①

SNOUT COMES STRAIGHT OUT OF CROWN, BUT NARROWER THAN OVAL ②

CHEEKS BULGE OUT AND BELOW SNOUT ③

SNOUT TAPERS TO BLUNT END, CHIN DROPS BELOW SNOUT ④

step 1

TOP OF SNOUT WIDER AT END AND NARROWER AT BASE ⑥

EYES AND BROW STICK OUT TO SIDES OF SNOUT ⑤

BESIDES FLARING NOSTRILS, NOSE IS LESS WIDE THAN CHIN ⑦

SQUARE OFF CHEEKS ⑧

MOUTH DOES NOT GO BACK FAR. JAW AND MUZZLE DROP TOGETHER WHEN MOUTH OPENS ⑨

step 2

EARS THICKEN IN MIDDLE, COME TO SHARP END ⑬

WILD MANE WITH BANGS STICKING OUT IN FRONT ⑭

ROUND EYES WITH SIMPLE PUPILS ⑫

FLAT-TOPPED NOSE, WITH VERTICAL NOSTRILS ⑩

LIKE MONKEYS, HORSES HAVE FLAT CHINS AND HUMAN-LIKE TEETH ⑪

step 3

VARIATIONS

LIKE HUMAN FEMALE, WIDER HEAD WITH LOWER, LARGER EYES ①

SNOUT BASE LOWER, GIVING MORE ROOM FOR EXPRESSIVE EYES AND BROWS ②

THINNER SNOUT AND SMALLER CHIN ③

step 1

MORE DELICATE EARS ④

SMALLER, MORE DISTINCT NOSTRILS ⑤

CHIN SMALLER AND FARTHER BACK, BRINGING SNOUT TO POINT ⑥

BRAIDED MANE AND ORNAMENTS ADD DELICACY ⑦

step 2

SMALL HEAD CIRCLE ①

VERY LARGE, BROAD SNOUT WITH BLUNT NOSE AND CHIN ③

HEAD HANGS WEARILY LOW ②

WIDE MOUTH ④

step 1

EARS HANG LOW ⑧

LOW, FLAT BROWS AND DROOPY EYES ⑤

SNOUT CURVES OUT, SHOWING STRENGTH ⑥

HAIR HANGS IN RAGGED CLUMPS ⑨

LOW JOWLS SUGGEST FATIGUE OR OLD AGE ⑦

step 2

THE HORSE IN ACTION

SMALL, NARROW MARE'S HEAD ②

NECK STRAINS FORWARD IN MOTION, BACK OF NECK LESS CURVED ③

SMALLER, HIGHER RUMP ④

SLIGHTLY MORE THREE-DIMENSIONAL VIEW OF HORSE, SEEING CHEST AND OTHER "CIRCLES" AT AN ANGLE ①

step 1

walk

WALKING HORSE HAS SAME ALTERNATING LEG MOVEMENT AS OTHER ANIMALS, BUT GALLOPING HORSE HAS ECHOING LEG MOVEMENTS; FRONT LEFT, FRONT RIGHT, REAR LEFT, REAR RIGHT

WHEN NECK EXTENDED, NECK AND HEAD AS LONG AS BODY ①

IN GALLOP, BOTH RIGHT LEGS LEAD BEFORE BOTH LEFT LEGS, AND VICE VERSA ②

ON EACH SIDE OF CHEST, SHOULDER COMES DOWN FROM BOTTOM FRONT QUARTER ③

HEEL STANDS OUT MORE ON BENT LEGS ④

ONLY ONE HOOF TOUCHING (OR ALMOST TOUCHING) GROUND ⑤

gallop

step 2

THIS IS ACTUALLY THE MOST FAMOUS HORSE POSE IN HISTORY, BASED ON ANCIENT CHINESE STATUES.*

LEANING FORWARD TO NECK SHOWS URGENCY ⑦

A GOOD RIDER KEEPS SPINE STRAIGHT, AND GRIPS HORSE'S SIDES WITH KNEES ⑥

LONG TAIL SWEEPS BACK TO EMPHASIZE HORIZONTAL MOTION ⑤

REINS ARE HELD IN HORSE'S MOUTH, AND COME OUT ON EITHER SIDE ①

SHOULDER CREASES MOST CLEAR WHEN LEGS LIFTED ②

FRONT LEGS IN SIMILAR POSES, BUT NOT PARALLEL ③

KEEP TIPS SHARP AND STRAIGHT, AND KEEP LEGS SLENDER, TO ADD GRACE AND MOTION ④

step 3

*SHANG DYNASTY BRONZE SCULPTURES, IF YOU REALLY WANT TO KNOW.

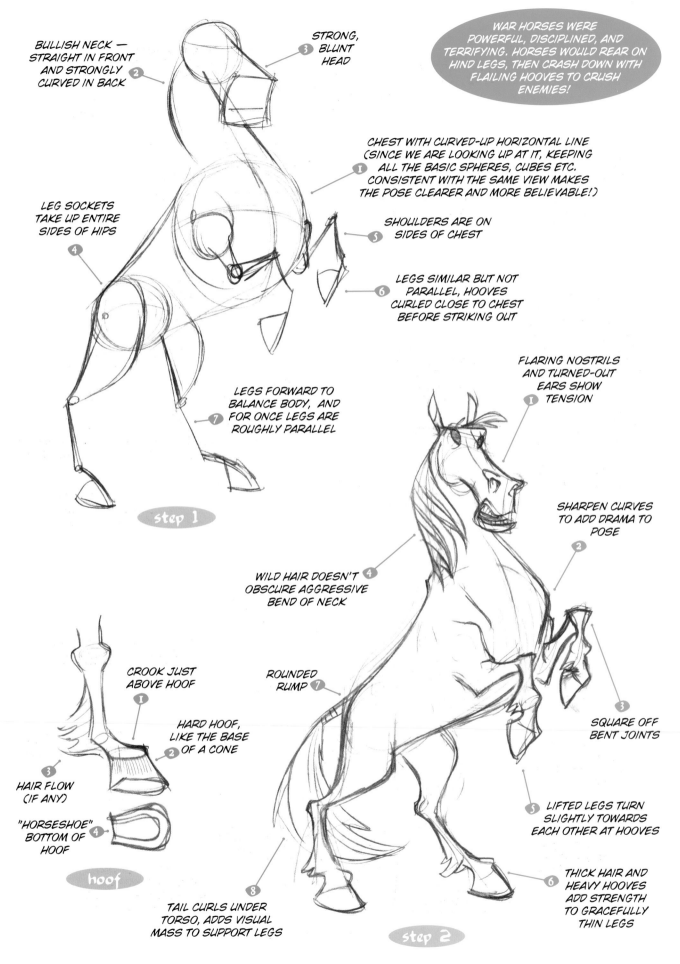

BULLISH NECK — STRAIGHT IN FRONT AND STRONGLY CURVED IN BACK **②**

STRONG, BLUNT HEAD **③**

WAR HORSES WERE POWERFUL, DISCIPLINED, AND TERRIFYING. HORSES WOULD REAR ON HIND LEGS, THEN CRASH DOWN WITH FLAILING HOOVES TO CRUSH ENEMIES!

CHEST WITH CURVED-UP HORIZONTAL LINE (SINCE WE ARE LOOKING UP AT IT, KEEPING ALL THE BASIC SPHERES, CUBES ETC. CONSISTENT WITH THE SAME VIEW MAKES THE POSE CLEARER AND MORE BELIEVABLE!) **①**

LEG SOCKETS TAKE UP ENTIRE SIDES OF HIPS **④**

SHOULDERS ARE ON SIDES OF CHEST **⑤**

LEGS SIMILAR BUT NOT PARALLEL, HOOVES CURLED CLOSE TO CHEST BEFORE STRIKING OUT **⑥**

FLARING NOSTRILS AND TURNED-OUT EARS SHOW TENSION **①**

LEGS FORWARD TO BALANCE BODY, AND FOR ONCE LEGS ARE ROUGHLY PARALLEL **⑦**

SHARPEN CURVES TO ADD DRAMA TO POSE **②**

step 1

WILD HAIR DOESN'T OBSCURE AGGRESSIVE BEND OF NECK **④**

CROOK JUST ABOVE HOOF **①**

ROUNDED RUMP **⑦**

HARD HOOF, LIKE THE BASE OF A CONE **②**

HAIR FLOW (IF ANY) **③**

SQUARE OFF BENT JOINTS **③**

"HORSESHOE" BOTTOM OF HOOF **④**

LIFTED LEGS TURN SLIGHTLY TOWARDS EACH OTHER AT HOOVES **⑤**

hoof

THICK HAIR AND HEAVY HOOVES ADD STRENGTH TO GRACEFULLY THIN LEGS **⑥**

TAIL CURLS UNDER TORSO, ADDS VISUAL MASS TO SUPPORT LEGS **⑧**

step 2

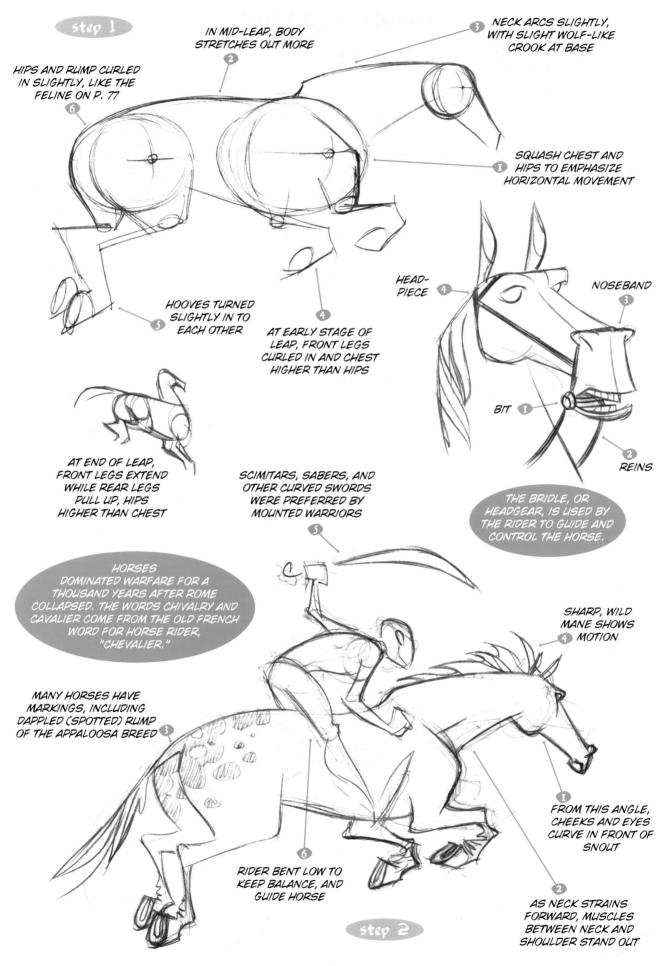

IN MID-LEAP, BODY STRETCHES OUT MORE

2

NECK ARCS SLIGHTLY, WITH SLIGHT WOLF-LIKE CROOK AT BASE

3

HIPS AND RUMP CURLED IN SLIGHTLY, LIKE THE FELINE ON P. 77

6

SQUASH CHEST AND HIPS TO EMPHASIZE HORIZONTAL MOVEMENT

1

HOOVES TURNED SLIGHTLY IN TO EACH OTHER

5

AT EARLY STAGE OF LEAP, FRONT LEGS CURLED IN AND CHEST HIGHER THAN HIPS

4

HEAD-PIECE

4

NOSEBAND

3

BIT

1

REINS

2

AT END OF LEAP, FRONT LEGS EXTEND WHILE REAR LEGS PULL UP, HIPS HIGHER THAN CHEST

SCIMITARS, SABERS, AND OTHER CURVED SWORDS WERE PREFERRED BY MOUNTED WARRIORS

5

THE BRIDLE, OR HEADGEAR, IS USED BY THE RIDER TO GUIDE AND CONTROL THE HORSE.

HORSES DOMINATED WARFARE FOR A THOUSAND YEARS AFTER ROME COLLAPSED. THE WORDS CHIVALRY AND CAVALIER COME FROM THE OLD FRENCH WORD FOR HORSE RIDER, "CHEVALIER."

SHARP, WILD MANE SHOWS MOTION

4

MANY HORSES HAVE MARKINGS, INCLUDING DAPPLED (SPOTTED) RUMP OF THE APPALOOSA BREED

3

1

FROM THIS ANGLE, CHEEKS AND EYES CURVE IN FRONT OF SNOUT

6

RIDER BENT LOW TO KEEP BALANCE, AND GUIDE HORSE

2

AS NECK STRAINS FORWARD, MUSCLES BETWEEN NECK AND SHOULDER STAND OUT

HORSING AROUND

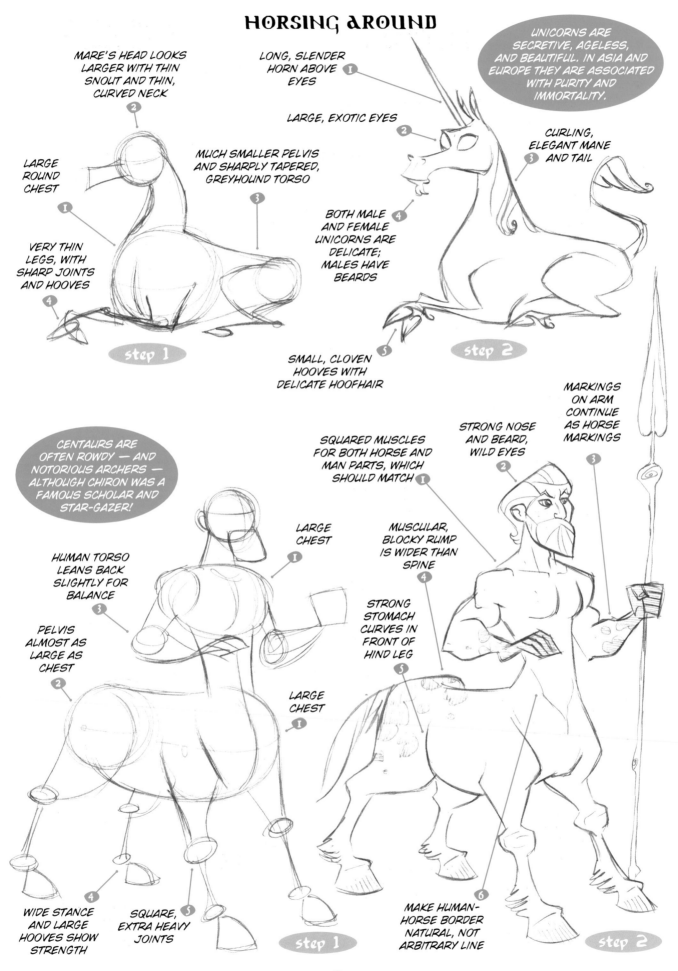

MARE'S HEAD LOOKS LARGER WITH THIN SNOUT AND THIN, CURVED NECK

LONG, SLENDER HORN ABOVE EYES

UNICORNS ARE SECRETIVE, AGELESS, AND BEAUTIFUL. IN ASIA AND EUROPE THEY ARE ASSOCIATED WITH PURITY AND IMMORTALITY.

LARGE ROUND CHEST

MUCH SMALLER PELVIS AND SHARPLY TAPERED, GREYHOUND TORSO

LARGE, EXOTIC EYES

CURLING, ELEGANT MANE AND TAIL

VERY THIN LEGS, WITH SHARP JOINTS AND HOOVES

BOTH MALE AND FEMALE UNICORNS ARE DELICATE; MALES HAVE BEARDS

step 1

SMALL, CLOVEN HOOVES WITH DELICATE HOOFHAIR

step 2

CENTAURS ARE OFTEN ROWDY — AND NOTORIOUS ARCHERS — ALTHOUGH CHIRON WAS A FAMOUS SCHOLAR AND STAR-GAZER!

SQUARED MUSCLES FOR BOTH HORSE AND MAN PARTS, WHICH SHOULD MATCH

STRONG NOSE AND BEARD, WILD EYES

MARKINGS ON ARM CONTINUE AS HORSE MARKINGS

LARGE CHEST

HUMAN TORSO LEANS BACK SLIGHTLY FOR BALANCE

MUSCULAR, BLOCKY RUMP IS WIDER THAN SPINE

PELVIS ALMOST AS LARGE AS CHEST

STRONG STOMACH CURVES IN FRONT OF HIND LEG

LARGE CHEST

WIDE STANCE AND LARGE HOOVES SHOW STRENGTH

SQUARE, EXTRA HEAVY JOINTS

MAKE HUMAN-HORSE BORDER NATURAL, NOT ARBITRARY LINE

step 1

step 2

DRAGONS

THE TRUE LORDS OF FANTASY ARE DRAGONS. ANCIENT, MYSTERIOUS, AND MAGICAL, DRAGONS ARE THE GREATEST OBSTACLE — OR AID — IN ANY HEROIC ENDEAVOR.

DRAGONS HAVE BEEN DESCRIBED IN A VARIETY OF WAYS, BUT CARTOONED DRAGONS SHOULD REFLECT THE INNER NATURE OF THE BEAST. START WITH THE BASIC *IDEA* OF THE DRAGON.

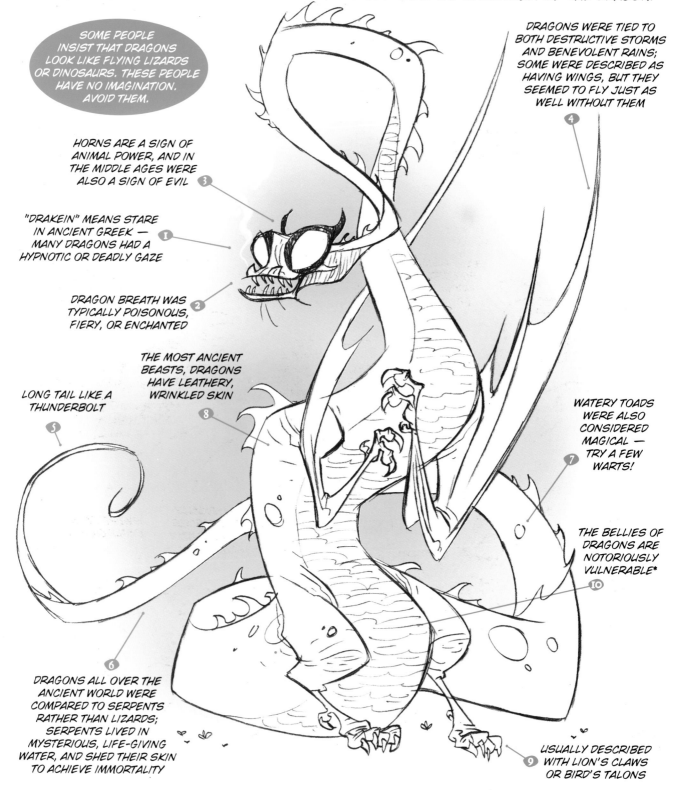

SOME PEOPLE INSIST THAT DRAGONS LOOK LIKE FLYING LIZARDS OR DINOSAURS. THESE PEOPLE HAVE NO IMAGINATION. AVOID THEM.

DRAGONS WERE TIED TO BOTH DESTRUCTIVE STORMS AND BENEVOLENT RAINS; SOME WERE DESCRIBED AS HAVING WINGS, BUT THEY SEEMED TO FLY JUST AS WELL WITHOUT THEM

4

HORNS ARE A SIGN OF ANIMAL POWER, AND IN THE MIDDLE AGES WERE ALSO A SIGN OF EVIL

3

"DRAKEIN" MEANS STARE IN ANCIENT GREEK — MANY DRAGONS HAD A HYPNOTIC OR DEADLY GAZE

1

DRAGON BREATH WAS TYPICALLY POISONOUS, FIERY, OR ENCHANTED

2

THE MOST ANCIENT BEASTS, DRAGONS HAVE LEATHERY, WRINKLED SKIN

LONG TAIL LIKE A THUNDERBOLT

5

8

WATERY TOADS WERE ALSO CONSIDERED MAGICAL — TRY A FEW WARTS!

7

THE BELLIES OF DRAGONS ARE NOTORIOUSLY VULNERABLE*

10

6

DRAGONS ALL OVER THE ANCIENT WORLD WERE COMPARED TO SERPENTS RATHER THAN LIZARDS; SERPENTS LIVED IN MYSTERIOUS, LIFE-GIVING WATER, AND SHED THEIR SKIN TO ACHIEVE IMMORTALITY

USUALLY DESCRIBED WITH LION'S CLAWS OR BIRD'S TALONS

9

*CONSIDER THE SAD FATE OF FAFNIR, IN "THE SONG OF THE VOLSUNGS"

THE DRAGON HEAD

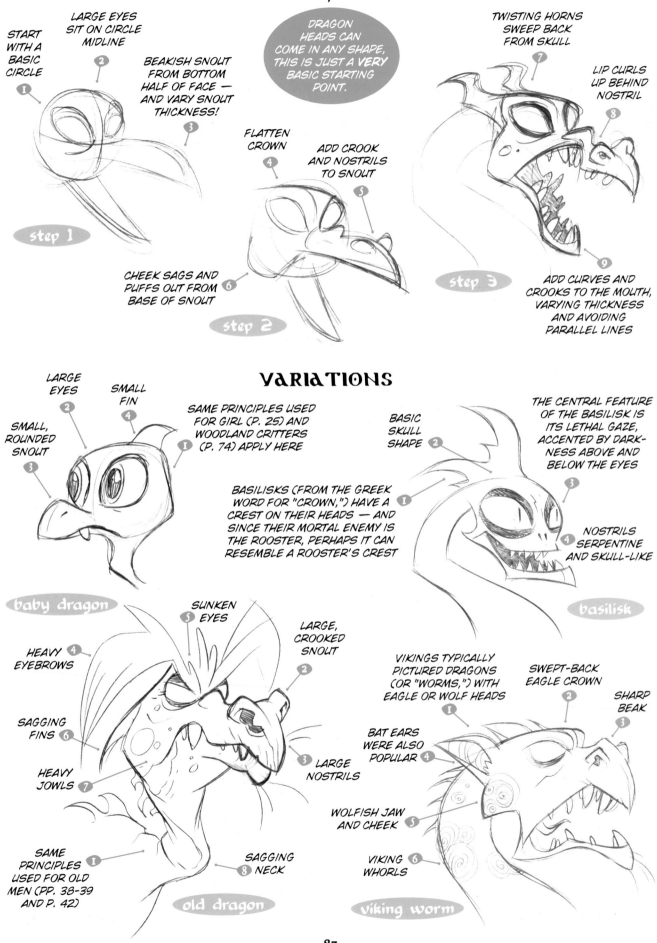

START WITH A BASIC CIRCLE ①

LARGE EYES SIT ON CIRCLE MIDLINE ②

BEAKISH SNOUT FROM BOTTOM HALF OF FACE — AND VARY SNOUT THICKNESS! ③

DRAGON HEADS CAN COME IN ANY SHAPE, THIS IS JUST A VERY BASIC STARTING POINT.

TWISTING HORNS SWEEP BACK FROM SKULL ⑦

LIP CURLS UP BEHIND NOSTRIL ⑧

FLATTEN CROWN ④

ADD CROOK AND NOSTRILS TO SNOUT ⑤

step 1

CHEEK SAGS AND PUFFS OUT FROM BASE OF SNOUT ⑥

step 2

step 3

ADD CURVES AND CROOKS TO THE MOUTH, VARYING THICKNESS AND AVOIDING PARALLEL LINES ⑨

VARIATIONS

LARGE EYES ②

SMALL FIN ④

SMALL, ROUNDED SNOUT ③

①

SAME PRINCIPLES USED FOR GIRL (P. 25) AND WOODLAND CRITTERS (P. 74) APPLY HERE

BASILISKS (FROM THE GREEK WORD FOR "CROWN,") HAVE A CREST ON THEIR HEADS — AND SINCE THEIR MORTAL ENEMY IS THE ROOSTER, PERHAPS IT CAN RESEMBLE A ROOSTER'S CREST

BASIC SKULL SHAPE ②

①

THE CENTRAL FEATURE OF THE BASILISK IS ITS LETHAL GAZE, ACCENTED BY DARKNESS ABOVE AND BELOW THE EYES ③

NOSTRILS SERPENTINE AND SKULL-LIKE ④

baby dragon

basilisk

SUNKEN EYES ⑤

HEAVY EYEBROWS ④

LARGE, CROOKED SNOUT ②

SAGGING FINS ⑥

HEAVY JOWLS ⑦

③ LARGE NOSTRILS

VIKINGS TYPICALLY PICTURED DRAGONS (OR "WORMS,") WITH EAGLE OR WOLF HEADS ①

SWEPT-BACK EAGLE CROWN ②

SHARP BEAK ③

BAT EARS WERE ALSO POPULAR ④

WOLFISH JAW AND CHEEK ⑤

SAME PRINCIPLES USED FOR OLD MEN (PP. 38-39 AND P. 42) ①

SAGGING NECK ⑧

VIKING WHORLS ⑥

old dragon

viking worm

—87—

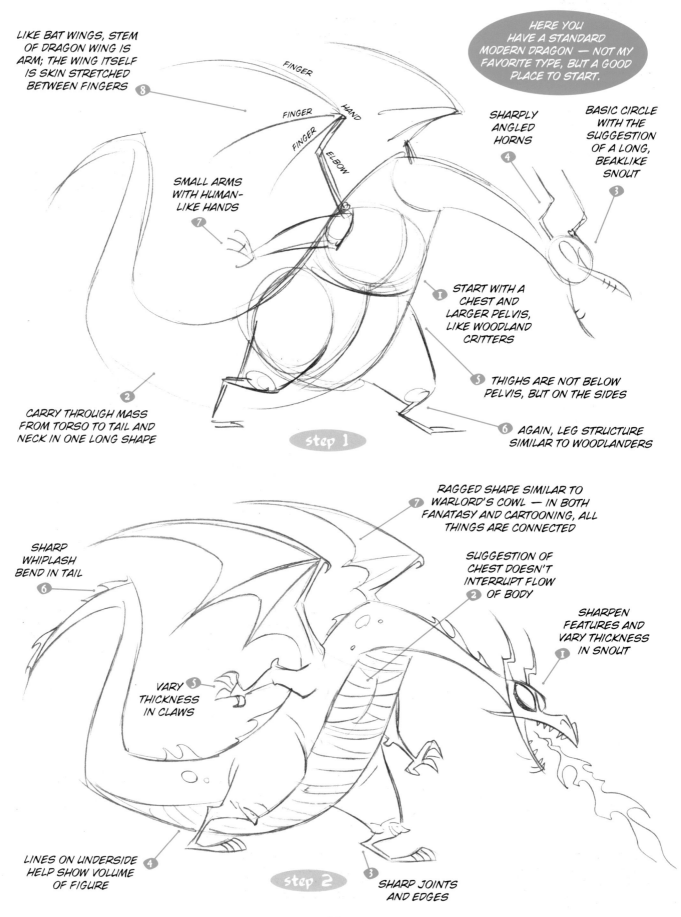

HERE YOU HAVE A STANDARD MODERN DRAGON — NOT MY FAVORITE TYPE, BUT A GOOD PLACE TO START.

LIKE BAT WINGS, STEM OF DRAGON WING IS ARM; THE WING ITSELF IS SKIN STRETCHED BETWEEN FINGERS 8

FINGER

FINGER

FINGER

HAND

ELBOW

SHARPLY ANGLED HORNS 4

BASIC CIRCLE WITH THE SUGGESTION OF A LONG, BEAKLIKE SNOUT 3

SMALL ARMS WITH HUMAN-LIKE HANDS 7

START WITH A CHEST AND LARGER PELVIS, LIKE WOODLAND CRITTERS 1

THIGHS ARE NOT BELOW PELVIS, BUT ON THE SIDES 5

CARRY THROUGH MASS FROM TORSO TO TAIL AND NECK IN ONE LONG SHAPE 2

step 1

AGAIN, LEG STRUCTURE SIMILAR TO WOODLANDERS 6

RAGGED SHAPE SIMILAR TO WARLORD'S COWL — IN BOTH FANATASY AND CARTOONING, ALL THINGS ARE CONNECTED 7

SHARP WHIPLASH BEND IN TAIL 6

SUGGESTION OF CHEST DOESN'T INTERRUPT FLOW OF BODY 2

SHARPEN FEATURES AND VARY THICKNESS IN SNOUT 1

VARY THICKNESS IN CLAWS 5

LINES ON UNDERSIDE HELP SHOW VOLUME OF FIGURE 4

step 2

SHARP JOINTS AND EDGES 3

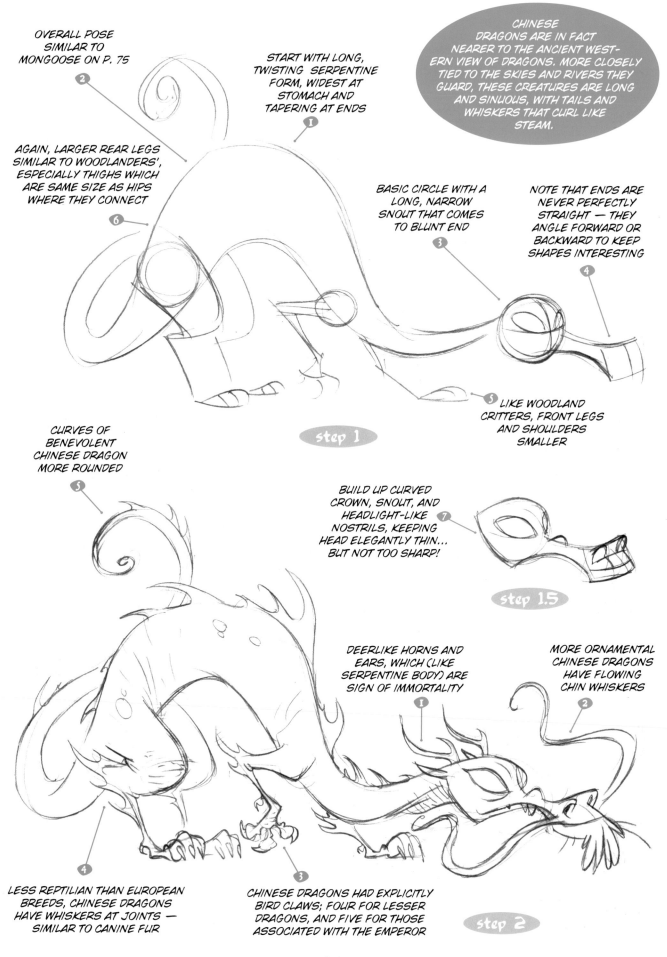

OVERALL POSE SIMILAR TO MONGOOSE ON P. 75
2

START WITH LONG, TWISTING SERPENTINE FORM, WIDEST AT STOMACH AND TAPERING AT ENDS
1

CHINESE DRAGONS ARE IN FACT NEARER TO THE ANCIENT WESTERN VIEW OF DRAGONS. MORE CLOSELY TIED TO THE SKIES AND RIVERS THEY GUARD, THESE CREATURES ARE LONG AND SINUOUS, WITH TAILS AND WHISKERS THAT CURL LIKE STEAM.

AGAIN, LARGER REAR LEGS SIMILAR TO WOODLANDERS', ESPECIALLY THIGHS WHICH ARE SAME SIZE AS HIPS WHERE THEY CONNECT
6

BASIC CIRCLE WITH A LONG, NARROW SNOUT THAT COMES TO BLUNT END
3

NOTE THAT ENDS ARE NEVER PERFECTLY STRAIGHT — THEY ANGLE FORWARD OR BACKWARD TO KEEP SHAPES INTERESTING
4

LIKE WOODLAND CRITTERS, FRONT LEGS AND SHOULDERS SMALLER
5

step 1

CURVES OF BENEVOLENT CHINESE DRAGON MORE ROUNDED
5

BUILD UP CURVED CROWN, SNOUT, AND HEADLIGHT-LIKE NOSTRILS, KEEPING HEAD ELEGANTLY THIN... BUT NOT TOO SHARP!
7

step 1.5

DEERLIKE HORNS AND EARS, WHICH (LIKE SERPENTINE BODY) ARE SIGN OF IMMORTALITY
1

MORE ORNAMENTAL CHINESE DRAGONS HAVE FLOWING CHIN WHISKERS
2

LESS REPTILIAN THAN EUROPEAN BREEDS, CHINESE DRAGONS HAVE WHISKERS AT JOINTS — SIMILAR TO CANINE FUR
4

CHINESE DRAGONS HAD EXPLICITLY BIRD CLAWS; FOUR FOR LESSER DRAGONS, AND FIVE FOR THOSE ASSOCIATED WITH THE EMPEROR
3

step 2

DRAGON FLIGHT

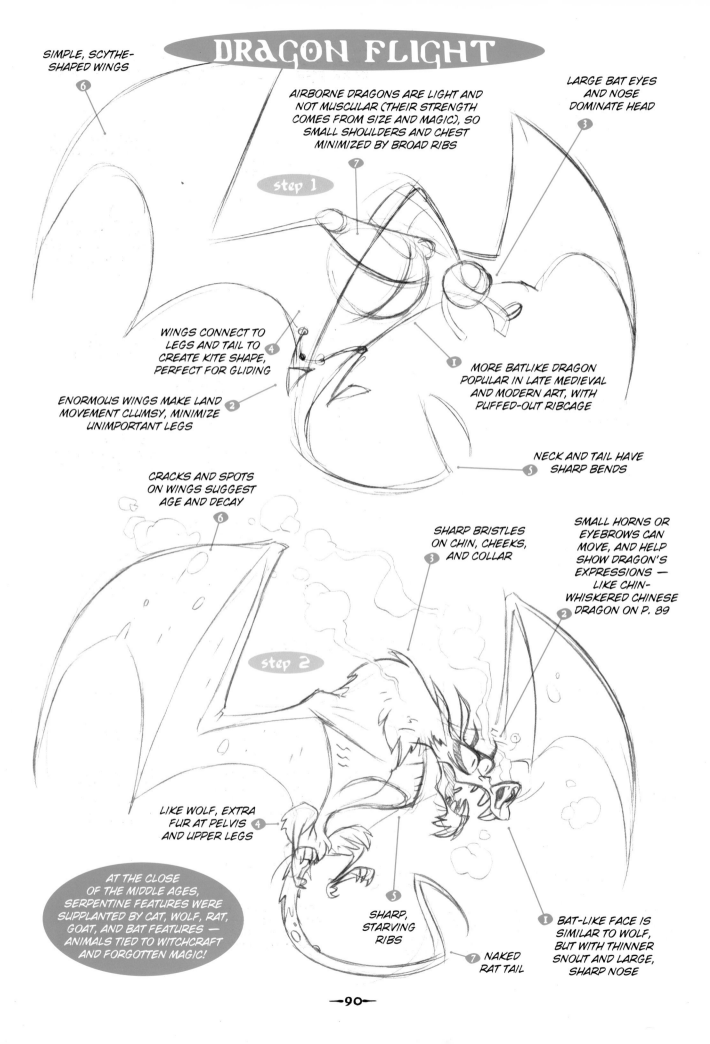

SIMPLE, SCYTHE-SHAPED WINGS ⑥

AIRBORNE DRAGONS ARE LIGHT AND NOT MUSCULAR (THEIR STRENGTH COMES FROM SIZE AND MAGIC), SO SMALL SHOULDERS AND CHEST MINIMIZED BY BROAD RIBS ⑦

LARGE BAT EYES AND NOSE DOMINATE HEAD ③

step 1

WINGS CONNECT TO LEGS AND TAIL TO CREATE KITE SHAPE, PERFECT FOR GLIDING ④

ENORMOUS WINGS MAKE LAND MOVEMENT CLUMSY, MINIMIZE UNIMPORTANT LEGS ②

① MORE BATLIKE DRAGON POPULAR IN LATE MEDIEVAL AND MODERN ART, WITH PUFFED-OUT RIBCAGE

NECK AND TAIL HAVE SHARP BENDS ⑤

CRACKS AND SPOTS ON WINGS SUGGEST AGE AND DECAY ⑥

SHARP BRISTLES ON CHIN, CHEEKS, AND COLLAR ③

SMALL HORNS OR EYEBROWS CAN MOVE, AND HELP SHOW DRAGON'S EXPRESSIONS — LIKE CHIN-WHISKERED CHINESE DRAGON ON P. 89 ②

step 2

LIKE WOLF, EXTRA FUR AT PELVIS AND UPPER LEGS ④

AT THE CLOSE OF THE MIDDLE AGES, SERPENTINE FEATURES WERE SUPPLANTED BY CAT, WOLF, RAT, GOAT, AND BAT FEATURES — ANIMALS TIED TO WITCHCRAFT AND FORGOTTEN MAGIC!

SHARP, STARVING RIBS ⑤

NAKED RAT TAIL ⑦

① BAT-LIKE FACE IS SIMILAR TO WOLF, BUT WITH THINNER SNOUT AND LARGE, SHARP NOSE

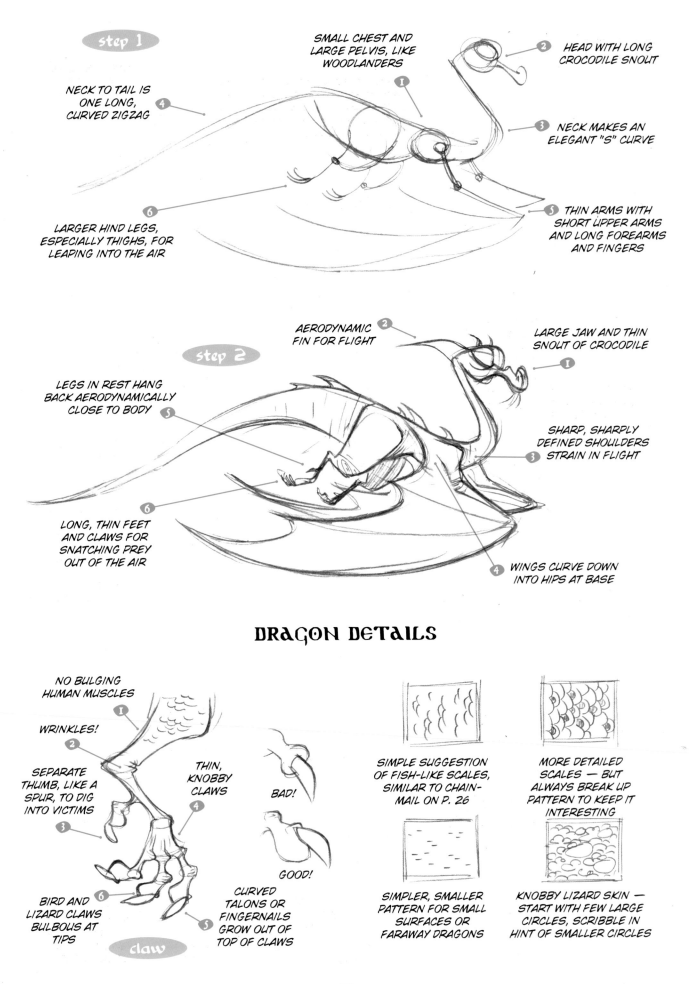

step 1

SMALL CHEST AND LARGE PELVIS, LIKE WOODLANDERS

① ② HEAD WITH LONG CROCODILE SNOUT

NECK TO TAIL IS ONE LONG, CURVED ZIGZAG ④

③ NECK MAKES AN ELEGANT "S" CURVE

⑥

LARGER HIND LEGS, ESPECIALLY THIGHS, FOR LEAPING INTO THE AIR

⑤ THIN ARMS WITH SHORT UPPER ARMS AND LONG FOREARMS AND FINGERS

AERODYNAMIC FIN FOR FLIGHT ②

LARGE JAW AND THIN SNOUT OF CROCODILE ①

step 2

LEGS IN REST HANG BACK AERODYNAMICALLY CLOSE TO BODY ⑤

SHARP, SHARPLY DEFINED SHOULDERS STRAIN IN FLIGHT ③

⑥

LONG, THIN FEET AND CLAWS FOR SNATCHING PREY OUT OF THE AIR

④ WINGS CURVE DOWN INTO HIPS AT BASE

DRAGON DETAILS

NO BULGING HUMAN MUSCLES ①

WRINKLES! ②

SEPARATE THUMB, LIKE A SPUR, TO DIG INTO VICTIMS ③

THIN, KNOBBY CLAWS ④

BAD!

GOOD!

BIRD AND LIZARD CLAWS BULBOUS AT TIPS ⑥

⑤ CURVED TALONS OR FINGERNAILS GROW OUT OF TOP OF CLAWS

claw

SIMPLE SUGGESTION OF FISH-LIKE SCALES, SIMILAR TO CHAIN-MAIL ON P. 26

MORE DETAILED SCALES — BUT ALWAYS BREAK UP PATTERN TO KEEP IT INTERESTING

SIMPLER, SMALLER PATTERN FOR SMALL SURFACES OR FARAWAY DRAGONS

KNOBBY LIZARD SKIN — START WITH FEW LARGE CIRCLES, SCRIBBLE IN HINT OF SMALLER CIRCLES

AFTERWORD

SO THAT WAS YOUR INTRODUCTION TO THE WORLD OF FANTASY CHARACTERS! NOW THAT YOU'VE SEEN THE BASIC ELEMENTS OF FANTASY CARTOONING, YOU CAN DEVELOP YOUR OWN UNIQUE CHARACTERS, MONSTERS, AND ACTION POSES. BUT REMEMBER — THIS BOOK (AND OTHERS LIKE IT) ARE JUST THE STARTING POINT! IT'S UP TO YOU TO PUSH THE BOUNDARIES OF WHAT IS NORMAL AND WHAT IS STRANGE... BECAUSE SOMEWHERE BEYOND LIES THE BEAUTIFUL, HORRIFYING, HILARIOUS, AND MYSTIFYING WORLD OF FANTASY!

INDEX

INDEX

THERE ARE LITERALLY THOUSANDS OF AMAZING FANTASY STORIES AND ARTISTS TO INSPIRE YOU. BELOW IS A BRIEF LIST OF SOME OF MY FAVORITES! AND DON'T FORGET ALL THE GREAT MATERIAL FROM HISTORY: CENTURIONS AND HERALDRY AND MONGOL HORDES!

BOOKS

BEOWULF
 TRADITIONAL ANGLO-SAXON
BONE
 JEFF SMITH
THE CHRONICLES OF NARNIA
 C. S. LEWIS
DRACULA
 BRAM STOKER
THE EARTHSEA BOOKS
 URSULA K. LE GUIN
THE FLIGHT OF DRAGONS
 PETER DICKINSON
HARRY POTTER AND...
 J. K. ROWLING
THE HOBBIT, THE LORD OF THE RINGS
 J. R. R. TOLKIEN
THE LAST UNICORN
 PETER BEAGLE
THE MABINOGION
 TRADITIONAL CELTIC
MONKEY!
 TRADITIONAL CHINESE
THE ODYSSEY
 HOMER
THE PRYDAIN CHRONICLES
 LLOYD ALEXANDER

THE RAMAYANA
 TRADITIONAL INDIAN
THE WIZARD OF OZ
 L. FRANK BAUM

ARTISTS

WAYNE ANDERSON
COR BLOK
DON BLUTH
 ("THE SECRET OF NIMH,"
 "DRAGON'S LAIR")
LEO & DIANE DILLON
EDMUND DULAC
EYVIND EARLE
 ("SLEEPING BEAUTY," "FANTASIA")
EDWARD GOREY
IAN MILLER
HIYAO MIYAZAKI
 ("TOTORO," "SPIRITED AWAY")
KAY NIELSON
BOB PEPPER
RANKIN & BASS
 ("THE HOBBIT," "THE LAST UNICORN")
PETER SIS
UDERZO
LISBETH ZWERGER